Oil Painting Workshop

ALBERT HANDELL
AND LESLIE TRAINOR

Oil Painting Workshop

WATSON-GUPTILL PUBLICATIONS/NEW YORK
PITMAN HOUSE/LONDON

This book is dedicated to
my dearest mother, Mrs. Sophie Handell,
and to the beloved memory of
my dear father, Meyer Joel Handell.

First published 1980 in the United States and Canada by Watson-Guptill Publications,
a division of Billboard Publications, Inc.
1515 Broadway, New York, N.Y. 10036

Library of Congress Cataloging in Publication Data
Handell, Albert, 1937–
 Oil painting workshop.
 Bibliography: p.
 Includes index.
 1. Painting—Technique. I. Trainor, Leslie,
1949– joint author. II. Title.
ND1500.H33 751.45 80-15407
ISBN 0-8230-3292-2

Published in Great Britain by Pitman House,
39 Parker Street, London WC2B 5PB
ISBN 0-273-01621-0

Manufactured in Japan

First Printing, 1980

Special thanks to my coauthor, Leslie Trainor, for a beautiful job in the understanding and writing of this book; to Marsha Melnick and Don Holden who helped to organize and formulate it; to Bonnie Silverstein for a fine job of editing; to Jay Anning for the design of the book; and a very special thanks to all the wonderful students who have studied with me over the years. For, without you, there never would have been a book.

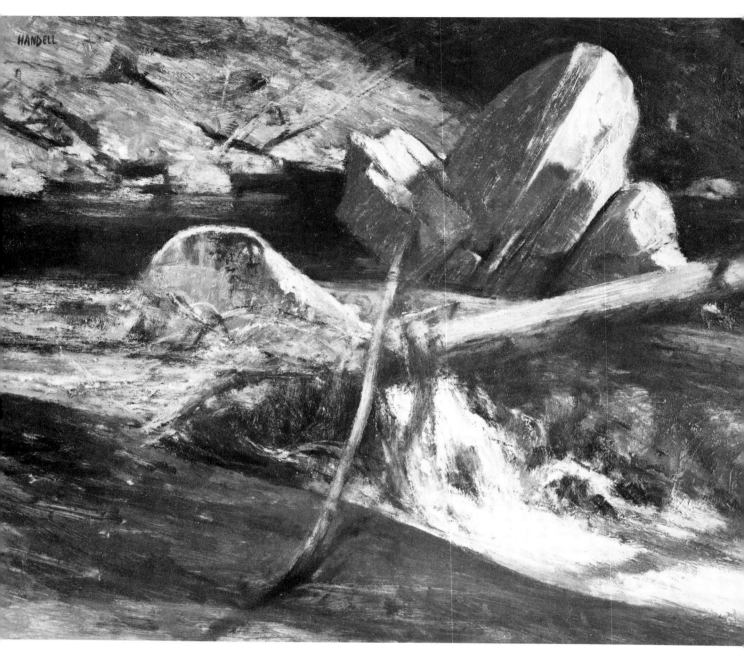

THE STREAM AT WOODLAND VALLEY, *oil, 16″ x 20″ (41 x 51 cm), collection Dr. and Mrs. Bruce Sorrin.* Rushing, swirling water never ceases to amaze me. More and more I am centering my paintings around it rather than using it as merely one of the elements of a painting. But this means learning more about water, and thinking about the design of the painting in slightly different terms.

This painting was done on location. I started with a transparent full-color wash-in and worked on top of it with opaque paint that got heavy in places, like the upright rocks and the gushing white foam of the water. For these aspects of the painting I used a palette knife (see Lesson 6).

Contents

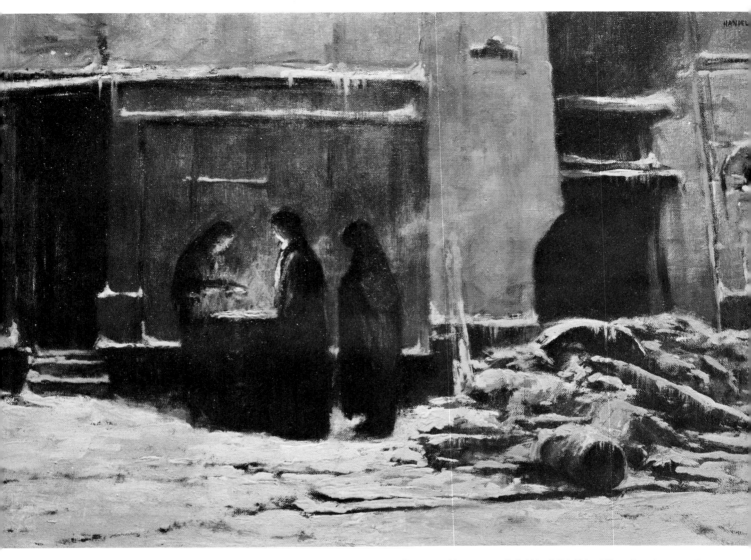

CENTRAL HEATING, *oil, 24″ x 30″ (61 x 76 cm), private collection. Photo Peter A. Juley & Son.* This painting was composed from drawings I did while living in Paris. It is late afternoon on a cold winter day. All the colors are cool and very harmonized. Suddenly the people around the barrel are illuminated by the warm, yellow-orange glow of the fire in the barrel. It's a ''schmaltzy'' painting, but I loved doing it. This type of painting makes you realize how rich harmonious colors can be when the colors of the palette are used in a lopsided manner.

Introduction

This book is for everyone whose dream is to paint out-of-doors with oil paints. Whether it be still lifes, architectural subjects, trees, running water, or other forms of nature, I offer this book not only as a source of information but as an inspiration to pursue that dream.

The painting techniques presented vary greatly, starting with basic beginning techniques and progressing to the more advanced. If you are new to working with oils outdoors, you can start by reading and studying each chapter, moving at your own pace. Don't be in a rush; each chapter will mean more to you if you have digested and absorbed the information from the preceding one.

On the other hand, if you have been working with oils outdoors for a while, you can use the information in this book in a slightly different manner, referring back and forth through the chapters to find what you might need at any given time. For instance, should you wish to know more about glazing and scumbling, you can jump to Chapter 8; or, if you wish to learn more about painting shadows, you can skip to Chapter 7. No matter what your stage of development, you can easily find what you need.

The subject matter is also organized to suit a variety of needs, from readily accessible subject matter, such as a group of baskets, to more complicated motifs, like a woods interior.

Student Days

I was born in Brooklyn and started studying at the Art Students League of New York on Saturdays when I was 16. I first studied with Louis Priscilla, a student of the famed George Bridgman; he taught drawing and anatomy. I was attending the High School of Industrial Arts (now the High School of Art and Design) at that time, and, as I was unhappy with the teaching there, I found the Art Students League of New York a wonderful alternative. At 19 I began studying painting with Frank Mason, who is still teaching there. At 20, I decided to spend an entire year working on my own, painting landscapes and street scenes. I had my first car then, a 1954 Pontiac. My painting of it is reproduced in color on page 94. The car enabled me to travel around New York for my subject matter. For beach scenes and rocks, I used Canarsie Bay and the beaches at Far Rockaway. Street scenes were everywhere: Greenwich Village, the Lower East Side, Brooklyn Heights, Park Slope, and my immediate neighborhood, Crown Heights. For landscapes, I frequented Prospect Park, a beautiful park located in the heart of Brooklyn.

As a student, the main thrust of my painting objectives was to bring everything into tonal relationship and harmony. I painted smaller then, and, as I was poor, I worked on ordinary canvas board. I was told that these canvas boards would not last

long, but the paintings I did 20 years ago on these surfaces are still in perfect condition, and I expect them to remain so for many, many years. These little paintings, many of which I still have, remind me tenderly of my early days. They were more than little studies; I like to think of them as poems, little painted poems.

My work schedule in those days was hectic. I would get up at 6 AM and go out to a predetermined area that I had seen before and start painting at 7:30 or 8 AM. I would work until around 10 or 10:30 AM, until the light had shifted so much that I just had to stop. (Later, when my painting improved, I was able to stay out longer, for I understood how I could control changing light conditions.) After cleaning my palette and brushes I would go home, eat, rest, and relax. In the afternoons, at around 3, I would set out again to paint a second street scene or landscape. At times during the long hours of the summer, I was even able to get in a third painting session. Or, if I was too tired I would often paint on the rooftop of my Eastern Parkway apartment house.

After painting for well over a year this way, I got to know New York City, especially Brooklyn, quite well. Sometimes I'd even venture out to Long Island for a change. Because of the regularity of my working habits, I was soon able to tell time without a clock. My awareness and sense of connection with nature also grew at that time. I still remember a day in Prospect Park in late March or early April. It had been a long cold winter, and the snow was still on the ground. Standing there and painting, I kept hearing a strange creaking sound behind me. I kept turning around but couldn't see anything. Cu-rious and fascinated, I stopped painting, determined to discover what caused this strange sound. Pretty soon I discovered that in the silence and quiet of the day I had been hearing the snow melt and fall!

Teaching and Painting
This book is a result of 23 years of study and painting and many years of teaching. It seemed as though students always came to me for help, and I gave it freely. Even as a student at the Art Students League, I had an "unofficial" class of my own. It was an unstructured arrangement but I was definitely teaching. This type of arrangement continued wherever I studied—Paris, Brooklyn, Mexico, Salt Lake City. I even attempted to teach at the University of Utah for a short time but soon discovered the experience too constricting for personal growth.

With my father's death, I returned East and settled in Woodstock, New York. Shortly afterward, I decided to offer classes in a workshop format. I advertised nationally and the response was overwhelming. Over the years, my Woodstock school has grown, and each summer I offer intensive two-week workshops in the two media I work in primarily: oils and pastels. I separate the media and also the subject matter: the portrait and figure, and landscapes. I am equally drawn to both subjects, feeling a close connection to both living experiences, people and nature.

In this book I offer ten lessons gathered from a lifetime of teaching and wish to share the joys and personal rewards of oil painting with an ever-growing audience.

EASTERN PARKWAY, *oil, 10'' x 14'' (25 x 36 cm), collection the artist.* Here is another of those little paintings of some 20 years ago done on canvasboard (which, by the way, has held up perfectly). I was living on Eastern Parkway in Brooklyn then, and it snowed often that winter, reducing movement in the city to a quiet crawl. I painted this one morning, taking careful note of the value relationships and subduing the colors to obtain a much cherished harmony. It is painted simply and directly using an opaque alla prima technique.

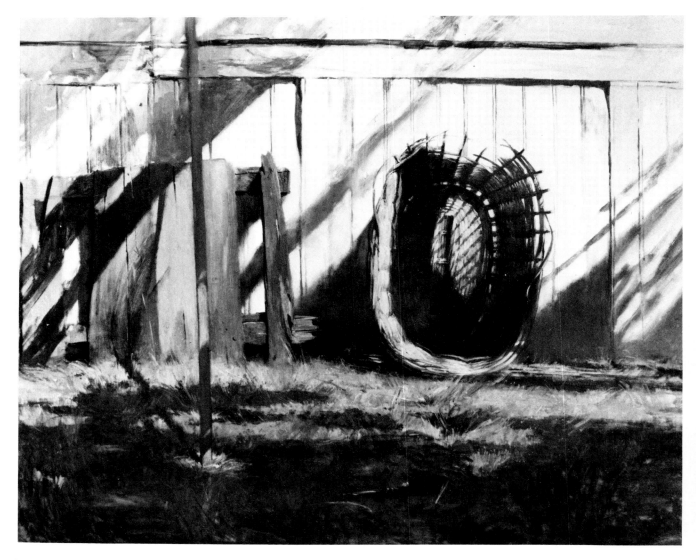

MY BACKYARD, *oil, 24'' x 30'' (61 x 76 cm), collection Mr. and Mrs. Irving Litt. Photo Richard di Liberto.* This is the largest painting of the ''basket'' series. After working on smaller studies for close to a week, painting, drawing, and observing the basket daily, I just had to get involved with a larger painting and a more complicated composition. Also, I adored the old broken-down driftwood fence leaning against the white wooden wall. Probably the best way to start a painting like this is to use the transparent monochromatic underpainting (see Lesson 7), and then slowly complete it opaquely. Though I didn't use a Polaroid camera, I recommend doing so. The light changes radically too soon in a subject like this, and it can be confusing.

(Right)
THE WASH BASKET, *oil, 14'' x 18'' (36 x 46 cm), collection Janaan Moncure. Photo Richard DiLiberto.* This is a study that became a small painting. The variety and delightful intricacy that can be found in a wash basket leaning against the wall are truly amazing. This painting was done when I lived in Utah, where the sun shines all summer long. Every day I would go out to the backyard and sit there all day long, observing and painting this one solitary wash basket. It became a series of 12 or so works in oil, watercolor, and pastel, and the subject of numerous pencil and wash drawings. The effect of sunlight on this subject was enormous, for there is light and shadow, reflected light, and at times translucent light or an effect of light that looks like translucent light. The sun would change all day, forcing me to observe what I had going and to marvel at the different beautiful effects of sunlight on my subject. Each painting could be worked on for no more than an hour each day. After a week of working on this subject, I had a number of different studies all around. As the sun would move, I would move from one painting to another. For most of them I stayed put in one or at most two locations. I would recommend painting a subject lit like this with a transparent monochromatic underpainting, using raw umber to start with (see Lesson 7), and then working opaquely on top of this tonal skeleton to finish it.

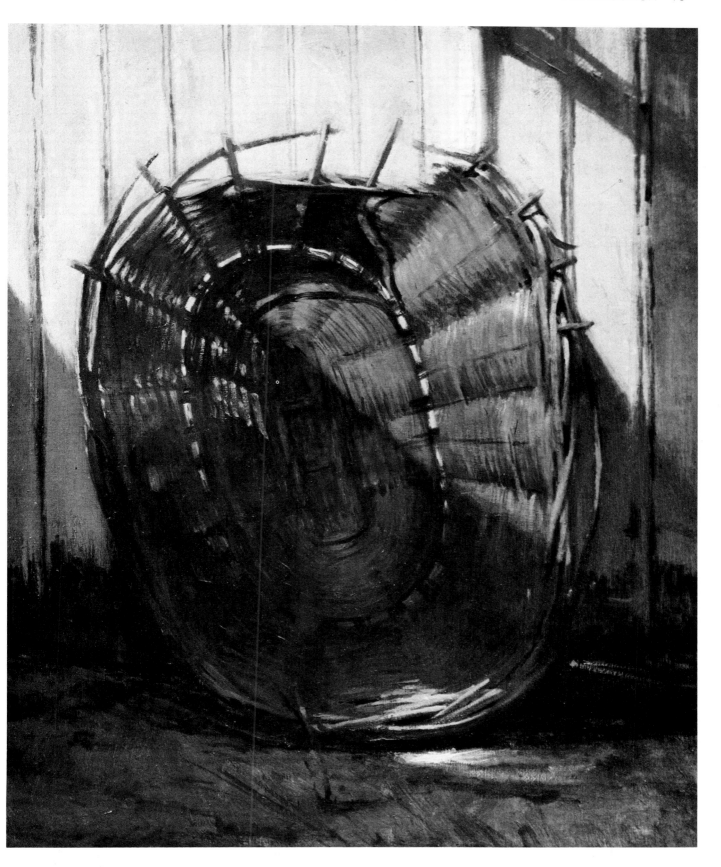

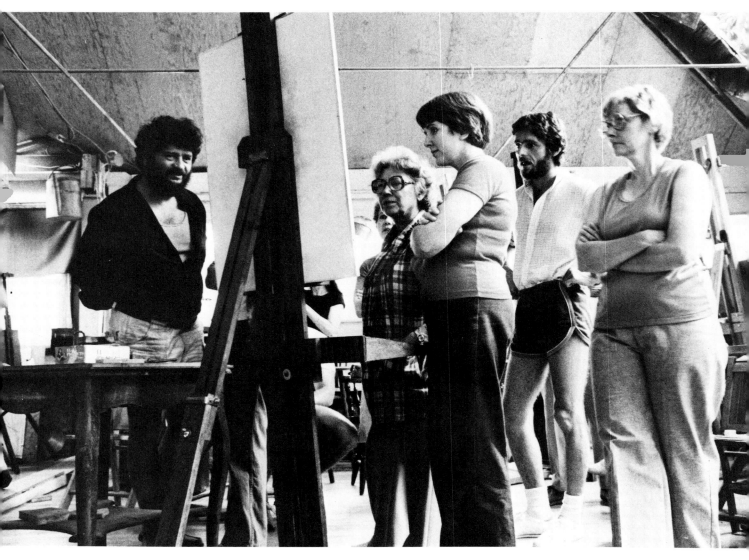

A painting demonstration at my studio in Woodstock, N.Y.

Studio Notes

On the following pages, I describe my materials and give practical advice on such topics as selecting and preparing canvases and panels and making Maroger medium. I also discuss such important elements of painting as color, composition, massing, edges, and rhythm, and I suggest ways of seeing, painting, drawing, and selecting a subject for a painting. Perhaps I will even persuade you of the wonders of painting and drawing outdoors.

The Support

In oil painting there are several options in supports (what you paint on) and surfaces (the ground that covers the support). You can choose a flexible support, such as linen or good-quality cotton duck stretched over a frame, or a rigid support, such as wood or metal. Whichever one you choose, however, should suit your personal needs and artistic aims. Since it is only through experience and experimentation that you will discover which support best suits your particular style, try them all!

A well-made surface is a good foundation for a painting, and, since you will wish to preserve your painting as long as possible, it is also important to prepare the ground properly. This is how I select and prepare linen canvas and pressed-wood panels for painting.

Traditional Linen Canvas

Many artists prefer the traditional flexible support because they like the sensation of ''digging'' into the canvas that the trampoline effect of stretched canvas affords. Also, the weave of the linen adds a beautiful texture to the painting.

Choosing the Linen

Throughout the history of painting, a variety of textile fabrics have been used in preparing surfaces for oil paintings. Linen remains the most preferred because of its durability, its variety of weight (light to heavy, and in many weaves, from smooth to rough), and its lesser contraction and expansion due to moisture than other suitable textiles (namely, good-grade cotton duck).

Always select a good-quality linen though the texture of the weave will depend on the size and nature of the subject. A fine weave is best for small paintings and delicate portraiture. For larger pictures, a coarser weave is preferable.

Stretching the Canvas

Canvas is sold in rolls and is later cut to the size you wish and stretched across wooden stretcher bars with mitered corners. These stretcher bars are available in various lengths. Especially for large

paintings, I use double-duty stretcher strips with a crossbar placed in the center of the assembled frame to hold the corners steady and avoid problems of warping that can arise when the canvas shrinks after the sizing is applied.

A few simple rules can ensure a well-stretched canvas:

1. Make sure the stretcher bars you select are strong enough and not warped.
2. After assembling the frame and securing the crossbar in the center, check the corners with a T square to see that they are exact.
3. Cut the canvas 4″ (10 cm) larger than the frame, to ensure an excess of 2″ (5 cm) all around.
4. Lay the canvas on a flat surface and place the assembled stretcher frame in the center so there is an equal amount of excess all around. Have the weave of the fabric running parallel to the sides of the frame.
5. Fold the excess over the frame and tack in the center on each side. Staples may be used, but I prefer tacks because they can be easily removed and replaced for adjustments.
6. Stand the frame and canvas up on its edge and begin pulling it tight with stretcher pliers. Always pull and tack from the center to each corner to avoid folds or wrinkles and to keep the canvas taut.
7. To secure the corners, pull the canvas taut at the edge and the adjacent corner taut to the edge, make a fold (miter), as when cornering the sheet of a bed, and tack the fold securely.

Applying the Size

Sizing the canvas is the process of applying a thin layer of rabbitskin glue (the size) to the linen surface. When it dries, it becomes extremely taut, so that it stretches the linen thoroughly. Rabbitskin glue, which is used traditionally, comes in crystals and dry sheets. Both give excellent results. Soak the glue overnight or until the crystals or sheets are swollen—1.5 to 2 ounces of glue in 32 fluid ounces of water. Heat the mixture in a double boiler and stir until the glue is dissolved and has become a brown, gravy-like liquid, free of lumps. Don't boil the liquid, or the strength of the glue will be lost.

Allow the liquid to cool and gel overnight. Then scoop some out in the palm of your hand and work it into the canvas with a circular motion. I rub it around and press it in gently; the heat of my hand and the friction of the movement dissolve the glue into the weave of the linen. I also work out from the center to the edges. As the glue dries, it shrinks and contracts the linen so that the surface becomes as taut as a drum. When the surface is completely dry, any lumps on the surface can be lightly sanded off.

Priming the Canvas

When priming the canvas, a decision must be made as to how absorbent you wish the ground to be. With an absorbent ground, your paints will dry quickly, allowing you to work on top of them very soon. On a nonabsorbent ground, your paints will stay wet longer, allowing you to paint into them and manipulate them over a longer period of time.

For an absorbent ground, I prime the canvas with an acrylic-based gesso (such as Liquitex, Aqua-Tec, or Hyplar brands), brushed on as it comes from the can. (If you wet your brush with water before dipping it in the gesso, the paint will wash off more easily at cleanup time.) Using a 3″ (7.5 cm) brush, brush on a coat in one direction, and, when dry (within two hours), brush on a second coat in the opposite direction. Three or four coats should be applied in this manner. The surface requires no sanding when dry.

A nonabsorbent surface (the oil ground) is prepared with Dutch Boy white lead oil paint. The procedure followed is the same as that above. Start with two layers of gesso prime for the base. Then, apply two layers of Dutch Boy white lead house paint. Mix the white lead with turpentine to the consistency of thick cream. Apply to the surface with a 3″ (7.5 cm) brush in the opposite direction of the previous coat of prime. Lay the surface flat and allow it to dry for approximately four days. Give it a light sanding if there are any lumps on the surface. Then give the surface a second and final coat of white lead. You can also apply the last coat of white lead with a large spatula or wide palette knife to help spread it evenly. This coat of prime may take as much as two to three weeks to dry thoroughly. It should be allowed to lie flat and dry naturally without any direct sun or fans.

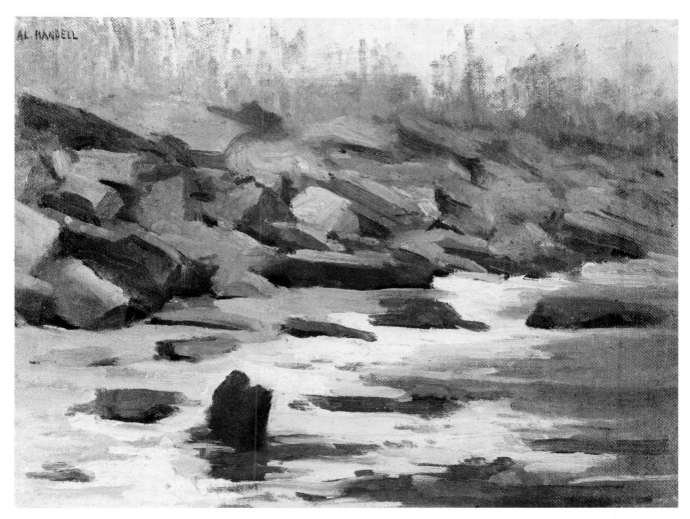

Toning the Ground

At this point the canvas is a stark white, and, since I find this surface unpleasant to work on, I tone it. A toned ground has several other advantages: it helps unify a painting in the early stages, before all the areas are covered with paint and when a pure white ground could be distracting. Also, the correct values of the colors, especially the lighter ones, show up better on a toned surface.

For a transparent tone, I mix an oil color, usually raw umber or raw sienna, with turpentine and scrub it onto the surface. For an opaque tone, I mix acrylic raw umber with acrylic white for a light, middle-value gray, and brush one coat on the primed surface in the same direction. I allow the surface to dry completely before painting on it. Both methods can also be applied to toning pressed-wood panels.

CANARSIE BEACH, *oil, 10'' x 14'' (25 x 36 cm), collection Mr. and Mrs. Christopher Carajohn.* This view of Canarsie Beach was painted 20 years ago, when I first became seriously involved with outdoor subjects and lighting. Notice how all the rocks on the beach gently fade into each other and only a modicum of detail is established. It was still quite cold, and there was melting ice on the beach. A middle-value gray floats over and interacts with all the colors in the rocks. I painted the rocks by first determining the value of their general mass. I then mixed this value as a gray on my palette. All the different colors of the rocks were mixed into this middle-value gray mixture; so it was easy to harmonize the rocks. The only problem with this approach is that the gray could become too prevalent and prevent you from getting rich colors. But it's a sensible way to paint a cluster of rocks, which can be a confusing subject.

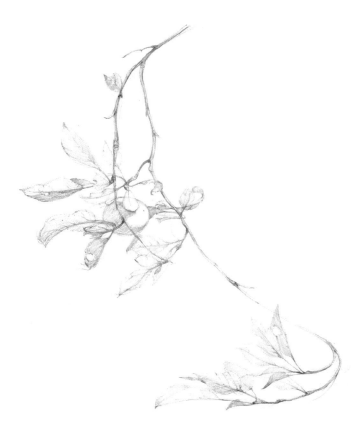

TWIG FROM AN APPLE TREE. This is a relaxing way to study a detail of a twig or plant. You can either work directly from the bush or tree or take a cutting of a twig. If you decide on a cutting, bring it indoors to the comfort and lighting conditions of your studio and put a large white sheet behind it so that you can see it as a whole. Look for its proportions, rhythms, and comparative shapes. Try to compose it on your page, working as large as you can. This is a good exercise for learning placement and composition.

Pressed-Wood Panels

Over the years, I have come to prefer working on gessoed pressed-wood panels. True, there is no give in such a rigid surface, but I like the free flow of the brush across a smooth surface. Thus, for the most part, I paint on a pressed-wood panel such as Masonite®, a hard composition board formed by the natural adhesion of wood fibers when pressed together. Pressed wood is used in building and is available at lumberyards in sizes up to 4' x 8' (1.2 x 2.4 m) and in thicknesses of ⅛'' and ¼'' (3 and 6 mm). For a small labor charge you can have a large sheet cut to the size panels you wish to work on.

Pressed wood is available in both ''tempered'' and ''untempered'' surfaces, tempered for indoor use and untempered for outdoor use. I work with the untempered; if it is made to withstand outdoor weather conditions, it certainly will last long under the indoor care a valued oil painting receives.

Some pressed wood has a rough texture on one side and a smooth one on the other; some is smooth on both sides. I use the kind that has two smooth sides. The rough-textured board is too rough and its surface too unnatural to be suitable for delicate work.

Priming the Surface

The procedure for preparing pressed-wood panels is relatively simple. Once the panels are cut to the desired size, they are ready to be primed. I use the same acrylic-based gesso as in the first layers of prime on the linen canvas, and prime only one side of the panel. (Usually, there is no warping. If there is, it disappears when the painting is framed.) I apply the gesso directly from the can with a 3'' brush, moving across the surface in the same direction. The pressed wood is very absorbent, and the gesso will dry quickly and darker than when first applied. Within two hours I apply a second coat, in the opposite direction from the first, and work in a little texture with the brush. Again, as the panel is still absorbent, the coat will dry darker than when applied but lighter than the first. I apply two more coats at two-hour intervals each, first in one direction and then the opposite. The fourth coat will dry very white, the absorbency of the panel having been much reduced at this point. You can leave the surface white or, as I do, work on a toned ground.

Toning the Surface

I work on a light, warm gray-toned ground, a value number 3 on a scale of 10, where white is value number 1. On this tone the tonal structure and color harmonies of the painting can be established solidly. A white ground is too brilliant, and white paint on a white surface won't show up well. However, white paint on a gray tone will show up as white, allowing you the flexibility to see and control the tonal range you are constructing.

To tone these pressed-wood panels, I mix acrylic raw umber diluted with water into the white acrylic gesso to form a light warm gray and apply it to the surface with a 3'' (7.5 cm) brush after the last coat of prime has dried thoroughly. Transparent grounds can be toned with washes of oil and turpentine, applied and then wiped dry with a rag.

Bracing the Panel

With large panels, bracing is recommended, as the panel may warp under its own weight when standing in storage. Since I use pressed wood in thicknesses of ½'' (13 cm) or more, there is little if any warping. However, according to the quality of pressed wood you have, you may feel safer bracing your panels.

The bracing should be done before you begin to work on the panel. Cut 1'' x 3'' (2.5 x 7.5 cm) strips of wood to fit squarely around the panel, then glue them to the back of the panel with white glue, and clamp until dry. Protect the front of the panel from the clamps by placing strips of wood under the metal edge so that no sharp indentation occurs.

Brushes

In general I use the following good-quality brushes:
 bristle rounds, nos. 1, 3, 5, 7, and 9;
 bristle flats, nos. 1, 3, 5, 7, and 9; and
 red sable flats, nos. 2, 4, and 6.
I work with several brushes of each size on hand, to keep the colors clean and separate.

When I paint very large canvases, I use larger brushes of the same series as these, but, in general, I prefer to use smaller brushes because they allow me to get more energy, electricity, and rhythm into my brushstrokes. Smaller brushes also help me avoid the blanket-like effect I would get with larger brushes. Instead, each area is built up with successive applications of relatively small

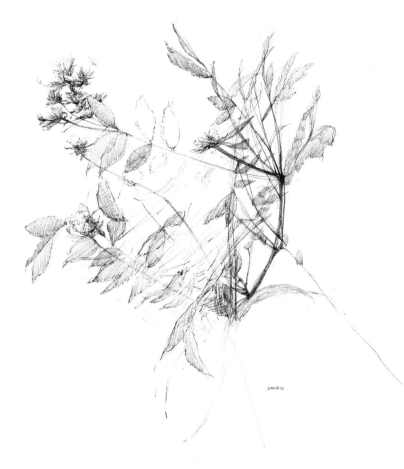

Here is a random cutting taken one June morning of wildflowers that grow near my studio. I put them in a vase of water and positioned them against a white sheet so I could observe the cutting as a whole. Notice the sense of rhythms in the drawing.

strokes, which are sensitive to the form I am painting at a given moment. In the finished painting, the small strokes of paint applied in different directions and various rhythmic relationships give the work a vitality and density I find very exciting.

Care of Brushes

When working outdoors I carry my brushes in a Japanese bamboo brush holder. This device, resembling a small bamboo curtain, allows you to secure the brushes in the cord binding and then roll them up in it. This way you keep the hairs of the brushes from receiving any pressure, which would destroy their shape.

I clean my brushes daily with turpentine, swishing them in the liquid and then drying them with a rag. Then I stand them up in a coffee can, brush-end up, so the hairs do not press against anything. Once a week, I give them a thorough cleaning with soap and water. I don't do this every day as I feel this type of cleaning tends to separate the hairs.

Tips

To save a brush that is full of dried paint, soak and swish it gently in paint remover and let it sit ten minutes. Then wipe off the loosened paint and clean the brush with turpentine.

To reshape a brush, wet it and coat it with a thick layer of soap. Reshape it and let the brush sit for a week with the soap on it, which will act as a glue. Then rinse and store the brush.

Palette Knives

Palette knives come in various trowel-shaped sizes and are either pointed or rounded at the end. I use them occasionally for special effects, but not as a general rule. They are excellent for achieving textural effects, especially in large paintings. They are also excellent for mixing colors on the palette.

Mediums

We all hear a lot of talk about painting mediums. In my opinion, any medium you enjoy working with is good. Remember that it is the aesthetics that are important: that is what makes for fine painting. However, a good rule to follow is that, whatever medium you choose, the less of it you use the better.

Today, my basic medium is the Maroger me-

dium. However, at times I have worked with no medium at all, or a little turpentine, or pure, sun-thickened linseed oil. Each paint medium has its own characteristics. Turpentine gives a free-flowing, fast-drying quality, while linseed oil is slower to dry and therefore ideal for working a painting wet into wet. A medium I have tried and also recommend is a mixture of one part each damar varnish, turpentine, and linseed oil.

Maroger Medium

Jacques Maroger, a 20th-century French restorer, experimented with mediums considerably. He was searching for the lost painting medium of the Flemish masters, to which were attributed many of the fine, lasting qualities of their paintings. Indeed, he finally came up with a unique gel medium known today as the Maroger medium.

As years go by, his discovery is becoming better known to practicing artists. During my student days at the Art Students League of New York, when we were all very eager to learn everything we could, the paint medium we used was very important to us. Many of us would make our own Maroger mediums then, and with quite good results.

There is much controversy regarding the use of the Maroger medium and its "magic" qualities. Critics of the medium believe it causes paintings to remain tacky for a long time. I have never had this problem. Those in favor of the medium believe it allows for great versatility, permanence, and delicate manipulations of the oil paints. Critics also claim the medium blackens the paint and that it isn't permanent, but after 20 years, I have never had this problem, nor have any of my contemporaries. Also, Rubens is supposed to have used such a medium, and yet his colors are as fresh and beautiful today as they were the day they were first painted. I personally prefer the Maroger medium for the buttery consistency it gives to the oil paints. As with any medium you use, it should be used sparingly. For myself, the Maroger medium feels good to work with, giving that "little extra something" to the body and texture of my paints. It is excellent for glazing and scumbling, allowing me to thin out the paints to a beautiful transparency yet maintaining a consistency which is not too watery and will not drip. There is little sinking in of the colors, and much of the freshness of the initial color applica-

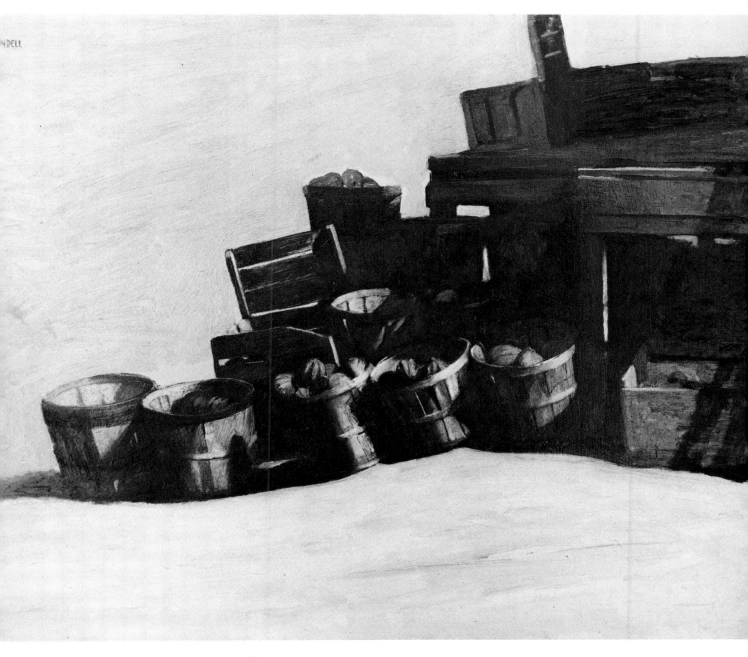

WOODSTOCK FRUIT STAND, *oil, 24'' x 30'' (61 x 76 cm), collection Ms. Helen Scungio. Photo The Tom Reynolds Studio.* Here we are dealing with light and dark patterns, strong shapes, and halftones (the bushels in the background). I decided to eliminate everything in the background and focus on the subject, keeping the whole painting a vignette and fading it out gradually. The painting was built up slowly, beginning with a transparent underpainting and working opaquely in the overpainting. I drew in the objects carefully because I would be adding details to these masses in the finishing stages, when accurate drawing would matter.

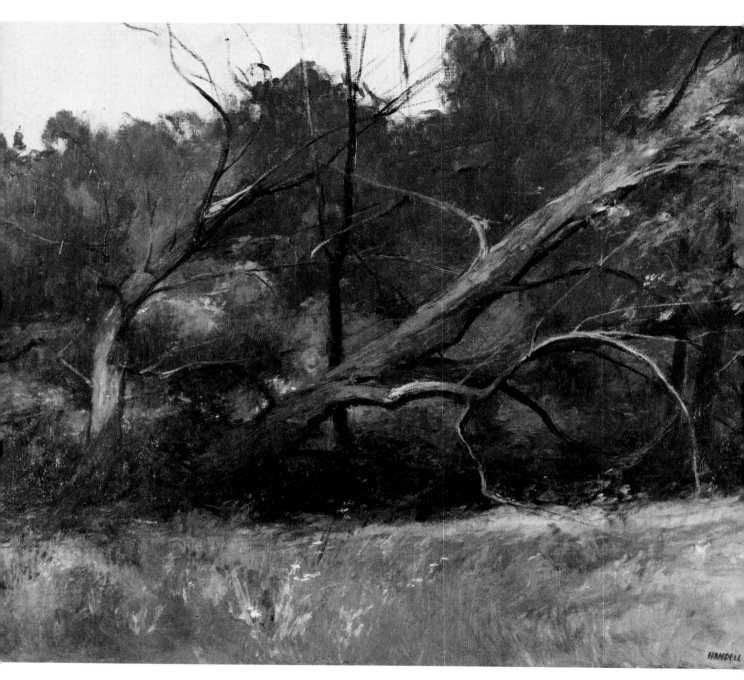

THE WOODS IN BUCKS COUNTY, *oil, 18'' x 24'' (46 x 61 cm), collection Mr. and Mrs. John LaValle.* Bucks County, Pennsylvania, is quite beautiful, with rolling hills, lush farmland, and gentle woods. I found my subject after a short stroll and laid in the entire painting using an opaque technique, with different variations of green, all very close in value. Once the painting was established, I simply went over everything, adding accents, highlights, and a few details.

tion is retained. Also, when using the Maroger no other solvent or medium is needed. It serves equally well as a retouch varnish and final varnish. Throughout the chapters of the book I will be demonstrating its versatility and the various ways I use this wonderful medium.

I always make my own Maroger medium. Although there may be slight variations in the method of preparation and the proportions from one artist to another, the following procedure is the one I use and have found successful:

Materials
10 parts cold-pressed linseed oil
10 parts pure gum spirits of turpentine
5 parts mastic crystal varnish
½ part litharge

Before you prepare the Maroger medium, observe this precaution: Work in a well-ventilated room with a fan and with the windows open or wear a nose mask because the fumes from the litharge, or white lead, are in powdered form and are poisonous. Using a pot that will be kept just for making Maroger medium, mix the linseed oil with the litharge and heat it slowly, for about 15 minutes, stirring it constantly with a wooden spoon. (Try not to linger over the pot while the mixture is cooking.) The boiling point of linseed oil is very high, and the mixture need not boil. At a certain point it will begin to turn brown. Keep heating and stirring it until it becomes jet black. When the oil is jet black, turn down the flame a bit and slowly pour in the mastic crystals. Continue stirring until the crystals are completely dissolved in the hot black oil. Some of the crystals may pop loudly as you do this, but there is no need to worry. When completely dissolved, remove the oil mixture from the heat and let cool.

Great care must be taken in this next step because, on the one hand, linseed oil has a very high boiling point, while, on the other, turpentine has a low flash point. You must make sure the mixture cools below 90° F (30° C) before adding the turpentine, or the mixture will ignite. While I go by feel and observation for the correct temperature, a candy thermometer might be a good idea! If the mixture should catch fire—though it never has with me—just put the lid on the pot.

When the mixture has cooled, add the turpentine cautiously, stirring in a few drops on the wooden spoon (at arm's length). It should not sizzle or percolate at all. (If it does, stop and let the mixture cool a bit longer.) Then continue adding the turpentine, small amounts at a time, stirring constantly, until all has been dissolved into the mixture thoroughly.

Pour the mixture—very gingerly—into small jars or tubes and let stand overnight to gel. Then screw the lid on the jar of the medium and store it in a cool place such as the refrigerator when not in use.

Varnishes

Since I use the Maroger medium, I find I don't need to apply a final varnish to my paintings because there is varnish in the medium itself in the form of mastic crystals. However, if you work with another medium, a final protective varnish should be applied.

The painting should be allowed to dry at least six months before a final varnish is applied. The varnish can be brushed or sprayed on. Traditionally, damar varnish was used as a final varnish, but today there are several new varnishes on the market. Kammar varnish, a synthetic varnish which comes only as a spray, gives excellent results and is also fast-drying. The advantage of spraying is that the spray can be controlled and applied evenly.

Retouch Varnish

A retouch varnish is applied just before you resume working on a painting already in progress. The retouch varnish, which can be brushed or sprayed on, brings out the original gloss of the colors that they had when they were fresh from the tube. Again, when using the Maroger medium, a retouch varnish is not necessary.

Blooming

Never varnish a painting on a sticky, muggy day, no matter what varnish you use. If moisture gets onto your oil painting as you are varnishing, a foggy, opaque, bluish film will cover the surface. This is called "blooming." If this occurs, you must take the painting to a professional restorer to have it removed.

The Portable Easel

A French easel is probably the single most valuable piece of painting equipment I own. I use it for all my on-the-spot outdoor painting and highly recom-

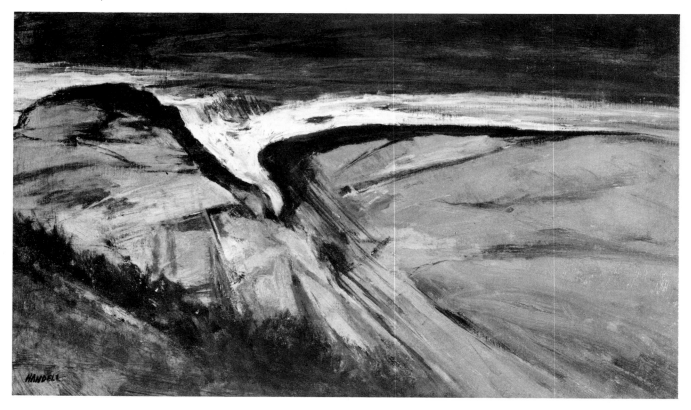

LOBSTER COVE, *oil, 9½" x 16" (24 x 41 cm), private collection. Photo The Tom Reynolds Studio.* Here again we're dealing with patterns, shapes, colors, textures, and movement. This is a small painting, done on location. The entire painting was established transparently, then with semi-opaque and opaque paint, it was brought to a quick finish. Notice the sense of rhythm and movement the rocks and flowing water give to the painting. This painting has a simple yet solid design quality.

mend you get one. The French easel has enough room to fit compactly and easily all my brushes, painting knives, paint tubes, mediums, and paint rags. When open, it stands on three adjustable legs, which are very sturdy, so I can sit or stand while I work. It also holds a canvas or panel as high as 36" (14 cm). For storage or transportation, the easel folds neatly into a box shape, with a handle for carrying it.

Hand-Held Palette

I always use a hand-held palette, both indoors and outdoors. I find it very convenient, and it fits my forearm comfortably, giving me great flexibility of movement. I also can tilt it, which allows me to see my paints without a glare on them. Palettes come in various sizes and are usually made of good-quality wood.

To break in a brand-new wooden palette, I rub linseed oil into it for three days before I begin using it, to eliminate the absorbency of the palette. Of course, this can also be done as you're breaking in the palette, by simply using it and oiling it at the end of each day with linseed oil.

To clean the palette, after each use simply scrape off excess paint mixtures with a palette knife and wipe the central mixing area with a rag and turpentine until clean. Don't clean off the fresh tubed colors around the edge of the palette if they're still soft and usable.

Colors

All brands of paints on the market today are generally good. I use Winsor & Newton oil colors, except for ultramarine red, which is made by Grumbacher. My palette of colors today consists of the following:

Titanium white	Cadmium green light
Naples yellow	Permanent green
Cadmium yellow light	Sap green
Yellow ochre	Cerulean blue
Raw sienna	Cobalt blue
Cadmium orange	Ultramarine blue
Cadmium red light	Ultramarine red
Alizarin crimson	Raw umber
Burnt sienna	Ivory black

This is my usual full-color palette, and I use it for both portraits and landscapes. I find it to be a truly well-balanced palette and can confidently paint almost any subject with it. The colors harmonize well, and I rarely find that I need additional colors to complete a painting. However, at times I will select an additional color for experimentation or to capture a specific color quality.

The colors are listed in the order I place them on the palette. As one is used up, I replace it in the same space. I lay out fresh colors each day, putting out a little more rather than a little less of each color. (It is better to waste a little than to have to stop in the heat of painting to look for more color.) After a while laying out paint becomes a natural process, and you know instinctively just how much color to squeeze out.

At the end of the day I scrape together the remaining paint on the palette to see what color mixture I come up with. It has been said that this mixture relates to the general tonal range of the picture. Though I don't necessarily agree with this, I like to keep this color, often a murky gray-brown, and use it in the painting when I work on it again. I find it to have special properties in unifying the colors of the painting.

A Word About Color

Seeing color is a very personal and individual experience. Some of us see much color everywhere, while others pass through life mostly unaware of it. Many painters are born with a gift for seeing color, while others can acquire the ability through studied awareness. To introduce you to the world of color, here are some terms that are commonly used!

Primary Colors

Primary colors are basic colors that cannot be mixed from any other colors; they simply *exist*. The primary colors are red, yellow, and blue.

Secondary Colors

Secondary colors are formed by mixing any two of the primary colors together. The results are:

Red + Blue = Purple
Red + Yellow = Orange
Yellow + Blue = Green.

All three primary colors mixed together result in a neutral brown-gray.

Complementary Colors

When you have *any* secondary color (for example, green, purple, or orange), the primary color not used for the mixture of this secondary color is its complement. For example, orange is mixed from yellow and red; the primary color that is missing is blue. So blue is the complementary color of orange. Using this simple method of deduction, find the complements of purple and green.

When secondary colors such as orange and green or purple and orange are mixed together, they form brownish-grays. These mixtures are referred to as tertiary colors.

Hue

Hue is another word for color, and, as commonly used, what is meant by hue or color is the *local color* of an object.

Local Color

Local color is the actual color of an object (such as a "red" sweater), without the modifying effects of the lighting or reflected light on the object. When we say trees are green, we are referring to local

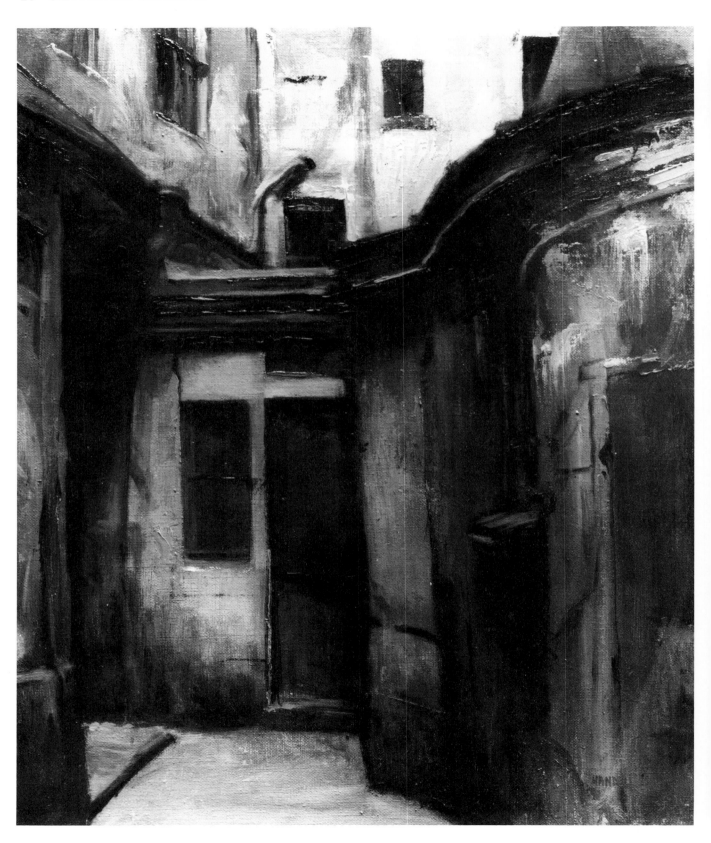

color, for they are one color in the springtime, yet another in late summer, another on a gray day, and yet another in the sun or shade.

Value

The value of a color is its degree of lightness or darkness. You can see value apart from hue when you compare a low-value red such as maroon to a high-value red such as pink. To understand the concept of color seen as value, picture a black-and-white photograph of a colorful scene, where the myriad colors that would normally be seen appear only as gradations of gray, with black as the darkest dark and white as the lightest light.

For practical purposes, artists limit the number of values they work with to approximately ten, ranging from white (1) to middle-tone gray to black (10). Of course, there are many more values in nature, but trying to capture each one would be as confusing, frustrating, and impossible as trying to duplicate nature itself. So organizing color into a limited number of values gives you a means of reducing a scene to simple artistic terms. Understanding the relationship between value and color is paramount to successful painting, although I often treat them separately in the lessons in this book for the sake of clarity.

Edges

An edge is created wherever two distinct values or colors meet. The sharpness or softness of the edge depends upon the degree of difference between the values or colors. For instance, where a dark limb of a tree cuts across a light sky, the edges are sharp; where the dark trunk is surrounded by dark earth and shadows, the edges are softer and blend into each other gradually. Understanding edges and using them effectively will add much to the unity of your painting.

Massing

Massing means organizing all the shapes of a painting that are similar in value into large groups. Massing values helps unify a painting, giving it much intrinsic strength. It also simplifies the shapes in the painting, thus giving the painting carrying power. I like to mass the darker values, usually in the shadow areas, first. Because it is much harder to see objects in these darker areas, the edges there are softer, and the value range is closer. Therefore, massing the darks is simpler and more obvious than massing the lights (which is why it is done first).

(Left)
PARISIAN COURTYARD NO. 2, *1963, oil, 16'' x 20'' (41 x 61 cm), collection Mr. and Mrs. George Velkas.* The curves, forms, and angles I found in this Parisian courtyard were truly unexpected and exciting. Here the entire lower two-thirds of the painting was kept cool to bring out the cool light that filtered into this section of the courtyard. On the other hand, the wall in the upper third of the painting was in a delicate, diffused sunlight, thus enabling me to switch to warm colors for this area.

(Right)
This 9'' x 12'' (23 x 30 cm) sketch was drawn with a 2H Venus pencil on two-ply plate finish bristol board. It was done in the Brooklyn Heights area of New York City. I love the patterns storefronts make. Usually you can look into the storefronts, and when you do, their interiors become patterns of light and shadow.

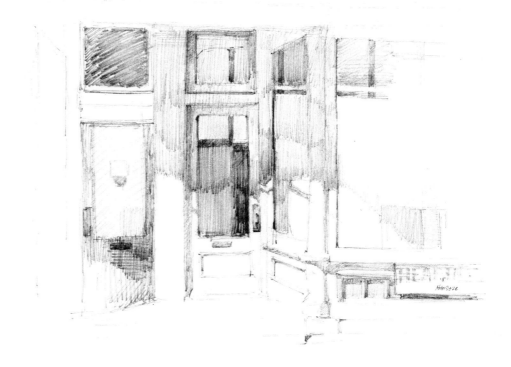

Working into a Wet Tone

To harmonize your outdoor sketches, you might find it helpful to take a blank white canvas with you on location. After you select a subject to paint, decide what general tone or color is most pertinent to the painting. Then mix this tone or color on your palette and, using a lot of turpentine, wash this tone lightly over the canvas before you begin to paint the scene. Since this underlying tone will still be wet when you paint, whatever colors you put on top of it will pick up some of this basic color. The result will be an automatic color harmony in your painting.

Rhythms

More and more I see the world in terms of rhythms. Rhythms can be defined as movement but not necessarily motion. There is an innate duality to all in nature, and rhythm to me is one reflection of this. Everything is at the same time both stationary and in motion. We are able to perceive the essence of this movement as rhythms; the directions of movement in objects as seen through light and shadow, shape, color, and texture, enhanced by the inner silent energy of existence. More and more in my paintings I strive to make this aspect of life an integral part of my artistic expression.

Finishing a Painting

Too often I find students rushing to complete their paintings, getting involved with details too soon and not spending enough valuable time in the planning stages of their work. Try to enjoy each stage of development from beginning to end, and plan your work carefully.

When I work toward the finish of a painting, I develop it slowly, reflecting often as I work. As you will see in the step-by-step demonstrations, the progress in the early stages is not abrupt, and I slowly feel my way around the painting. Then, suddenly, I reach a point where I feel in control; I know where I am and where I want to go with the picture. At this point instinct and feeling take over, and I carry the painting to completion, pulling out select details and accents.

Selective Finishing

After you decide the most important part of your painting (where you want the viewer to look first—your center of interest), you are ready for selective finishing. Zero in on this area and paint it to completion, placing a lot of detail and strong contrasts there. Then leave the surrounding areas unfinished, so they don't compete with the finished area. This will give your center of interest some breathing space. Then complete the rest of the painting, varying the amount of detail throughout the work.

At first you may want to finish everything—and perhaps you should do just that. But, as you gain experience, the decision as to what is and isn't important will become a key question in balancing the finished painting.

Tips on Looking

There are two ways you can look at the world: with your eyes wide open or squinting. Most people look only with their eyes wide open, and wherever they look all they see are details. As a result of photography, we have become used to observing and enjoying details in the photographs we view daily in newspapers and magazines. But there photographs are intended to be seen at arm's length, while paintings are meant to be viewed at a distance that is certainly farther than that! So while photographs with their detail look fine, paintings must have carrying power. You can achieve this carrying power by painting only what you see when you squint. Squinting forces you to eliminate detail and see only the shapes that make up the underlying masses of light and shadow. These underlying masses are important, for it is the basic abstract pattern that gives your painting its intrinsic carrying power. This is something all painters must learn.

Drawing

My students are always amazed when I tell them that I draw as much as I paint, but I can only tell you to draw as much as possible. Learn to see and feel as you draw. It is an excellent way to spend time observing and studying. After a while drawing will become a habit, a lifelong habit. Draw with whatever tools you wish, but draw.

I use two different types of paper for my drawings, two-ply bristol board with a kid finish, and two-ply bristol board with a plate finish. The kid finish has a tooth to it and thus gives the drawing a

MONHEGAN WOODS, *oil, 10'' x 14'' (25 x 36 cm), collection Mr. and Mrs. John J. Keough.* This lively little sketch was done on location in a relatively short period of time. First I massed in all the greens, using only one or two different mixtures to establish the entire painting. I worked with small brushes to keep fresh the movement and rhythms of the background woods. Then I painted the trunk with thick, opaque paint and scratched out the branches with the back of the brush.

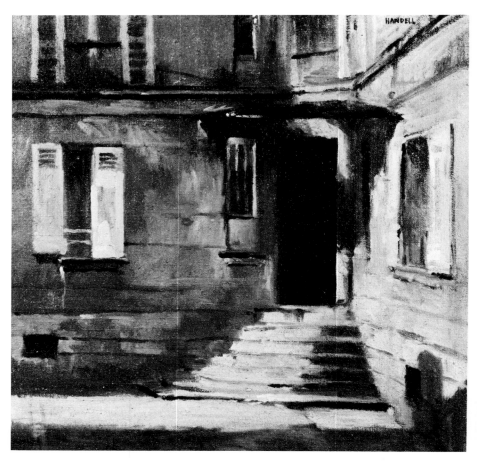

PARISIAN COURTYARD NO. 3, *oil, 24'' x 24'' (61 x 61 cm), private collection. Photo Geoffrey Clements.* This painting was done at midday, with direct overhead sunlight streaming down onto my subject. The door was open, giving me an opportunity to add rich darks. The bright sunlight created a strong reflected light that lightened the shadow areas—and virtually eliminated them—and warmed up the colors there. Actually, the entire color key of this painting was on the warm side.

texture. Also, when lightly erased, the pencil marks don't come off but blend together like a wash drawing, giving immediate and dramatic light-and-shadow patterns.

On the other hand, the plate finish is smooth with no tooth, and the pencil lines thus sit more precisely on the surface. It takes longer to build up the light and shadow on this paper, but more line work can be done on it, and it's very easy to erase.

The bristol board surface is lovely and durable, allowing me to work on it for a long time. I can also paint with watercolor on top of my drawings since the paper won't buckle with the application of water.

Painting from Drawings

In drawing on location, work to get the light and shadow and the proportions of your subject in your drawings. It takes a little practice, but after a while you will be able to envision the scene again as you look at the drawing. In this way you will develop a strong memory. Painting from drawings is a very good practice and one I think it is good to start

early in the game. Carry a little sketchbook with you at all times and draw whenever something catches your eye. I made it a point to do this for a number of years and still do it often. It's a terrific habit to get into, and, as you continue the discipline, your ability to recall subject matter will grow, allowing you to paint from drawings more easily.

Painting from Photographs and Slides

There are both advantages and drawbacks to painting from photographic images. On the positive side, a photograph or color slide has many details you may lose sight of as you work away from the subject, and referring to it may prove very useful. On the other hand, photographic images are limited and lack the excitement and movement that pervades on-the-spot painting. Often I see beginning students becoming too dependent on photographs and slides too soon. The result is washed-out tones and colors embroidered with details, with little understanding of the underlying masses.

Thus, I feel that beginning art students should stay away from slides and photographs and paint

from life as much as possible. In this way you will develop a personal vision not stultified by the photographic image. Once you have developed a vision all your own, you'll find that using the photographic image will be an aid, not a hindrance.

Painting from Life

Painting from life is an exhilarating experience. For me, this is the most exciting way to paint a landscape or street scene. You get out there and see all the various effects of light: the play of light and shadow and the variations of the different types of day. Outdoors you experience a grandeur you don't find inside the studio. The tonal range is much wider than that found indoors. The studio is like a dark cave compared to what you see outside. It is always brighter outside, and the colors are richer. Outdoors, you absorb and experience things that may not necessarily get onto your canvas, but certainly become part of future canvases. There is an excitement about painting outdoors, but the bathroom and kitchen facilities certainly are not the same, and you can freeze out there—so dress accordingly! Get into the habit of painting from life and you will develop a freshness of eye and color that will be a great asset to your work.

Selecting a Subject Outdoors

There is a wealth of subject matter outdoors, and probably you will find yourself wanting to paint all of it. If deciding what to paint is a problem, you must learn to limit yourself. Choose one subject you wish to study, and then stick with it. Capturing the essence of a particular subject requires much patient study and understanding.

For instance, over the years I have centered on studying select aspects of nature—closeups of trees, rocks, and streams—rather than an overall view or panorama. I am strongly drawn to the dynamic quality of a detail and the individual sense of being that each possesses. The possibilities open to me with just these three natural elements are always new and exciting. Likewise, my approach to urban landscapes has become one of detailed study rather than the overall view of the street scene. I find character studies of small sections of buildings forceful in the silent statement of their existence.

Whatever subject you choose to paint, listen to your innermost feelings. Most often you will not verbalize why you choose to paint a particular subject in a particular manner, but when the feeling is there you will know instinctively what you are looking for.

Using a Viewfinder

One way to choose a subject and create a composition is by using a viewfinder. To make one, take an ordinary piece of cardboard, approximately 8" x 10" (20 x 25 cm), and cut out an oblong shape, say 6" x 8" (15 x 20 cm), in the center. The surrounding cardboard will then become a frame. By holding this mat in front of you and bringing it closer or moving it farther from your eye, you will see many different compositions in the landscape. After a while you won't need to use a viewfinder to make these decisions, but it is a good tool to have at the beginning.

A Word About Composition

I follow no set rules of composition but design each painting with a fresh eye. Although the paintings in this book offer a wide range of composition, they all share three qualities. First, they have a *center of interest* which draws the viewer into the painting, capturing his attention. Then, whatever methods were used to accomplish this, *simplicity* is stressed to the utmost. Finally, all the paintings' combined elements are developed *harmoniously* around the center of interest.

My Personal Philosophy

I have never understood clearly what is meant by talent. Is talent the necessary ingredient to becoming an artist? Maybe. But I have some ideas of my own on this.

If you think of an artist as being a very able painter, then to become one yourself, I feel, you need a dose of the three D's: Desire, Disgust, and Determination. *The Desire* is to want to become a good painter above all else. *The Disgust* is the self-disgust you feel when you are not working toward your objectives. And *The Determination* is to go through all that is necessary in order to achieve your objectives. So, if you have a dose of the three D's and can set aside the necessary time to paint regularly, study, and grow, I think you can also become a good painter eventually. And who knows? One day you may go one step further and become an artist.

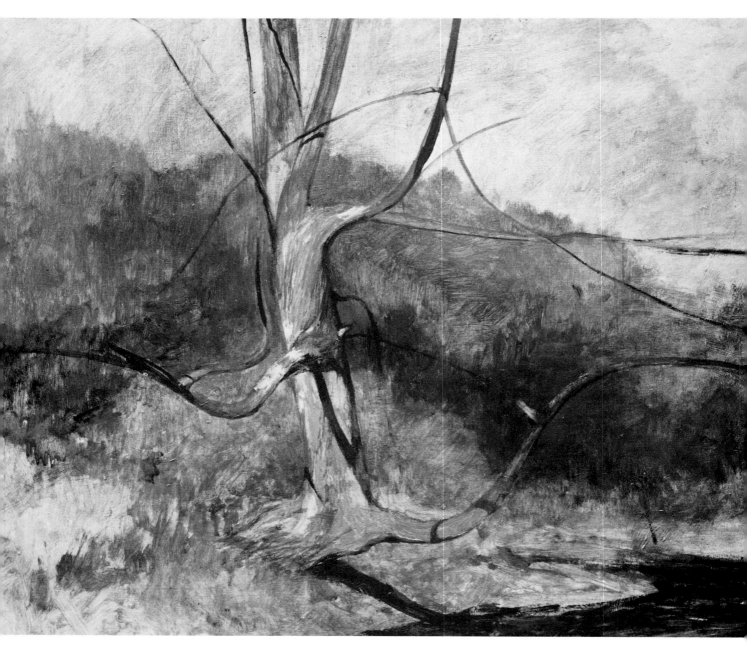

DANCING TREE, *oil, 24'' x 30'' (61 x 76 cm), collection Mrs. Jean Stern.* When I looked at this tree, it appeared to be weaving and dancing, and I kept that impression in mind as I painted it. It was early November, and the background colors were rich and subtle warm browns, grays, and purples—perfect background colors for the tree.

Learning About Values

Transparent Monochromatic Underpainting

In the transparent monochromatic technique, you are working on a white or light-toned ground with only one color. By using thinner or thicker paint, you can create a range of values and shapes. The result is somewhat like a black-and-white photograph, where you can get a feeling of form and color through value alone.

The transparent monochromatic underpainting technique dates back to several early European schools of painting. When used in the preliminary stages of a work, that is, in the underpainting, it gives a strong sense of the entire painting almost immediately. Also, by limiting yourself to one color, you are able to concentrate on values, value relationships, and the composition of your painting without worrying about the problems of color and harmony.

As a young student, I studied this technique at the Art Students League of New York. We called the underpainting an umber stain at that time, since we used only raw umber as the color. But since then I have learned that I can use any number of dark rich colors either separately or together to get basically the same results.

General Procedure

To start, I mix a dark rich color (usually raw umber or Van Dyck brown) with turpentine. I then proceed to define the objects on the canvas or panel. I establish the dark values first, defining their shapes with a flat solid value, and then put in the lighter values, relating them to the darks. As I develop the painting, I concentrate on four essential elements: values, light and shadow, drawing, and composition. These must be kept in mind throughout all stages of your work. Remember, a painting can't be finished all at once. It must have a structure, and the monochromatic underpainting, expressing these four elements, is the skeleton of the painting.

The Lesson

The essential things you'll be learning about values through this technique are the following. First, each color from the darkest dark to the lightest light has a value, and all the colors of the spectrum fit somewhere between black and white and are seen as grays. Second, it is possible to achieve the value or tonal structure of an entire painting by using only one color. Last, a strong sense of color and reality can be attained through the transparency of the paint.

Using Only One Color

There are many reasons for limiting yourself to one color. First of all, you won't have to deal with the complexities of harmonizing many colors with

each other, which will distract you from making major preliminary decisions affecting your final painting. Instead, you'll be able to direct your attention to developing the four essential elements of painting—value, light and shade, drawing, and composition—all of which must be thought out carefully in the beginning or will cause complications and weaknesses in the later stages of the painting.

Painting Transparently

The thin turpentine wash will allow you to make endless corrections and prevent you from working into a mess of thick opaque paint in the early stages of your painting, which could dampen your inspiration. Furthermore, the transparent monochromatic technique gives you the opportunity to get a feel for your paints and brushes from the very beginning.

Future Applications of the Technique

Mastery of the transparent monochromatic technique is time well spent because, as an underpainting, it provides a firm foundation for building a painting in full color. It can also be left as it is, a finished painting in one color, possessing a beauty all its own. Or it can be used as is, as a preliminary study for a painting. It can also be used as an underpainting for a full-color opaque or semi-opaque overpainting, as you will see later in this book.

Materials Required

The following materials were used in *The Fallen Tree*, demonstrated at the end of this chapter.

Support

I selected a 30″ x 36″ (75 x 90 cm) homemade gessoed pressed-wood panel, which I covered with a light gray tone. (See Studio Notes for instructions on how to gesso panels.) I chose to work large because I felt that the subject, a fallen tree, demanded space.

Medium

The paint medium applied in this technique is pure gum spirits of turpentine, a medium that lends itself beautifully to work on a large surface. With turpentine, the paints seem to flow freely, and it seems easier to get into the rhythms (again, see Studio

Notes) of the work. The turpentine also speeded up the drying process; my work was dry in three to four hours. In addition, the thin medium permits the texture of the surface of the support to come through, adding a special beauty to the work.

Brushes

I used a no. 3 round bristle brush for the initial laying out of the drawing, and a no. 9 round bristle and a no. 5 flat bristle brush.

Colors

As I mentioned earlier, I limit my colors to only one when using this technique; this is the best way to zero in on the values in the early planning stages of the painting. Here I chose to use raw umber, a neutral brown that is neither too warm nor too cool (see Soho, Lesson 7), but you can choose any dark rich color, depending upon the effect you want. For instance, burnt sienna, a warm brown, will give you a very warm underpainting, whereas cobalt or ultramarine blues, which are cool colors, will give you cool underpaintings (see *The White Pine*, Lesson 3).

Selecting a Subject

When choosing a subject for any painting you do, select something that inspires your imagination. A fascinating subject keeps my work on a level of excitement that continues to grow at all stages of the painting's development.

When working with the transparent monochromatic underpainting, however, there is one important consideration to take into account when selecting a subject. The subject must be in strong light, which will produce strong light and shade patterns that will show markedly as intense contrasting values. Take careful note of these contrasts in *The Fallen Tree* at the end of this chapter.

Planning the Composition

As I discussed earlier in Studio Notes, there are four basic elements to consider when planning a composition: (1) an attractive abstract pattern of light and shadow; (2) a sense of the form and weight of objects; (3) an exciting placement of objects; and (4) the use of harmonious colors throughout the forms. All of these elements must be present to some degree in any subject.

The subject here is a fallen tree, a theme that fascinates me and recurs in my work again and again. I like the angles fallen trees create, the lacework of their branches, and the play of light on them that is often enhanced by the colors of the surrounding woods. Here I was drawn to the strong light on the tree and to the exciting shadows its form cast upon the snow. The angle of the fallen tree was reinforced by these dark shadows, which emphasized its form and weight. I was also excited by the texture of the bark and the total effect of a natural, unstudied composition the tree created.

Arranging the Values

As I began to feel my way around this painting, I mentally began to relate the similar values of my subject to each other. I then started to lay out the composition of the entire painting, establishing the darkest areas first. Wherever I could, I massed similar values, making them a single value instead. For example, in *The Fallen Tree*, I massed the values of the dark sections of the tree with the dark shadows cast by the tree.

To further simplify the values, I divided the background of the painting into two contrasting values: the top half is a middle-to-dark value, and the bottom half is light. The tree, which is a dark form, stands out sharply. However, where some of the upper branches of the tree are the same value as the background, I massed them. I also simplified the area by losing a lot of edges—that is, by blurring and softening the edges between areas of similar value to make them less prominent. On the other hand, in the lower part of the painting, which is light in value, the darker tree stands out from the background, and its edges are sharper.

As I continued to work out the values and composition of this painting, I realized that the simplicity of the transparent monochromatic underpainting made it perfect for studying the light and shadow of a winter's day, when the ground is covered with snow.

Preliminary Studies

Since we are basically dealing with values in this method, obviously the most appropriate preliminary study would be a drawing medium that allows contrasting values to stand out. I suggest drawing with a no. 6B drawing pencil, a soft graphite pencil that establishes tones and values beautifully. An excellent paper to use is single-ply bristol board with a vellum finish because it has a tooth to it and allows you to achieve tones with pencil easily and dramatically.

On the day I began preliminary studies for this painting, it was late March or early April, and I could sense winter's end. Although it was still quite cold, I drove to one of my favorite painting areas and walked through the woods. Snow was still on the ground. The sun was breaking through the clouds, and it was a bright, luminous day.

A fallen tree caught my attention. I had a small drawing pad with me, and, although the cold was a bit disagreeable, my enthusiasm for my subject kept me standing there drawing for an hour and a half.

I returned to the studio with the image fresh in my mind and decided to experiment with the values of the composition. The result is the demonstration for Lesson 1, a transparent monochromatic underpainting with raw umber and turpentine. I established the upper part of the tree in front of the background, keeping them similar in value and thus fading into the background (see *The Fallen Tree*, Lesson 1). When finished, I felt a little unhappy with the dark background, but only because it was winter's end, and the dark background made it feel like November or December, with winter just beginning.

So the following day I returned to the same spot, taking my oils and panels with me. The panel was also 30" x 36" (75 x 90 cm), the same size as the transparent monochromatic underpainting. I decided to paint the subject transparently and while on location concentrated mostly on painting the tree, establishing the background lightly. Later, back in the studio, I reworked the background, keeping the paint light in color and opaque, which offered a strong contrast to the transparent colors of the tree.

Problems and How to Solve Them

Although the transparent monochromatic underpainting is essentially a simple and straightforward technique, you may run into problems: (1) the drawing could be wrong; (2) the values could be too dark; or (3) the entire composition may not be what you want.

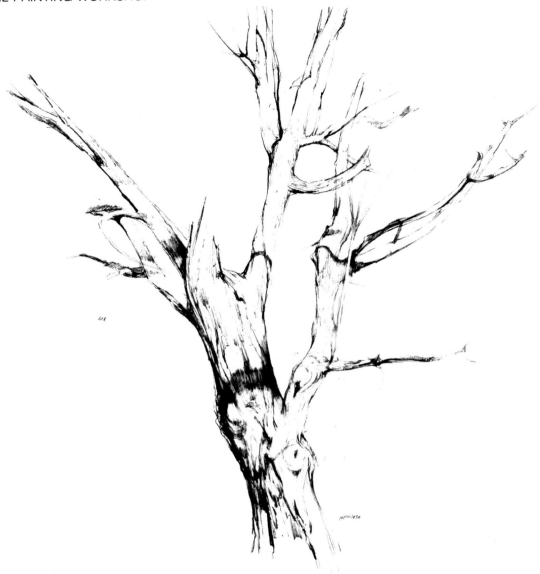

This dead tree has been standing in front of my studio for many years and parts of it have already fallen off. The coarseness of the bark helped bring out the rhythms of the tree.

If you find that there are areas to rework, you can simply dip a rag into turpentine and remove the area you wish to repaint. You may make any number of corrections in this manner, no matter what surface you are working on.

If your values are incorrect, an important point to remember is to look for the dark values first (as you did in the beginning of the painting) and clarify their shapes. Then relate the other values of the painting to them, keeping in mind the shapes and patterns of the entire composition.

Also, use your turpentine medium sparingly; use only a little to lighten values and much less to darken them. If you accumulate too much turpentine on the board, it can cause the mixture to be slippery or run and will break up the value harmony.

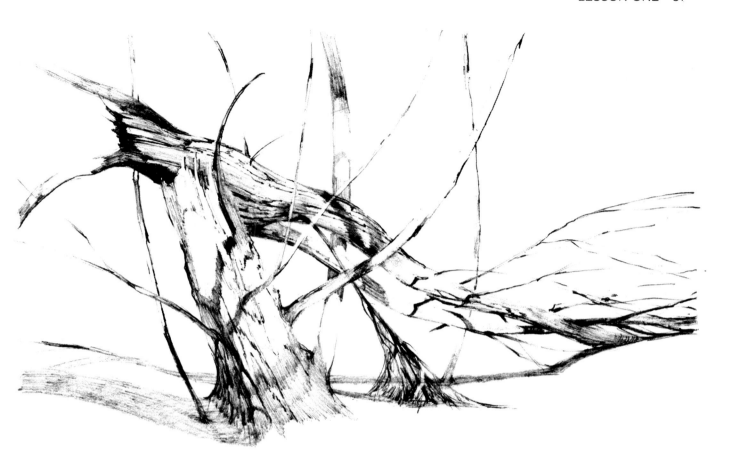

This drawing was done on location, using a 9" x 11" (23 x 28 cm), two-ply sheet of vellum bristol board and an IBM electronic scorer pencil, which is like a graphite pencil but can make an especially wide range of tones. I tried to establish the shapes, rhythms, and relative values of the fallen tree, sensing the design it would make on a larger canvas. I purposely eliminated anything behind the tree that would distract from it. Since I knew this drawing would be used for a monochromatic painting, I purposely stressed the values. (At other times when I go out to draw I am more interested in capturing the rhythms of the trees and in studying their growth.)

Step 1. Using raw umber diluted with lots of turpentine, I draw in the tree and decide its placement on the light gray-toned surface. I eliminate the details and keep the values simple as I wash in the general tone of the trunk. I estabiish some of the shadow areas, working to get the shapes the tree makes and as much of the rhythm as possible.

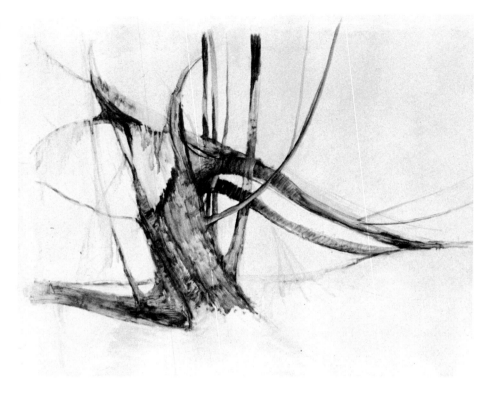

Step 2. I wash in the background lightly, diluting the raw umber with much turpentine, to give the sensation of a dense forest. The mixture does have a tendency to run, but it doesn't bother me; lovely ''accidents'' can occur when this is allowed to happen. Continuing to build and feel my way around the picture, I reinforce the darks of the tree, still not getting involved with details at this point.

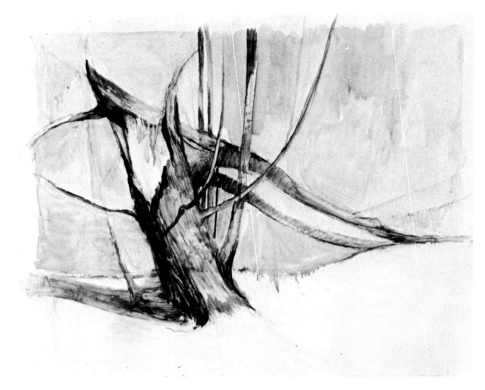

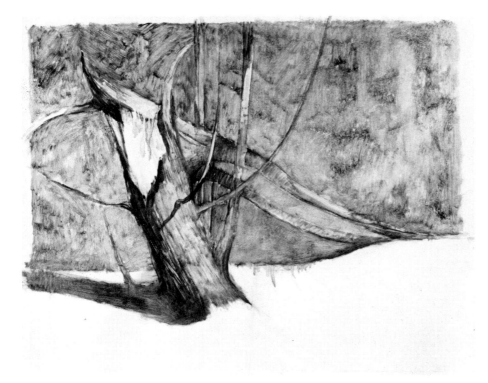

Step 3. I make the background richer and darker now, using less turpentine and more raw umber. Again, I simplify the values, contrasting the darker background with the lighter areas of bark. Once these two areas relate tonally, I reintensify the cast shadows on the snow. I establish a few more lighter and darker values in the tree but basically still keep it loose and simple. At this point, the picture is in a transitional stage. The basis has been developed solidly, and I am ready to add the fine details and finishing touches to the painting.

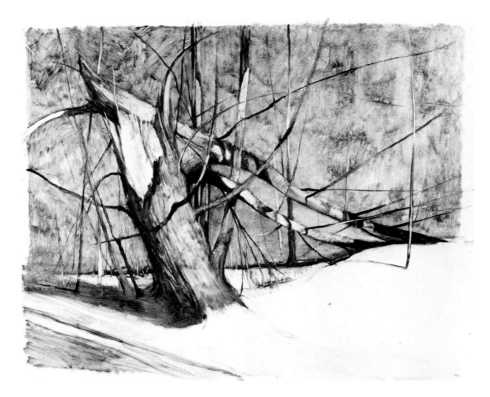

THE FALLEN TREE, *oil, 24'' x 30'' (61 x 76 cm), private collection.* Now I concentrate on the details of the branches and shadows they cast. I work with less turpentine at this stage, as I draw the sharp, delicate forms of the dark branches. To create lighter areas, for example, to indicate thin branches against the dark, dry background, I dip a clean brush into turpentine and without paint draw a line with the brush into the dark area. Then, wrapping a clean rag around my finger, I blot the area. Delicate wispy lines remain. In the finished painting you can see the two different ways I apply oil paint transparently. In the early stage, I applied it thinly, with a great deal of turpentine so it is very watery, almost like watercolor. Then later, when I paint the darker tones, I *scrub* the paint on, without medium. This paint is also transparent, but thicker. You'll see this technique demonstrated again in Lesson 3, with a limited palette of color.

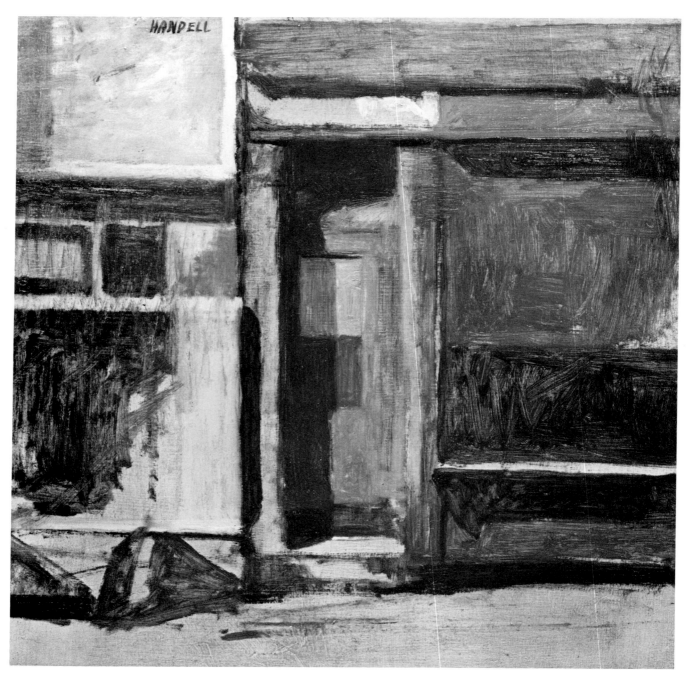

THE DOORWAY, *oil, 14'' x 14'' (36 x 36 cm), private collection.*
Here is a simple, carefree sketch I did on the spot. The
geometry of the painting is what delighted me; that, plus the
arrangement of the different colors individually and next to
each other. Also, the proportions of the different ingredients
of the subject all added up to a few pleasant hours of painting.
The technique I used here is described in Lesson 9 (harmo-
nizing underpainting, semi-opaque and opaque over-
painting), but of course this is only an oil sketch, not a finished
painting.

More About Values

Opaque Monochromatic Underpainting

The opaque monochromatic underpainting technique is a very sensible way to start a painting. Like the preceding transparent underpainting, it involves only one color, which allows you to concentrate on the composition and develop the painting through the drawing, the values of the individual objects, and the value relationships of the entire painting. However, there is one major difference between the two techniques. In the opaque technique, white is added to the color to lighten it and make it opaque, whereas in the transparent technique of the preceding lesson, to get a light value you had to apply your paint thinly, so that the light ground showed through the paint. The opaque color also adds another dimension to your work because you can now build up forms in the light areas three-dimensionally, and you can paint opaque areas against transparent ones.

In the past, an opaque monochromatic underpainting, which was called a *grisaille*, was used extensively by the old masters, especially the Italian masters of the Renaissance and later by artists like Jean-Auguste-Dominique Ingres. Using either black and white or raw umber and white to establish the opaque grays of the underpainting, they built up the rest of the work with consecutive layers of semi-opaque and transparent glazes and scumbles (see Lesson 8).

General Procedure

The opaque monochromatic underpainting is begun in much the same way as a transparent monochromatic underpainting, but, because it is opaque, everything is carried one step further. Again I find myself reaching for raw umber—you can choose another color if you wish—because I like the warm tone it gives my work. I start by mixing the raw umber with turpentine to lay out the drawing and establish the composition of the painting on the canvas or panel. I establish the shadow areas and other dark values first, with transparent color. Then, I mix titanium white with the raw umber for a wide range of warm opaque grays. With these grays, I now repaint many areas I have already established, particularly those in the light that I want to make come forward.

The Lesson

Again, because of the monochromatic technique, you will be reinforcing your knowledge of values and developing an awareness that the value structure for the entire painting must be established before color is applied. You will also learn how to mix a full range of opaque grays, from very light to middle value to dark, by mixing raw umber with titanium white. As you learn to paint a completed underpainting with these grays and get used to work-

ing with opaque paint, you will also begin to appreciate the subtle variations of values in the light areas.

Using Only One Color

As I said in the first lesson, working in any monochromatic technique eliminates the difficulty of controlling and harmonizing many colors, thus freeing you to concentrate on getting the correct values and value relationships in the painting.

Using Opaque Color

With opaque color, this process can be controlled even more. By varying the proportions of raw umber and titanium white, you can get an even wider range of values than you could with transparent paint alone. For example, 50 percent white and 50 percent raw umber will always give you a middle-value gray; 20 percent titanium white and 80 percent raw umber will always give a dark gray; and of course, 80 percent titanium white and 20 percent raw umber will always produce the same light gray. Because these mixtures are easily and consistently achieved, we can then expand our range of values into more subtle variations. Also, painting opaquely, you can achieve the characteristic "meaty" or impasto textures of oil paints and thus build up lovely textures, ones you will be striving for in the finished painting. The opaque monochromatic technique also means few painting problems, since values can always be remixed and corrected if need be. There is also an opportunity for making contrasting textures, especially if the light areas are kept opaque and the shadow areas are kept transparent. The painting will attain a particular beauty through these contrasts that you will be able to appreciate only by trying the technique yourself.

Other Applications of the Technique

Besides its use as an underpainting, the opaque monochromatic technique makes an excellent preliminary value study for a planned painting. Value structure is crucial to a painting; without it, painting with color can be very difficult.

Materials Required

The following materials were used in the demonstration painting *The Green Door*, which appears at the end of this chapter.

Support

Again I used a homemade gesso panel, this time 24" x 24" (60 x 60 cm) and toned a light gray. I find that starting with a gray tone helps me achieve the value relationships more easily than I could on a white surface. Also, titanium white does not show up well on a white surface.

Medium

I started with turpentine as the medium and laid in the basic drawing and values transparently. When I was ready to work opaquely, I switched to a medium that is a mixture of one part each damar varnish, linseed oil, and turpentine. This medium can be mixed and stored in a glass jar, with small amounts poured into the palette cup as needed. The mixture has more substance and body than does ordinary turpentine.

Brushes

I used the following brushes in this demonstration: round bristle brushes nos. 3 and 5, for drawing, flat bristles nos. 5 and 7 for massing in the large areas, and a no. 2 red sable for details. I suggest keeping two or three brushes of each size on hand to keep your values separate; one for light, one for middle, and one for dark values.

Color

The only color I used was raw umber, with the addition of titanium white.

Selecting a Subject

For this painting I chose one of my favorite themes: buildings in older urban neighborhoods. I have a special attraction for the variety and character of these buildings and the beautiful boxlike shapes created by their interesting architecture. Here, I concentrated on a detail of a storefront with green doors. I came across this subject on one of my strolls through the Soho section of New York City, an area I have often visited and painted.

Planning the Composition

I sensed groupings of squares and rectangles making up the composition and decided to work on a square panel. With a square-shaped panel, the composition can be monotonous, but here I felt strongly that the square was an excellent choice

for this subject.

The vertical lines of the building itself and the horizontal lines defining the top and bottom of the windows of the door and the windows alongside the door all worked together to create interesting shapes of squares and rectangles within squares and rectangles. The patterns of these shapes were brought out by the sunlight cutting across everything in the painting, illuminating it and creating rich, dark cast shadows.

Arranging the Values

The light on the subject was very dramatic, making everything vibrant and alive. Although most of the painting was in sunlight, there were areas of sharply contrasting shadow. These contrasting light and shadow areas, which cut diagonally across the picture, also worked to tie the composition together. In both areas I worked on the subtle variation within the major values, moving in and out of each area until I had obtained the right values.

For the opaque paint in the light areas of the painting, I dealt mostly with the framework of the doors and windows and the suggestion of curtains hanging inside them. Opaque paint effectively brings out the forms and overall values of the light areas. As a contrast to these light areas, I kept the darker values of the shadows more transparent.

Suggested Preliminary Studies

Any drawing medium that allows for the easy establishment of the different values of your subject makes a good preliminary study for this method. In addition to using the soft graphite 6B drawing pencil I described in Lesson 1, I often draw with an Eagle electronic scorer pencil no. 350. This is a terrific soft graphite pencil which can be found in any large stationery store. Also, at times, I use ordinary typing paper that has a tooth to it. These materials are inexpensive and create a wide range of tones.

To begin, I suggest drawing the subject lightly at first, outlining the objects of your composition. Next, establish the shadows, then the halftones, leaving the white of the paper for the light areas.

The preliminary studies I made for the demonstration painting *The Green Door*, which appears at the end of this chapter, came about quite by accident.

It was a mild April day. Winter was over, and I was in New York City visiting friends, galleries, and museums. Early one morning I found myself strolling through Soho, one of my favorite urban painting areas. I had a small two-ply bristol board pad and pencils with me, along with a small watercolor box containing a few watercolor quills and one color, Payne's gray. I noticed a green storefront with yellow curtains in the windows. The interior was dark, and I was struck by the sharp contrasts of light and shadow. I did a detailed pencil drawing, and then applied a watercolor wash of Payne's gray to capture the strong sense of light and shadow (see page 44).

Back in the studio, I decided to paint an opaque monochromatic underpainting to get a better feel for the values of the composition. (The result was the painting *The Green Doors*, demonstrated at the end of this chapter.) I kept some of the shadow areas transparent and used opaque paint for the light areas. I was very excited about the results and decided to do a more detailed painting of the doors. I worked with a transparent monochromatic underpainting followed by opaque overpainting. I again used a square panel, feeling the shape lends itself well to this type of subject matter.

I also decided to do a larger work in pastel of this same subject, concentrating on the center of interest, the doors and windows, and going after the light and shadow shapes and contrasts (see page 47). I also did one in watercolor (see next page).

Problems and How to Solve Them

Few problems are encountered with this method. The main one, ending up with the wrong values, is easily corrected by remixing the correct value and painting over what you have on your panel or canvas. Repeat this process as many times as is necessary until you have the correct value. Since color is not involved in this technique, you can repaint your values endlessly without your work getting muddy or overworked, as it would if several colors were involved.

This drawing on two-ply kid bristol board done with an electronic scorer pencil was a study for THE GREEN DOORS. Since we can't get the sun to stand still, quick sketches like this are essential. This drawing took ten minutes to execute, but it showed me the light and shadow patterns, which I eventually used in the demonstration painting.

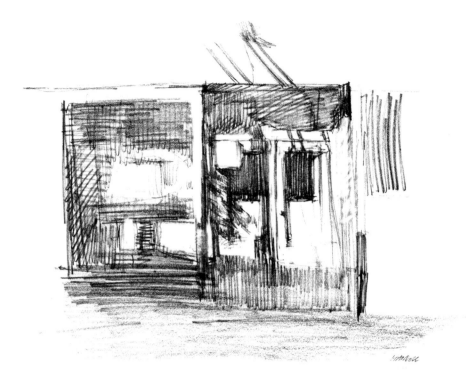

This watercolor drawing was also done on location, using a 9'' x 11'' (23 x 28 cm), two-ply bristol board with a vellum finish. I first did a detailed drawing of the subject, establishing the shapes of light and shadow. Then using one watercolor, Payne's gray, I established the various values. The completed preliminary study is very close to the look of the finished oil painting.

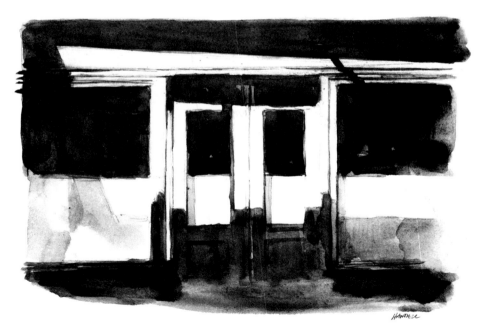

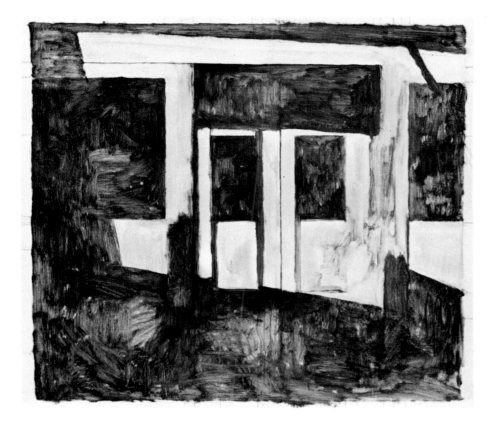

Step 1. I begin the opaque mono-chromatic underpainting, ironically, enough, by laying out the entire painting transparently first. I consider the placement of the subject on the canvas. Then I establish the shapes of light and shadow areas and indicate general values, without becoming involved with the details.

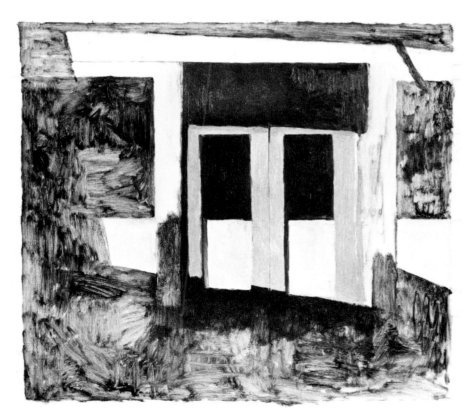

Step 2. I reestablish some of the dark tones of the lower section of the doors and the cast shadow over them by working with thicker raw umber paint, and thus more opaquely. I then mix the raw umber with white for the value of the green doors in sunlight, adding a touch of Maroger medium for texture. I build up the rest of the light areas opaquely and reintensify the dark surrounding areas and windows for contrast.

Step 3. With the basic tones and values now established, I continue to build up the picture. I do more work on the wooden framework around the doors and the curtain inside the windows. I then delineate the darker values of the window ledges to indicate where the windows end in the shadow areas.

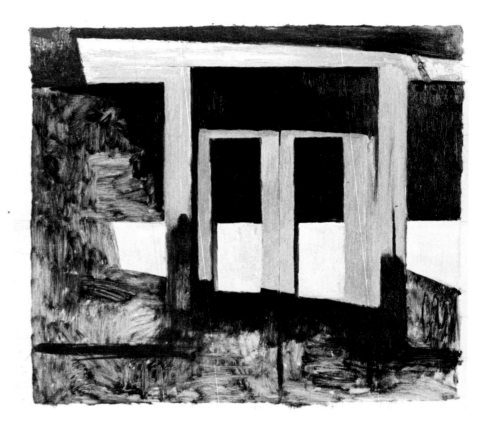

THE GREEN DOORS, *oil, 24'' x 24'' (61 x 61 cm), private collection.* Since I am interested in the shapes of the subject and the light and shadow I eliminate the details to emphasize the dynamic quality of the contrasting shapes. In this last step I redefine all of the established areas. I complete the lower position of the doors and foreground more opaquely with the raw umber and enlarge the shadow mass of the window to the left of the doors. I then work opaquely in the sunlit areas of the curtains and their surrounding shadows, keeping in mind at all times the contrast of shapes of objects, light and shadow areas, and opaque and transparent sections.

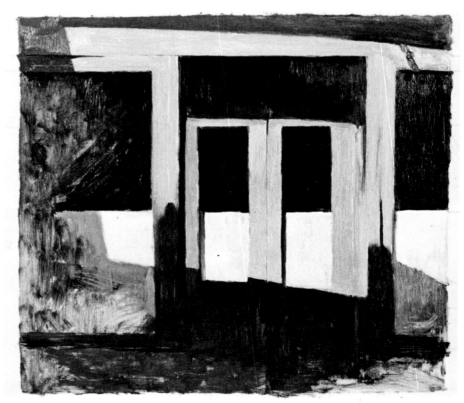

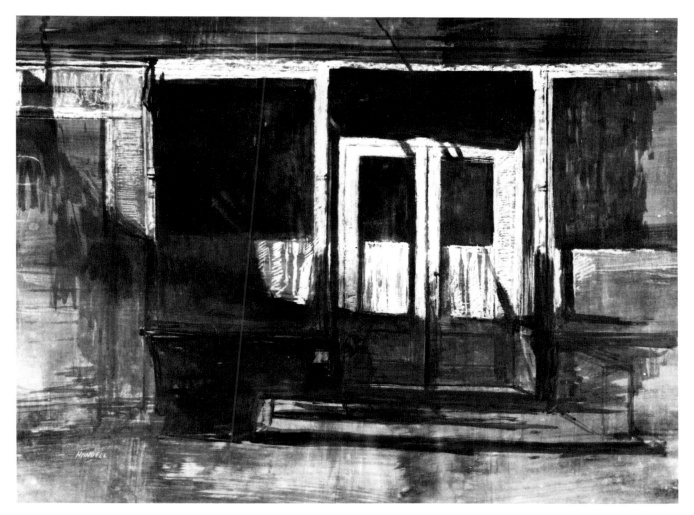

MULBERRY STREET STOREFRONT, *pastel, 24″ x 30″ (61 x 76 cm), Collection Mr. and Mrs. John A. Costello. (Winner, Third Honorable Mention, Fourth Annual Exhibition, Pastel Society of America.)* I sometimes do a number of paintings on the same subject, usually varying the medium each time. This is a mixed-media pastel painting done on a rich, reddish-brown toned, sanded pastel board. The pastel was initially laid in with a casein wash drawing, which can still be seen in the shadow area. I then worked the center of interest up with pastel. Mixed-media pastel painting allows for a lot of variety, much like the oil-painting techniques discussed in the demonstrations.

(Above)
One of my favorite pastimes is strolling about areas of a city, looking, admiring, and making small drawings. I have spent entire days doing nothing but just that. Here is a small 8″ x 10″ (20 x 25 cm) drawing I did in Chinatown (New York City), that eventually became a small oil-painting sketch.

(Right)
PARISIAN COURTYARD NO. 1, *oil, 24″ x 24″ (61 x 61 cm), collection Mr. and Mrs. David Cohen.* Being born in the city, I was used to courtyards, alleyways, and storefronts, and over the years I have often painted them. When I lived in Paris (1961–1965), I was fascinated by the courtyards there and painted many of them. They are small, and the closeness allowed me to concentrate on details. There was no sunlight here, so the colors were deliberately kept very cool. I mixed delicate, cool blues, purples, and grays into all my colors to keep a cool harmony in the painting.

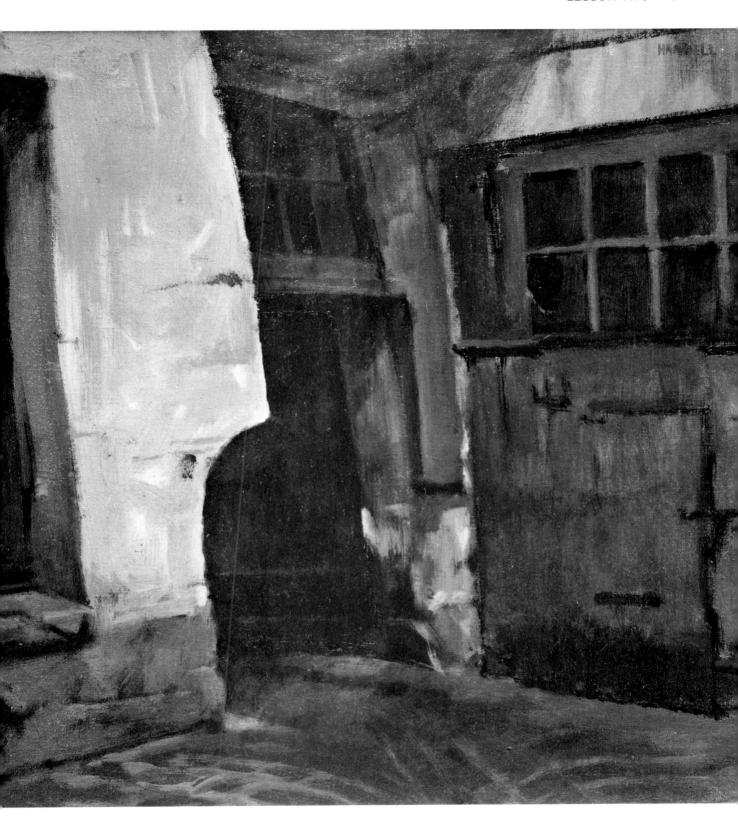

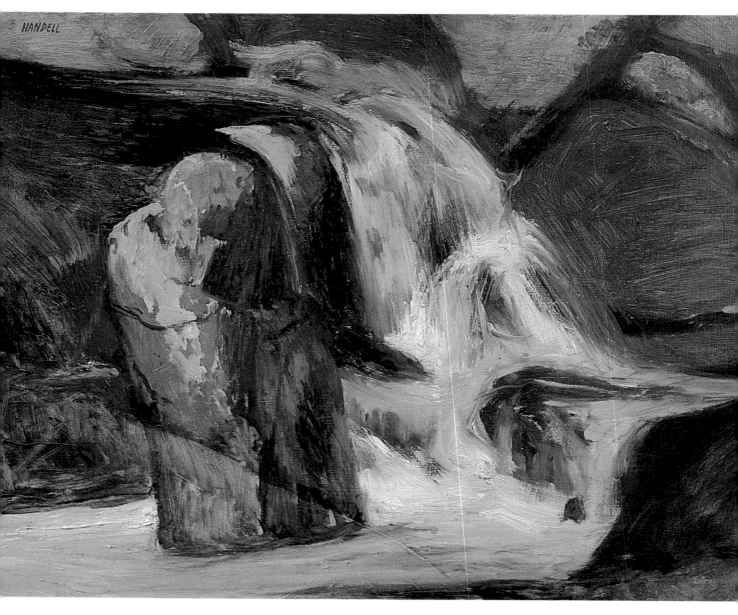

MOUNTAIN STREAM AT PALENVILLE, N.Y., *oil, 18'' x 24'' (46 x 61 cm), private collection.* This is painted with the same transparent oil technique as *The White Pine* (demonstrated in this chapter), also using a limited palette. The technique is well suited to paintings that have lots of movement, and since the rushing water was of particular interest to me here, I naturally selected this technique to portray it.

Translating Values into Color

Transparent Oil Painting, Limited Palette

Having concentrated up to now on values and value relationships, we will now learn how to translate these values into color. The transparent monochromatic underpainting of Lesson 1 (*The Fallen Tree*) was basically a value study on which a painting would later be built in full color. This chapter is an extension of that lesson, but this time using a limited number of colors (five plus black and white). Although we will be taking mental note of the value relationships between them, we will be thinking of these values as *color* now, not as grays.

Like the monochromatic underpainting technique, this technique can also act as an underpainting for a later overpainting. As a matter of fact, that is how I learned to use this technique as a student—and later in this book we will use it that way, too. But for now, the transparent, limited-color underpainting will be used as a final painting, complete of itself.

I have always enjoyed the rich luminosity of transparent colors; to me, they're fresh and free. When I discovered that by scrubbing one transparent or semi-transparent color on top of another I could get beautiful color effects, I refined this technique into the transparent, limited-color painting. I can now get a full-color, completely luminous, yet ''dense-looking,'' transparent painting. (However I may sometimes add a small

amount of semi-opaque paint at the end to bring about certain contrasting effects and to emphasize select details, as I have in *The White Pine*, the demonstration for this chapter.)

General Procedure

There are basically two methods of mixing paints transparently. One is to mix the oil color with lots of turpentine for free-flowing washes. The other is to mix the oil color with Maroger medium to create transparency but also to give a more controllable buttery consistency.

To begin a painting with a transparent oil technique, I first mix the colors with lots of turpentine and lay out the composition from dark to light, starting with the most obvious colors first. At this stage I don't expect to get the exact color but aim for only an approximation of the colors I see. I cover the entire canvas and carry the painting as far as I can with the turpentine washes. I often complete an entire painting with free-flowing turpentine washes, as I do in Lesson 5 (*Woods Interior*). When using such washes, however, I must sacrifice detail for an overall effect, a sense of place. When I wish to capture more detail in a transparent painting, as I do in *The White Pine*, the Maroger medium becomes important. This is a transparent gel medium, and I mix one part of it into

three parts of paint to achieve a buttery quality which, when applied thinly with a drybrush technique or scrubbed on with a brush or rag maintains the transparent quality while allowing me to pull out select details to contrast with the free-flowing washes. The Maroger medium also allows me to scrub in large areas.

The Lesson

This lesson will teach you three things. First, it will introduce you to the transparent oil painting technique. Second, you will learn to paint a picture with a limited number of basic colors. Third, you will begin to see color as value and learn to use it as value to express the tonal structure of a painting.

Using Transparent Paint

When you learn to paint transparently with oil, you will begin to appreciate its luminous beauty. Alone and in mixtures, this degree of luminosity and richness would be difficult to achieve with opaque paint. I actually discovered this technique when painting preliminary sketches with oil and found that by greatly diluting my colors with turpentine or mixing them with Maroger medium, I could achieve various effects. For example, in the demonstration painting here, the light greens suggest the background woods in contrast with the dark transparent luminous greens that surround the trunk.

Using a Limited Palette

When you work with color, every color must be related and in harmony with the others. This can be quite complicated with a full-color palette. But working with a limited number of colors gives an almost immediate harmony to your color scheme. Because there are so few of them, each color gets to be used almost everywhere in the painting or blended in mixtures with all the others, which automatically relates them. Also, the limited number of colors forces you to exploit each individual color to the fullest. You can experiment with each color, seeing its effects both alone and in mixtures, and slowly begin to expand your palette one color at a time, until you finally obtain a full-color palette. Limiting the number of colors also makes it easier to concentrate on the value structure of your painting. It is too easy for a beginner to be seduced by all the enticing colors in his paintbox and thus lose

sight of the relative values of his subject, which are essential to defining form convincingly.

Future Applications of the Technique

As I stated earlier, you can apply this technique to other work relatively easily. It can be used as a finished transparent oil painting with a limited palette, as it is here, or with a full-color palette, as in lesson 5 (*Woods Interior*). It can also be used as an underpainting, where it can either harmonize with the overpainting, as in Lesson 9 (*Monhegan Island*), or contrast with it, as in Lesson 10 (*Kaaterskill Stream*).

Materials Required

The materials I used in this and subsequent demonstrations are similar. They vary only according to the demands of the particular method and subject matter. The following materials were used in *The White Pine:*

Support

I worked on a 24″ x 30″ (60 x 90 cm) homemade gesso pressed-wood panel, a support I prefer when working transparently and strongly recommend for its fast-drying, absorbent qualities.

Medium

I used turpentine for its fluidity and for the luminosity and transparency it gives the colors.

Brushes

My brushes were all of good quality: bristle rounds, nos. 2, 4, and 6, and bristle long flats, nos. 5 and 7. For small details, I used nos. 2 and 4 pure red sable brights.

Palette

My limited palette consisted of five colors plus black and white:

Naples yellow, a light-value color
Yellow ochre, a middle-value color
Ultramarine red ⎫
Sap green ⎬ dark-value colors
Ultramarine blue ⎭
Ivory black
Titanium white

These five colors are all different, yet they harmo-

nize beautifully. Naples yellow and yellow ochre are easy to control and harmonize because they are subdued yellows. The ultramarine red, sap green, and ultramarine blue relate in value and can be varied easily with the addition of the subdued yellows. Also, beautiful ranges of grays can be mixed with black and white, Naples yellow and black, or black and white with Naples yellow. These grays will harmonize the dark colors still more then mixed into them.

Remember that in this technique, all of these colors and mixtures will be diluted with turpentine or Maroger medium, which will make them transparent to some degree, even when the color is relatively opaque (like titanium white or Naples yellow). The proportion of medium to color always determines the degree of transparency. For example, whenever I use white or Naples yellow in a transparent mixture, I always add one part Maroger medium to the mixture. This enables me to apply the mixture transparently or semi-transparently while still keeping the body of the paint. I do the same with the other opaque colors on the palette: yellow ochre, ultramarine red, and ivory black.

Selecting a Subject

Almost any subject is suitable for a semi-transparent technique with a limited palette. As a matter of fact, you should try painting as many different subjects as you can with a limited palette—for instance, a group of trees in a distant field at various times of the day, or even a bright red barn. Although you may be missing some of the necessary colors, the experience will teach you why and where you need additional colors to round out your palette and which ones they are. Using a limited palette is a sensible way to build up to a full-color palette that will suit your own personal needs.

My choice of subject for this demonstration, a white pine, was primarily a personal choice and grew out of my continuing fascination with trees. The effects of the white pine weevil bug are very prevalent in the forests of the Catskill Mountains where I live. When the weevil attacks the young pine from the top, killing the top of the trunk and stunting the growth of the tree, the white pines, like the one in this demonstration, undergo a metamorphosis. Eventually, however, one, two, or even three branches start taking over for the original

trunk, and each becomes a separate trunk. This painting is an expression of my amazement and delight at the distortions created in natural forms by other natural forms of life. The structure of this thwarted but determined pine intrigued me in a way that the usual straight-to-the-sky pines do not.

Planning the Composition

I decided to focus on a detail of the tree, finding it more forceful and interesting than a view of the entire tree at a distance. I chose the lower section of the tree, where the two trunks came out like two legs pointing up. This is a strong, simple, symmetrical shape, given interest and contrast by the horizontal branches growing out of it. By getting up close I could appreciate the textures, twists, and turns of the tree that are expressed as rhythms in my work.

The 24″ x 30″ (60 x 90 cm) panel I chose was neither too big and overwhelming nor too small but was perfect for capturing details of the rhythms and textures of the tree. It also enabled me to work with my preferred smaller brushes. I could have worked on an even larger panel without losing these powerful effects, but on a smaller panel the branches would have appeared too cramped.

Arranging the Values

As I prepared to paint *The White Pine*, I observed the tree under various lighting conditions. This is important because the subject can change radically under the play of different types of light, which influence form and surface appearance. With trees, entire limbs and branches can disappear under certain lighting conditions while, at other times of day, these same limbs will be the most striking feature of your subject. This is especially true on sunny days, when the light on the subject changes radically as the sun moves from east to west. Therefore, to emphasize the intrinsic rhythms and textures of the tree, I purposely chose to paint *The White Pine* on a day without bright sunlight and from an angle that avoided having strong cast shadows that would cut across the form and obscure the tree's rhythms and textures. The lighting, however, was still fairly bright and warm, and I confined the cast shadows to areas that worked with the overall design rather than against it.

The values in this painting are basically simple: the lighter value of the tree is seen against the middle values of the background and against the darks of the pine needles, cast shadows, and background branches. I started drawing the tree and laying in the basic shapes of the painting with ultramarine blue thinned with lots of turpentine. I chose ultramarine blue because I wanted a cool bluish effect on the tree in the finished painting. As is my usual procedure, I laid in the dark values first and then the middle values. This is generally a good idea in working with oil because it's easier to work light colors on top of dark ones. Also, because I was working very transparently, I wanted the blue values to come through the colors I later floated or scumbled over them, giving everything a blue harmony. The light areas of the painting, however, were handled differently. Because they could always be glazed down in value later, I made them a bit lighter than they were at first, keeping the paint consistency thin. Later, in the final stages of the painting, I brushed a bit of Naples yellow (mixed with Maroger) over the light values on the tree—for just a bit of a semi-opaque effect in this transparent painting—to add contrast to the dark transparent blues of the background limbs and trunk and to bring out the shape, textures, and details of the trunk in the light.

Deciding the Colors

There are no rules for selecting a basic limited palette. It should be made up to suit your subject matter and stage of artistic development. I suggest analyzing your subject closely and experimenting with various limited palettes.

In The White Pine, because the subject was surrounded by green woods, I chose to start with blue, since green is made up of blue and yellow mixed together. The dark blue background established very transparently at first gave me an ideal tonal base for later application of dark, rich, transparent greens (Step 1). For the background greens I chose three dark colors similar in value: ultramarine blue and sap green, which are cool colors, and ultramarine red, which is warm, to balance the blue and green (Steps 2 and 3).

The tree trunk itself consists of variations of grays, painted transparently with Maroger medium. I could have mixed the three dark background colors into grays composed of black and white and harmonized the trunk with the background. But instead I decided to use yellow ochre for the tree to add contrast and round out the color scheme (Step 4). To lighten the values on the trunk, I chose Naples yellow, which I alternated with titanium white. Grays made with titanium white and black are more extreme than the subdued and harmonious grays I made with Naples yellow and black. To keep the transparency of these light-value colors, I mix one part Maroger (a transparent gets medium) with three parts paint, and drybrush and scrub on the color.

Suggested Preliminary Studies

Before you paint trees, I recommend observing and studying them closely by drawing them with pencil and paper. The idea is to become intimately acquainted with your subject before you set out to paint it. You can choose even one tree to study. One with a sense of presence and character can offer a wealth of material.

Viewing the tree from a distance, you can draw it from top to bottom, taking careful note of its silhouette. Or, you can explore the possibilities of the same tree close up, focusing on the textures, rhythms, and color of the bark, as I did in The White Pine. I often prefer this kind of closeup study because I can feel a greater emotional intensity from close proximity to my subject matter.

These studies should be made under as many lighting conditions as possible and in different seasons and weather. However, deciduous trees can best be studied from November to May, when their leaves have fallen and the skeleton of the tree can be seen clearly. If trees fascinate you as much as they do me, then draw them as often as possible.

Keep your drawing materials simple. I recommend pencil, paper, and much patience. I use an electronic scorer pencil no. 350, which can be bought in any stationery store, and single-ply bristol board with either a vellum or plate finish.

You can also do tonal color studies for this transparent oil technique in watercolor because it too is a transparent medium. Watercolor offers a good first step for translating your pencil studies into color and affords an excellent opportunity for exploring the basic color and value relationships in your painting before you begin to work with oil.

In making these studies, you must decide how much of your subject you wish to include. Then you must choose the lighting that is best for bringing your subject out. Also include value relationships, foreground-background relationships, and suggest an approximate size and shape for the future painting.

Problems and How to Solve Them

With this method, you will not be able to see any mistakes until the entire painting is laid out transparently. At that point you may discover that you have used one color more than the others, making the work too monochromatic. To correct this, put in more of its complement or near complement.

For example if it's too warm overall, use more cool colors; or if it's too cool, introduce some warmer tones. If your painting happens to be too blue, use a color like yellow ochre more heavily to balance out the blue and harmonize the colors in the painting.

Another problem that may arise is not getting enough variation into your mixtures, especially in the lighter values. For example, if you mix too many greens with blue and yellow only, you won't have much variety in your color nuances. If this is the case, the solution would be to try other combinations, such as ivory black and yellow ochre, to increase the variety of mixtures and add more subtle color to your work.

Here is a simple pencil drawing of part of a tree that emphasizes its textures and rhythms. I believe in drawings of this type as studies for a picture like *The White Pine*.

Step 1. Working on an absorbent, prepared pressed-wood panel, toned a light gray, I draw in the tree with a no. 4 round bristle brush. Because I already know that the painting is going to be relatively cool, I establish the light-and-shadow patterns with ultramarine blue. I work very transparently, with a lot of turpentine as the medium, keeping the paint quality very much like watercolor.

Step 2. Painting with a mixture of ultramarine blue, yellow ochre, and a touch of Naples yellow for warm, subdued, greenish tones, I wash in the remaining areas of the painting. Notice that I still maintain the transparent watercolor wash effect.

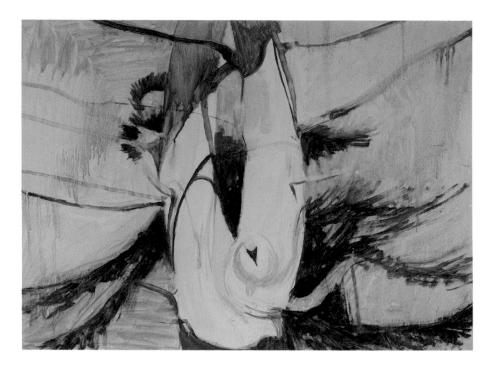

Step 3. Using a green mixed with yellow ochre and ultramarine blue and a no. 6 round bristle brush, I establish all of the surrounding areas, still continuing to keep the paint quality transparent and airy by using plenty of turpentine. The green, which is very olive, is dark and rich.

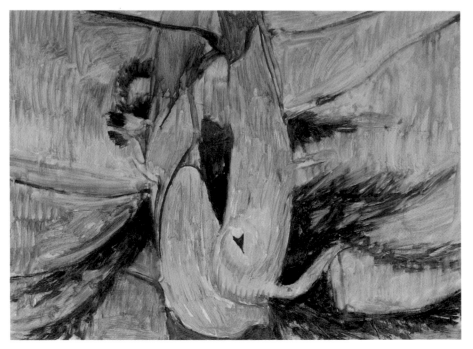

Step 4. With no. 5 flat and no. 6 round bristle brushes, I restate and intensify the background by repainting it with more ultramarine blue and yellow ochre. Then, still using only turpentine, I put a wash of yellow ochre mixed with black and white over the whole tree trunk. This tones down the painting and is the first indication of local color I have made.

Step 5. Using a no. 2 round bristle brush and nos. 2 and 4 sable brights, I start capturing details in the bark, going after the rhythms, movement, and texture. I use a warm neutral mixture of black and Naples yellow.

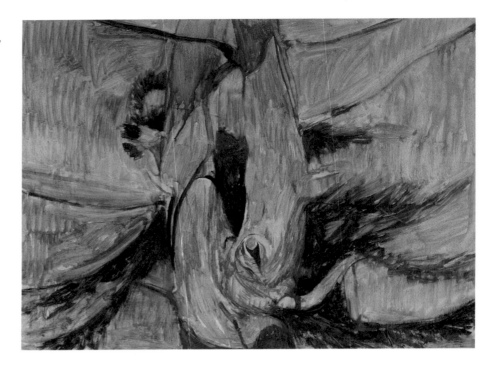

Step 6. I introduce sap green around the tree trunk to intensify the color already there. The effect strengthens the picture and makes it darker and richer. I also start to mass in the cast shadows on top of the trunk with a no. 7 flat bristle brush. I establish more details in the light area of the trunk with a combination of Naples yellow added to sap green for lighter greens. The light greens give the area more interest.

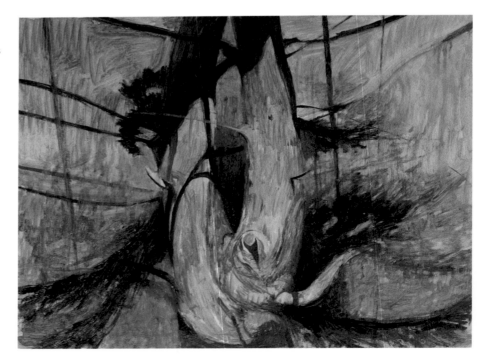

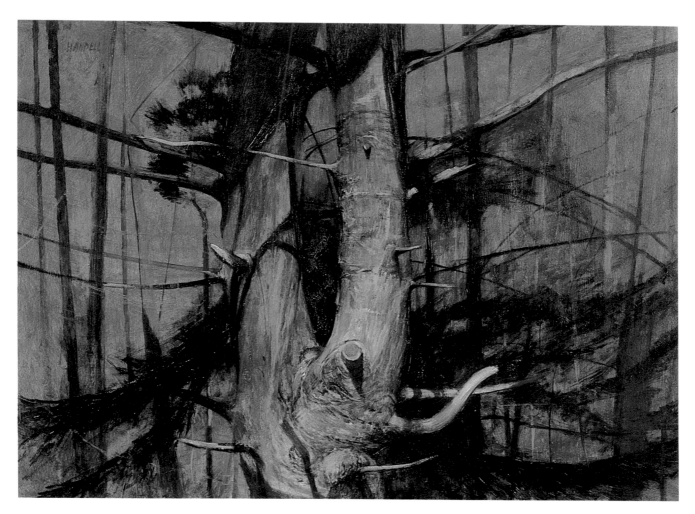

THE WHITE PINE, *oil on panel, 24" x 30" (61 x 76 cm), collection Mr. Harry Chester and Dr. Suzana Bouquet Chester.*
Completing the painting is now a matter of pulling out select details. I work over the entire painting, alternating all my brushes and applying the paint semi-opaquely in certain areas and transparently in others, all the while balancing, harmonizing, and pulling out details. I introduce a bit of ultramarine red sparingly into the split in the lower area of the tree which is the center of interest, to balance the coolness of most of the other colors.

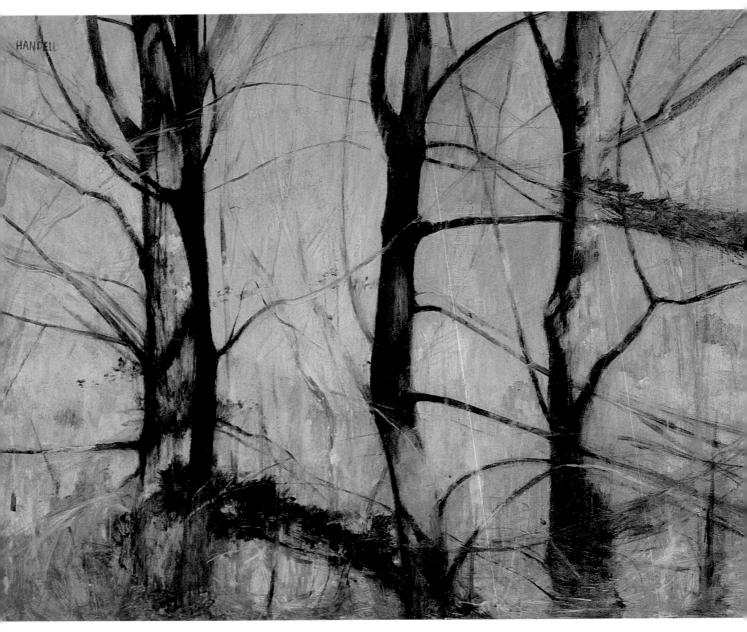

TREES IN WINTER, *20'' x 24'' (51 x 61 cm), collection the artist.* Winter colors are quite beautiful and have a harmony all their own. Here, using an opaque oil painting technique and a limited palette, I've captured the cold cerulean blue of the sky against the warm tan colors of the trees in sunlight. Despite the differences in color, the values of the colors in the light are close, though the blues are darker in the shadow areas of the foreground trees than they are in the more distant shadows.

Translating Values into Opaque Color

Opaque Oil Painting, Limited Palette

In this chapter we again explore the use of a limited palette as we continue to learn to translate values into color. In Lesson 3 we dealt with different degrees of transparent color, but here the color is used opaquely, in a distinctly different procedure. In the transparent technique, as you recall, color harmonies are developed by applying successive layers of paint, one over the other. Since the layers are thin (because more turpentine is used with each color), each underlying layer to one degree or another shows through, creating an optical blend of color.

In opaque oil painting, instead of mixing the colors in layers on the support, the various blends are *premixed* on the palette and then applied to the canvas (or panel) with brush or palette knife. Because the color is opaque and thus completely conceals what is beneath it, you don't have to worry about harmonizing it with the color below. However, every new color or color mixture applied to the canvas must work with the colors already on the canvas.

General Procedure

To begin a painting with the opaque oil technique, I first lay in the entire composition with diluted and thus somewhat transparent color—that is, color mixed with a lot of medium (here, turpentine).

Working thinly in the beginning, and from *dark* to light, I first establish the composition and values. As I place the various objects on the canvas, I try to get the right value of each color and note the various relationships among them. When I have established the basic composition and values to my satisfaction, I work over this transparent color lay-in with opaque paint until the painting is completed. I make the paint thicker by using less (or no) turpentine, or by switching to a thicker medium, such as Maroger. Because of this thick paint, opaque oil paintings have a very characteristic ''meaty'' texture.

After establishing the dark shadow areas first, I then go after the obvious colors, such as a red shirt, green scarf, or white contrasting patterns. Because the paint is thick, the light areas stand out more. This is an advantage. The thicker the paint, especially where the subject is in the light, the greater the sense of light, energy, texture, and mass that can be achieved.

The Lesson

In mastering the opaque technique with a limited palette, you will learn to build up textures with paint and get maximum results from only a few colors as you continue to practice translating values into color.

Using Opaque Color

Opaque color allows you to paint solid-looking masses with great varieties of texture. For example, I used the opaque technique in the painting for this demonstration to express the strong light and shadow masses and the many varied textures of the baskets, crates, fruits, and vegetables.

Opaque color also allows you greater control of your color mixtures by increasing the range of tones of the same value you can mix. As in Lesson 2, where we controlled the various values by varying the proportion of raw umber to white, we can now control the variations of color here through careful attention to their proportions in mixtures with each other and with white. (In the transparent technique, values can only be controlled through the amount of medium used—thin paint for lighter values and thicker paint for darker ones.)

Using a Limited Palette

As in Lesson 3, the limited palette allows you to develop a thorough understanding of each color you use, both alone and in color mixtures, and in harmony with other colors. It is a logical intermediate step to learning to work with a full-color palette which, at this stage, would only be confusing and complicated. Thus, you can continue to develop a sense for value as color slowly and with understanding as you relate each color to the tonal structure of your painting.

As you continue to experiment, you'll be surprised at how much can be done with only a few colors, getting the most out of the least. As Degas once said, "One object of painting is to make burnt sienna look like vermilion." A limited palette forces you to explore the full range of mixtures possible and automatically harmonizes the colors in your painting. When a painting is done well, few people will realize just how limited the palette actually was.

Other Applications of the Technique

Opaque oil painting is probably the most widespread technique in use. The opaque technique may be used for a tonal study or underpainting for a planned painting (Lesson 2). It can also be used as the basis for a finished painting, either with a limited palette (as it is here) or a full-color palette (Lesson 6). It can also be combined with the transparent technique to create various interesting effects (Lessons 7 and 8).

Materials Required

I selected the following materials for my opaque painting *The Marketplace*, demonstrated at the end of this chapter.

Support

Again, I used a homemade gessoed panel, 16½" x 28" (34 x 70 cm), which I toned light gray. I often work on a light-gray toned panel to produce a better contrast between the lighter and darker areas of the painting.

Medium

I used turpentine to lay in my colors transparently at first and then switched to the Maroger medium for the opaque application of paint and to finish the painting. Instead of the Maroger medium, if you prefer, you can use a mixture of one part each damar varnish, turpentine, and linseed oil.

Brushes

My brushes were the same as those in the preceding demonstration. Unless I'm working very large or very small, I rarely vary them. They're all of the best quality: nos. 2, 4, and 6 bristle rounds; nos. 5 and 7 bristle flats (long-hair); and nos. 2 and 4 red sable brights (short-hair), for the details.

Palette

Again, I used a limited palette consisting of five colors plus black and white, but my colors differed from the preceding demonstration because the subject was different. I selected:

Raw sienna, a middle-value color
Ultramarine blue ⎫
Sap green ⎬ dark colors
Alizarin crimson ⎬
Raw umber ⎭
Ivory black
Titanium white

The raw sienna is an earth color, an orangish, reddish, tannish, warm brown. When mixed into the other colors on the palette it creates warm tonal variations. For example, with alizarin crimson, a dark cool red (red is usually a warm color), the raw sienna makes a beautiful warm middle-tone red.

Raw umber, the dark neutral brown used in Lessons 1 and 2, is used here for warm grays. When

mixed with white, it makes a number of gray values that control the different colors of the baskets and crates.

Selecting a Subject

Almost any subject can be painted opaquely. But whatever subject you choose, continue to practice the opaque technique with a limited palette. Limited palettes are best for simple, direct statements, where you want to zero in on a particular aspect or section of the subject matter and build the entire painting around this.

In *The Marketplace*, I chose a section of the stand and emphasized the baskets and crates there. I decided to play down the vegetables and fruits, though, because I would need a full palette to capture their diverse colors. Having limited myself to baskets and crates only, I could now express these elements directly and beautifully with the limited palette I would be working with.

I grew up in the Brownsville section of Brooklyn, where vegetable stands and pushcarts were a part of my daily life. Awnings, sunlight, bright colors, and beautiful, interesting patterns of strong light and shadow have always intrigued me. I particularly enjoyed the light dancing over these delightful objects and the arrangements of objects. Over the years I have painted a number of vegetable stands opaquely. These scenes are quite varied, and I would find that the opaque painting technique was the one best suited to bringing out the numerous textures and patterns to be discovered there. Also, since I would most often paint such scenes in strong light and shadow, the thick application of opaque paints in the light areas would bring out the effects of sunlight in these areas distinctly.

Planning the Composition

To plan the composition, I asked myself a few basic questions first: Should I work large? Small? Rectangular? Square? Where is the center of interest? Is it the entire fruit and vegetable stand? The vendor? A barrel or basket? Once you decide what to paint and how much of it to include, you will have to arrange it in relationship to the size and shape of your canvas.

For *The Marketplace*, I decided to look at my subject as an outdoor still life. I also decided to select only a section of the entire scene and focus on this as a single shape. Upon analyzing my subject,

I realized that this shape was quite horizontal. I therefore chose a long, rectangular panel, 16½" x 28" (34 x 70 cm) and developed the composition as one long, rectangular shape made up of varying geometric shapes of squares, rectangles, circles, and spheres within the larger rectangular shape of the canvas. There would be a symphony of shapes in the composition, with the square and rectangular boxes contrasted with the circles and spheres of the baskets.

Arranging the Values

As I worked out the values, I decided that I wanted this painting to be a simple, uncomplicated outdoor still life, and I wanted the values to reflect this decision. Therefore I chose a scene in bright sunlight, where the strong light and shadow patterns in the painting divided it into two parts: the light values of the baskets and the white cloth and the dark values of the shadows and background. The dark background, which represents the obscure windows of the store behind the stand, creates an effect of quiet simplicity. Normally, many objects of the outside world would be reflected in these background windows. But painting all that would create too many different values there, which would distract from the brightly lit shapes of the foreground. Instead, since I wanted the background to act as a foil for the busy shapes in the foreground, I simplified it. I reduced it to only one value and blocked it in as a single dark shape.

Deciding the Colors

Since the subject matter itself represents warmth to me—the sunshine, the warm brownish tans of the baskets and sunlit fruits and vegetables—I knew I wanted the finished painting to have a warm effect. I kept this effect in mind as I selected the colors of my limited palette.

To choose colors for your own limited palette, first squint at your subject to lose the details. Determine the prevailing color of the subject and select the color you own that is closest to what you see. For *The Marketplace*, I noted that the tan colors of the basket predominated, so I chose raw sienna, a middle-value tannish yellow-brown—realizing that it would have to be modified with warm grays. As you know from previous lessons, raw umber and white make warm brownish grays. I therefore planned to mix those grays with the raw sienna for

beautiful color effects. I also expected to modify these warm grays with touches of the cool, dark colors I had selected for the fruits and vegetables. This would add color variety to the baskets when I needed it.

Preliminary Studies

Preliminary studies are always important, for they show you in advance where your weaknesses are. The studies you choose to do should also be relevant to the subject matter you will be painting.

As always, I suggest drawing. Both line and tonal studies with pencil and paper are excellent. To prepare for a subject like *The Marketplace*, draw the objects separately or in possible combinations. You don't necessarily have to compose them, but you should draw each object carefully enough to study it. I set up baskets, crates, and boxes and over a several-month period completed numerous studies. I also observed the objects both outdoors and in the studio for the effects of varied light on them.

If at all possible, I suggest taking a Polaroid camera with you on location and supplementing your drawings with photographs. Since a pencil drawing will most likely take one to two hours to complete, it is a good idea to snap a picture of your sub-

ject every half-hour to record the light and shadow patterns as the light changes. This is especially important if you are working in bright sunlight, since many changes occur in the light and shade pattern during a two-hour period. Such an experiment will help you decide at what point to freeze the light and shadow in your final painting.

Value studies in oil, using both opaque and monochromatic techniques, can also be done for this type of subject. There are many textures in a subject such as *The Marketplace*, and, as you examine the value relationships of your painting, you will also be getting a feel for the textures of paint you will achieve in the final work.

Problems and How to Solve Them

The main problem to watch out for is having the wrong colors or values. When you determine where the error lies, remix the correct colors on your palette and paint over what you have. If, after several tries, you build up an excess of paint of the wrong colors, you can simply scrape it off with a palette knife. This will remass that particular area of the painting, allowing you to see the underlying shapes clearly once again. Wait until the area is dry and rework it opaquely.

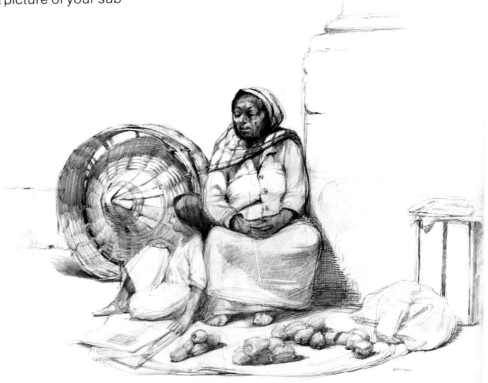

AT THE MARKETPLACE IN SAN MIGUEL DE ALLENDE, *drawing, 11'' x 14'' (28 x 36 cm).* Of all the marketplaces I have been to, none has been more exciting and has been the basis for more paintings than the one at San Miguel de Allende in Mexico. This tight little drawing, which was also used as the basis of a painting, took a while to compose and execute. It was done from many quick sketches on the spot. I also purchased the large round straw basket and did many drawing studies of it in the studio.

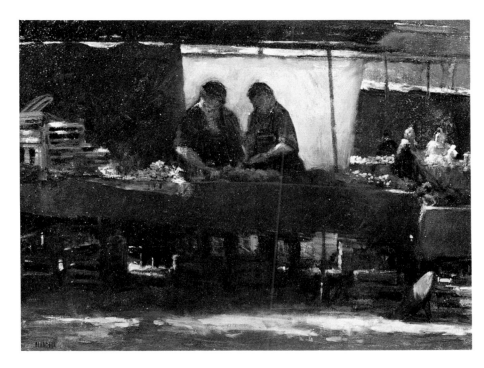

PARISIAN MARKETPLACE, *oil, 20'' x 24'' (50 x 61 cm), private collection. Photo Geoffrey Clements.* A lifetime could be spent just observing and painting marketplaces and vendors. To prevent the intense sun from burning the produce, all sorts of makeshift awnings, both upright and overlapping, have been devised. Visually, this adds to the exciting possibilities in painting this type of subject. In this instance, the vendors are arranging their display under a canopy that casts rich, dark shadow patterns, with sunlight breaking through in spots.

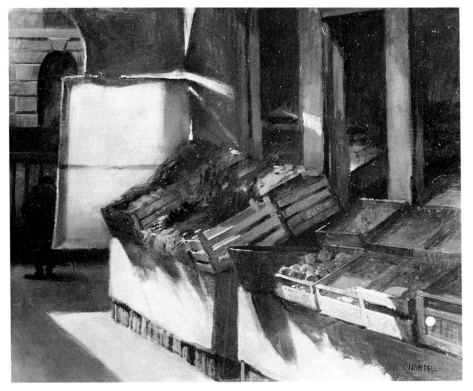

THE FRUITSTAND ON RUE DU MOULIN VERT, *oil, 24'' x 24'' (61 x 61 cm), private collection. Photo Geoffrey Clements.* Here again there is a wonderful play of sunlight on the subject. Although the produce is under a protective shadow area, one of the protecting drapes is white. Thus, as the sunlight streams through, there is a wonderful play of colors in translucent light.

Step 1. With a no. 4 round bristle brush, I thin out raw sienna with turpentine, draw in the objects, and lay out the composition. Once the outlines of the baskets and tabletop are established, still using the same brush, I mix raw sienna with raw umber and lay in the warm, tannish shapes of light and shadow of the entire painting. I keep the painting transparent at this stage, building up to the time I can paint opaquely.

Step 2. Now, picking up a no. 7 flat bristle brush, I brush in the entire background rather freely with Maroger medium mixed into ivory black (a warm black) and a bit of ultramarine blue to help balance the warmth of this painting. (The raw sienna and raw umber base is quite warm.) As I lay in the dark tone of the background, delineating the baskets, it causes a shift in the shapes of the painting. The contrast of simply working in the dark background intensifies everything that had been established on the canvas already.

Step 3. Working more opaquely, using round bristles nos. 2 and 4 for smaller areas of the painting, I establish more precise detail. With a no. 5 long flat brush I darken the shadows of the baskets with raw umber mixed with Naples yellow. A sense of texture develops quickly.

Step 4. As I continue my opaque buildup of paint, I also establish the rest of the shelf. Because of the opaque quality of the paint, the boxes and baskets take on a sense of weight. Notes of red are introduced now, as I begin to establish the color of the fruits and vegetables.

Step 5. With a bit of Maroger medium mixed into my paints, I work on the green broccoli in the right-hand side of the painting. I rework the baskets to the left and begin to work in the white cloth on the shelf.

Step 6. The opaque paint build-up continues, as I slowly add detail, make corrections, put in cast shadows, and define and subtly develop the painting. I decide to lower the dark background on the right to improve the allover pattern.

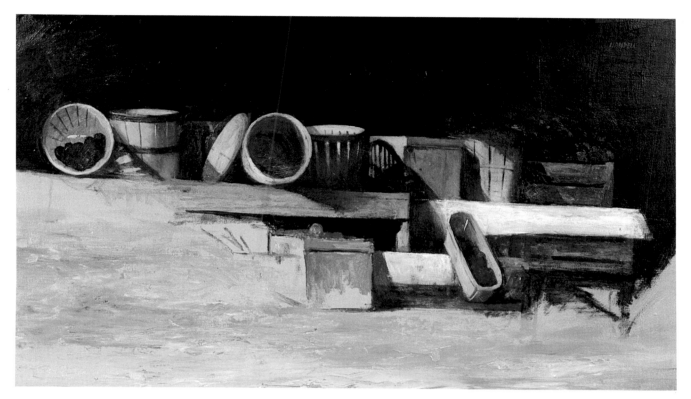

THE MARKETPLACE, *oil, 16½'' x 28'' (42 x 71 cm), private collection.* Now that all the areas of the painting have been designed and laid out to my satisfaction, I concentrate entirely on textures and select details. I build up the textures of the broccoli on the right and the stringbeans in the center. With the back of a brush, I scratch into the opaque build-up of the baskets, following the rhythms, and pulling out details. With a palette knife, I build additional textural variety into the grayish foreground of the countertop covering. The horizontal strokes of this very opaque area create a simple yet striking contrast to the flat, dark background. The final touches, my careful accenting of the textures of the baskets, are done with a palette knife.

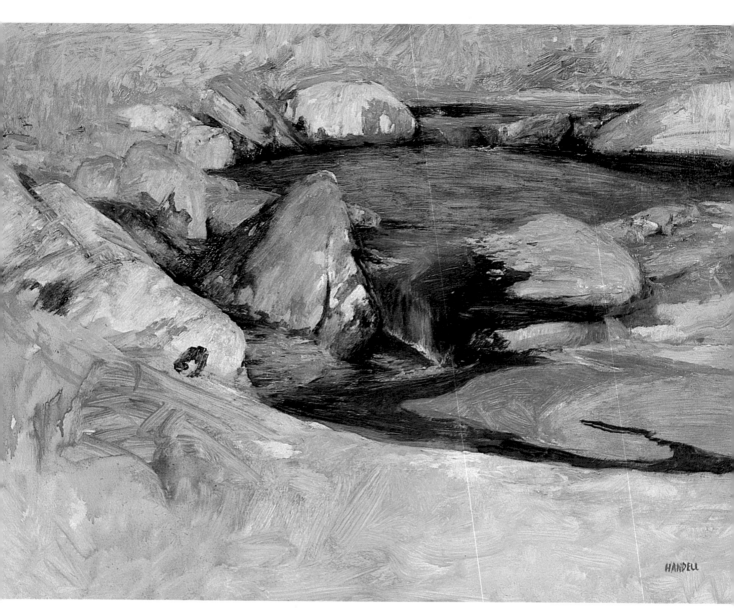

THE POND, *oil, 18'' x 24'' (46 x 61 cm), private collection.* This is a good example of a painting completed with the turpentine wash technique. Notice how the greens are kept thin throughout and that the colors are as fresh now as when first established on the canvas. The rocks and water have received a second layer of paint. Using turpentine alone as the medium, the paint was applied more thickly to the rocks, for instance, to bring out their solid quality. Treating the water in this way also gives beautiful variety to the painting and adds a delightful contrast to the free-flowing greens.

Learning About Color

Transparent Oil Painting, Full-Color Palette
"The Loose Turpentine Wash Technique"

The transparent oil painting technique is generally reserved for underpaintings that are later painted over opaquely. Since I have always preferred transparent colors, and being reluctant to cover this beautiful underpainting with opaque paint, I began to experiment with transparent mixtures and developed the technique I now call the loose "turpentine wash technique." Basically, this is a technique in which I thin my oil colors to a great degree with turpentine and paint very freely, very loosely, and very transparently with the mixture, the oils in this technique flowing very much like watercolor.

Procedure

To begin a painting transparently with the loose turpentine wash technique, I start with a light pencil drawing and sketch in the subject, drawing directly on the surface of the gessoed panel I use. In this technique I always work on a very absorbent ground, so the homemade gesso panels I make are perfect. I mix the colors lighter in value than I normally would if I were painting opaquely, and begin laying in the painting with the predominant color I see in the subject. After applying this color thinly and loosely to the canvas wherever it appears, I mix other colors I see and apply them one by one in a similar manner. When the colors are applied cleanly and with care, the painting will remain uncluttered with excess layers of oil paint, and the colors will stay rich, fresh, and luminous.

The Lesson

In this demonstration of the turpentine wash technique, you will learn to paint loosely, freely, and quickly. Therefore, this technique is excellent for capturing the essence of a moment or the sense of presence of a scene.

Preceding lessons have slowly and gradually taught you how to use color, first through tonal studies to achieve a sense of values and then through the use of a limited palette to translate this knowledge into color. I always stress this type of study and experimentation in my workshops, because a thorough understanding of values is crucial to the successful use of color.

In this lesson you will learn to deal with a full palette of colors. First I will show you how to select a range of colors for a full palette and use them harmoniously. In this demonstration of an interior forest scene, I will emphasize the predominating greens that express it, and you will see how a painting can be developed around the "milieu" or environment of a single tone or color.

Using a Turpentine Wash

The main advantage to the loose turpentine wash is the luminous, rich color effects you can get, using very little paint and surprisingly few colors. This also allows for an interesting harmony because the surface and color of each layer show through.

As in watercolor, this free flow of paint also

creates "happy accidents" if the turpentine-filled paint is allowed to drip. When it dries, you'll discover that it has added a certain charm and uninhibited life to your painting. And since the free flow of the paint allows you to cover large areas with big washes, you can easily get tonal or color nuances throughout the entire painting.

Glazing

You will also get the feel of glazing with this technique—that is, of brushing thinned layers of paint over previously applied color in order to unify and harmonize colors in the latter stages of the painting. Of course, glazing is always done on a dry surface, so you don't pull up the color below. But this should present no problem, since the turpentine wash dries so quickly.

Using a Gessoed Panel

There are many advantages to working on a homemade gessoed panel. Because the surface is absorbent, the thinly applied paint film dries quickly (within half an hour), so you can continue to work without worrying about disturbing previously applied layers of paint. Also, loose pencil drawings can be done directly on its hard surface. This is important because drawing with paint is difficult in this technique since it is so thin and watery.

Using a Full-Color Palette

The full-color palette will give you the opportunity to capture all of the colors and color nuances that exist in nature. Of course, this calls for an awareness of values and an understanding of color harmony. But when you're prepared for the experience, working with a full palette can be exciting and challenging.

Materials Required

The following materials were used to paint *Woods Interior,* demonstrated at the end of this chapter:

Support

Again I used a homemade gessoed panel, 24" x 30" (60 x 90 cm). Here the fast-drying property of this surface was an advantage in completing the painting quickly.

Medium

The pure gum spirits of turpentine I used as the me-dium also helped speed the drying of my paints. It also kept the paint layers thin and transparent.

Brushes

The brushes I used were round bristles, nos. 2, 3, and 5; flat bristles, nos. 5 and 7; and a no. 4 red sable flat.

Varnish

A spray can of damar varnish was also needed for varnishing the finished painting when it was dry. The varnish ensures that the luminous effect of the colors is retained. It is sprayed rather than brushed on so as not to disturb the thin paint film.

Colors

I used a full-color palette of 18 colors. Listed in the order in which I lay them out, from left to right, they are:

> Titanium white
> Naples yellow, a muted, light color
> Cadmium yellow light, a warm, intense, light color
> Yellow ochre, a muted, light-to-middle-value color
> Raw sienna, a warm, muted, middle-value color
> Burnt sienna, a warm, muted dark color
> Cadmium orange, a warm, intense, middle-value color
> Cadmium red light, a warm, intense, middle-value color
> Alizarin crimson, a cool, dark color with an acidy "dye" quality
> Raw umber, a cool, muted dark color
> Cadmium green light, a warm, intense, light color
> Permanent green, a muted rich, middle-value color
> Sap green, a cool, dark color with an acidy "dye" quality
> Ultramarine red, a dark, muted, neutral purple
> Cerulean blue, a warm, light-to-middle-value color
> Cobalt blue, a warm, rich, dark color
> Ultramarine blue, a cool, dark color
> Ivory black, a warm black

All these colors mix and harmonize well together. Experimenting with them separately and in combinations will give you invaluable knowledge of their

potentials. For instance, alizarin crimson and sap green are strong dye colors and should be used with great care. They have a great intensity that can easily pervade your painting and become overpowering. On the other hand, colors like Naples yellow, yellow ochre, and cerulean blue are weak, yet they can add sensitive nuances to a painting. Colors like ultramarine blue, cobalt blue, and cadmium red light are well balanced; they are strong, yet not too overpowering.

Suggested Color Exercises

Experiment and practice with these colors as often as possible. Appreciating their subtleties will take time, but to speed the process try the following exercise: Mix white into each of your dark colors and dark-color mixtures to see their true hues. Combinations of dark mixtures like alizarin crimson and sap green may look black, but they're not—as you will see when you add white to them; they express a definite color sensation. Lightening them with white will help you appreciate their subtleties. You can also conduct the same experiment substituting Naples yellow for the white. This will alter their intensities as well as their hues. Working with a full-color palette will open up a world of opportunities!

Selecting a Subject

In painting landscapes, I am often moved by a particular moment in nature. To capture the flow of the emotional experience as it happens, I automatically find myself selecting the loose turpentine technique. The best subject for this technique is one in which a sense of place is important and the emphasis is on the general overall tone of the scene rather than on specific details or objects. For example, the technique would be appropriate for capturing the essence of wind in the trees rather than the detailed texture of the bark; it would also be good for expressing the mood of a gray day or twilight moment when color contrasts are not predominant.

Woods Interior was painted along the Mill Stream in Woodstock, where I live. It was a peaceful day in August. I enjoy being surrounded by the delicate greens of the woods, a floating mystery of color, with its gentle breezes, flurries of delicate leaves, and interior play of beautiful light. My eyes settled on an embankment with a fallen tree,

branches, and other smaller trees shooting upward, and I sensed a painting. Wanting to capture the quality of this beautiful place I was experiencing, I completed the work transparently with the loose turpentine technique.

Planning the Composition

Ways of planning a composition can be as varied as choices of subject matter. Some compositions are conjured up with a specific center of interest in mind. Others are methodically planned and tested for balance and compositional tightness. Both types of compositions could be termed "obvious."

In *Woods Interior,* the planning of the composition was very subtle and elusive. I just stood still and forgot about trying to conjure up a picture. Instead, I allowed my eye to flow over the area. In wishing to capture a feeling or a sense of place, the painting became a poetic, ethereal statement. The composition here is not as obvious as in other paintings of mine where the center of interest is more specific. Here it is made up in part by the rhythms of the scene, the embodiment of the sense of movement, and the subtle sensations of flow in what I was viewing. There is the rhythm of the earth sloping downward in the foreground, the sense of the fallen trunk and its pull and flow, the sensation of other trees and their healthy upward growth, and the grace and directions in which they flowed and reached out. These specific objects in themselves don't make up the subject or the composition. None of them stands out strongly or apart from the others. Instead, they are "within" the surrounding area, and the sensation of flow and rhythm they create *in combination* with each other creates the essence of the elusive, lyrical composition of *Woods Interior.*

Arranging the Values

When painting woods interiors, it is important to squint and take in the overall tonal effect of the woods. When you sense the general tonal value, ask yourself how light or dark it is. How warm or cool? How intense? Are there sharp value contrasts or are they all muted? Are they flowing together to make up the entire scene?

The overall color of *Woods Interior* is a warm, middle-value green. It was painted on a sunny day, but the sun had already passed over this area deep in the woods. Hence, there was no strong, direct

sunlight creating sharp contrasts anywhere. There was a sensation of sun all around, which created warm greens; but the absence of direct sunlight caused the light to be muted, creating delicate value relationships. There are no solid objects standing out in strong sunlight; the resulting values are close, adding to the sense of place.

There are also no intense yellow-greens or very dark blue-greens. Instead, a delicate middle-value range of greens dominates the picture. The darks were kept to a minimum, added only to bring out a few branches or accents for a touch of contrast. The light areas of the painting are basically the warm green areas of the upper background and two small darker areas (the fallen tree and the embankment) in the center of the painting. These areas were treated very carefully. Not wanting them to stand out, I applied semi-opaque paint very judiciously to the fallen tree for a slight contrast. The lighter values of these small areas were not any lighter than the background, as my intention was to add only slight contrast and to retain the overall quiet, mesmerizing effect of the deep interior of the forest.

Deciding the Colors

Woods Interior is painted with the full palette of colors listed earlier though some were used extensively and others to a lesser degree. Your subject and the effect you wish to create should determine your choice of colors and the amount of each to use.

Since I was concentrating on capturing a sense of place through the use of the loose turpentine technique, my color choices and their handling had to further this effect. I wanted a quiet, mesmerizing quality that would draw the viewer into the serene green surroundings. I therefore chose colors that would add to the overall feeling of serenity. This effect was achieved by selecting a single tone to predominate, with only a few stark color contrasts for interest.

I decided to make the dominant tone a warm, light, muted yellow-green. I chose a mixture of Naples yellow and cadmium green light for this warm green base, and painted my other colors on top of it.

Since green is a secondary color (made of blue and yellow) its many variations can be mixed readily on the palette. Although I still prefer to mix my own greens, there are now many greens already mixed and tubed on the market. Tubed greens are convenient to use and some are very beautiful. Three I have added to my palette are permanent green, cadmium green pale, and sap green. I chose the cadmium green pale for the major tonal effect of the painting. It is a very rich light green that reminds me of summer foliage. I varied this predominant shade with permanent green, a rich, middle-value, neutral green which I used for foliage shadows and with sap green which I used for darker, cooler accents.

I work with the blues and yellows of my palette to vary and harmonize the greens, softening their harsh intensity and rounding them out to keep them from being too green. I also use colors of the yellow-tan family, such as yellow ochre and raw sienna, to quiet the greens and harmonize them. I also had reds (the complement of green) on the palette, as I always do when working with a predominantly green painting like *Woods Interior*. I either mix the reds into some of the greens to neutralize them or add one or two red accents to the painting to balance the greens.

I easily mixed the various combinations of browns and grays for the fallen trees and patches of earth from the other colors on the palette, making sure a little ultramarine red was added to each mixture—to keep a harmony throughout.

Suggested Preliminary Studies

Painting an interior woods scene needs special consideration because such a complicated subject is composed of many different elements that must be harmonized into one painting. Here are some useful preliminary studies that will help you accomplish this difficult task.

An excellent way to begin is by making a pencil drawing of a tree on location or in the studio. When you're done prepare a watercolor wash of Hooker's green light (mixed with plenty of water for a middle-value green) and, using a large watercolor brush, tone the entire drawing with this color. I use a surface such as two-ply bristol board, to avoid buckling.) Now observe how the drawing of the tree recedes into the green surroundings.

You can also experiment like this with drawings of groups of trees, continuing to observe how the tonal watercolor wash gives a poetic harmony to the objects of the drawing. Don't fret if the green

wash causes you to lose some of the details of the trees. When the study is dry, you can always draw on top of it again with pencil to darken any areas you want.

Should you wish to lighten some areas, here's a useful tip: draw over what you have with a brush dipped in clean water. Wait a few moments, then with a cloth or tissue, wipe it quickly over the area. This will remove some of the watercolor paint and lighten the area.

Here's another preliminary study that will train you to harmonize the many different objects in a woods interior. A good way to begin is with a pre-pared toned paper, again a two-ply kid or plate fin-ish bristol board. You can tone these surfaces with watercolor washes in the studio ahead of time so that they're dry by the time you go out to draw. I suggest washes of Payne's gray or Hooker's green light, or combinations of these colors since they're excellent for representing the overall tonal effect of woods. It's best to keep the tone a middle value—neither too dark, too light, nor too thick—to allow yourself maximum flexibility in the drawings you'll be doing on top. You can work on these toned sur-faces with pencil or even with white pastel. Draw-ing with white pastel is an excellent way to pick out objects and, if there is sunshine, to capture strong contrasts.

With both types of studies, remember that you're going after a sense of harmony in a complicated subject, attempting to grasp a poetic harmony and a sense of place.

Problems and How to Solve Them

The finished transparent oil painting should be fresh and free, with the colors vibrant and alive. Therefore, don't work too thickly or darkly or you'll lose the beauty of the washes. Your colors could also run together if you paint too heavily and you could end up with a muddy, dull effect. If there are too many muddy layers of color, the light won't be reflected from the surface below, and the painting will no longer be transparent.

Should your color become too thick or muddy, there is a clear-cut, uncomplicated solution: Go over the muddy area with a clean brush dipped in turpentine. Then, with a clean rag, wipe out the area you wish to remove. You can then rework it. If you started with a pencil drawing, it will remain in-tact as you wipe off the paint, and you won't lose your original structural outline.

A word of advice: Keep the drawing light and loose, and your basic structural lines simple. If the drawing is too dark or strong, it may show through the finished transparent painting.

Transparent oil painting with the turpentine wash technique will require a lot of practice, but you'll soon discover that it is a very rewarding way to express spontaneous feeling visually and artistically.

This 11" x 14" (28 x 36 cm) drawing was done to familiarize me with the interactions of several trees as they grew, partic-ularly the counterpoint of their limbs as they interwove in curves and angles against each other. To study this, try draw-ing only two tree clusters at first. You can add more later when you become accustomed to handling their complex in-terrelationships. Also try drawing them under various lighting conditions. They're especially fascinating in sunlight, when their light and shadow patterns are constantly changing. It might be a good idea to take a Polaroid camera along too and photograph your subject every 20 minutes to compare these changing shadow shapes and decide which ones you like best.

Step 1. To capture some of the elu-siveness of the scene I start drawing lightly on the panel with an IBM electronic scorer pencil no. 350. As I said before, the responsivity of this soft graphite pencil allows me to capture many nuances. I loosely sketch in the fallen tree, the sloping earth, and some of the surrounding branches and smaller trees, getting a sense of the elements that are to be part of the painting.

Step 2. With a clean no. 5 flat bristle brush, I float turpentine over the entire panel drawing, washing it in with the rhythms and movements of the trees and earth. This preliminary transparent turpentine wash is important because it fixes the pencil drawing to the panel so the washes that follow will go on cleanly, without picking up or smearing the pencil.

Step 3. Since I am painting a woods interior, I float delicate greens over the entire painting, using lots of turpentine and letting it run. I now have established two important basic elements of the painting upon which I will build: the drawing and placement, especially that of the trees and earth, and a sense of pervading color, a beautiful green to which all colors thereafter will be keyed.

Step 4. I begin to build up the painting, still only using turpentine as the medium but mixing a little less of it into my greens and browns to get darker tones. I work from the center outward, and, although the painting is being built up, I am able to keep the same watercolor wash effect so the colors remain fresh. I allow the thinly applied turpentine-saturated colors to run downward because I like the spontaneous beauty these free-flowing runs add to the painting.

Step 5. I continue developing the painting still more, working outward from the center, keeping the wet watercolor effect. I now establish the denser buildup of the green foliage with mixtures of cadmium green light, permanent green, and sap green. For this I use a combination of brushes, a soft no. 4 red sable flat and nos. 3 and 5 round bristles. With small, vital strokes I strive to grasp the "inner activity" of the scene.

Step 6. Now I intensify the entire painting, working on an angle from upper left to lower right, following the natural slant of the earth. The painting is now transformed from a loose wash into a painting with depth and dimension. The colors I work in are richer and darker but still luminous. Everything is there now, ready for completion, and I begin to add suggestions of detail to the leaves and bark.

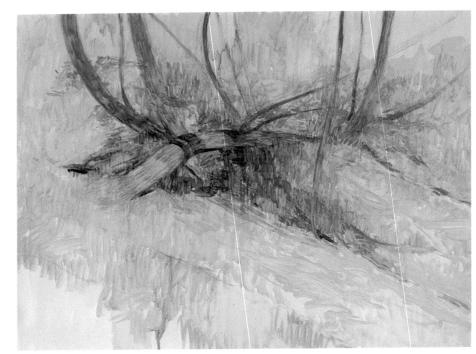

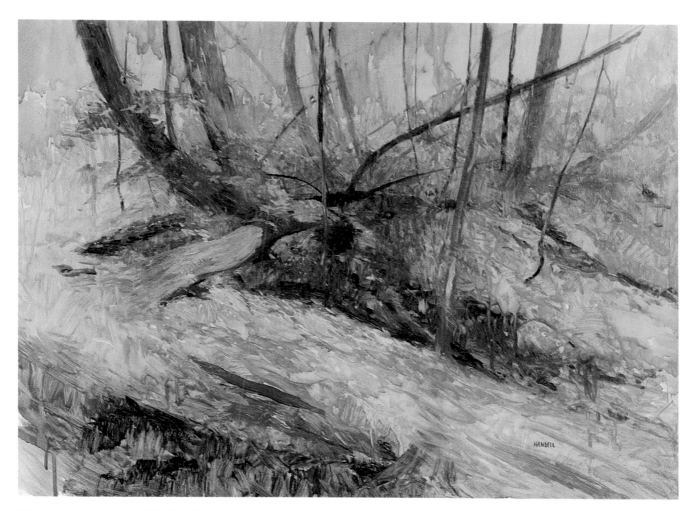

WOODS INTERIOR, *24'' x 30'' (61 x 76 cm), collection Bernard and Mary Paturel, The Bear Cafe, Bearsville, N.Y.* Right up to the end, I continue using turpentine washes with color. To lighten areas, I draw into the washes with a no. 4 flat red sable dipped in turpentine, then blot out the area with a clean rag wrapped around my finger. Sharpening edges for a crispness of detail can also be achieved through this method. I use a bit of semi-opaque paint for variety and contrast on the left part of the fallen tree and for some of the green leaves that float over the tree. As I select particular details to emphasize throughout the central areas of the painting, the underlying color wash creates a unity and strength that can be sensed throughout the painting.

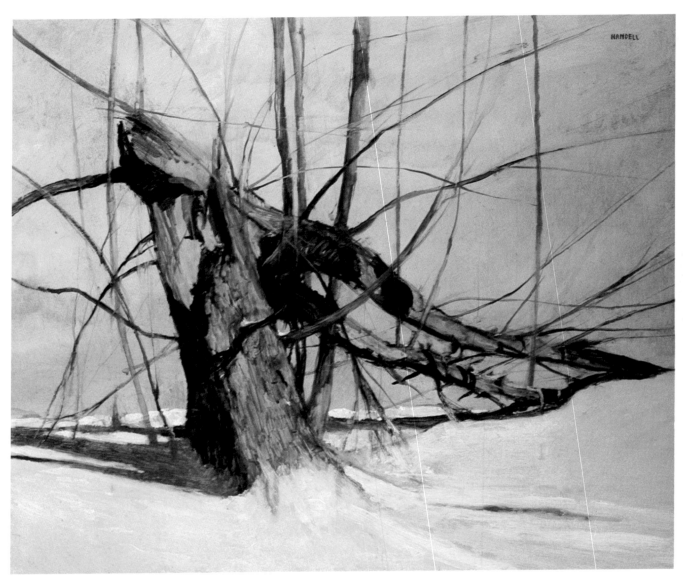

THE FALLEN TREE, *oil, 30'' x 36'' (76 x 91 cm), collection Michael Bartlett.* The transparent monochromatic demonstration of Lesson 1 was actually a study for this painting. The composition consists of many repetitious upright lines, representing the branches of the tree. There are also diagonal lines cutting across the lower left toward the upper right; they contrast with the broken trunk, which lies diagonally in the opposite direction. If you look more closely at the trunk and broken branches, you will see how loose and free the brushstrokes are. This, plus the vibrancy of the colors, is one advantage of using oil paints transparently. The shadows are simply stated with little detail, giving me a wonderful opportunity to suggest details and textures in the light areas instead.

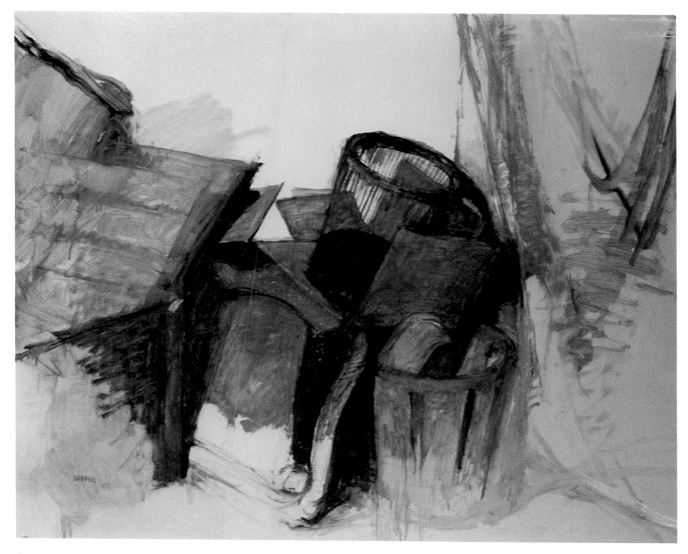

CORNER OF MY STUDIO, *oil, 24'' x 30'' (61 x 76 cm), collection
Mr. and Mrs. Christopher Carajohn.* This was painted in the
heat of the moment, using the loose wash technique de-
scribed in this chapter. The objects—a bushel and a small
rounded green bean box sticking out of it on the right, plus an
open vegetable crate on the left—are always kept in my stu-
dio. I have made countless drawings of them to familiarize
myself with marketplace scenes.

(Right)
This small 8'' x 10'' (20 x 25 cm) pencil drawing of two bush-
els, one on top of the other, was done on location. Though it
never became a painting, it certainly is a memory that will ulti-
mately add to the richness of future works. That is why I rec-
ommend that you constantly draw detailed pencil studies of
your subject.

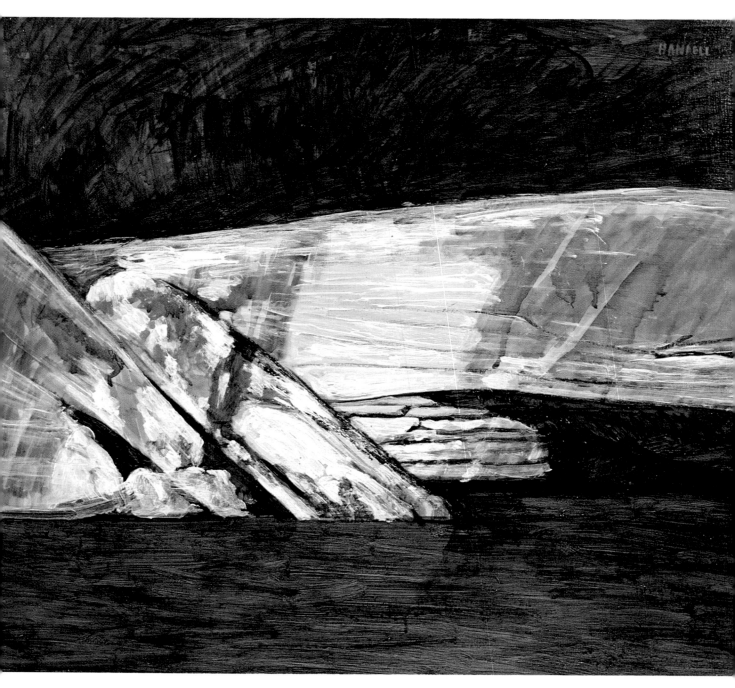

ROCKS AT MINNEWASKA, *oil, 18'' x 24'' (46 x 61 cm), collection the artist.* I came upon these rocks while visiting Lake Minnewaska in New Paltz, New York, and couldn't resist painting them. The opaque paint used in combination with transparent paint brings out the texture and weight of the rocks. The opaque paint is handled much as in *Sally's Red Barn* (demonstrated at the end of this chapter), but here I held back the color and instead emphasized the thick, meaty texture of the paint. The composition is simple and forceful because I wanted to capture the weight, form, and rhythm of the rocks. The color is also played down to emphasize the starkness of the rocks.

More About Color

Opaque Oil Painting, Full-Color Palette

Opaque oil painting is probably the most widely practiced oil-painting technique; it is the one I learned first at the Art Students League of New York. The control and ease with which colors can be mixed and applied and the great variety of effects that can be achieved with opaque paint have no doubt made this technique so popular.

In transparent oil painting (see Lesson 5), layers of paint are applied thinly and loosely to capture a free, spontaneous feeling and reflect rich, luminous colors. Here, in contrast, layers of opaque paint are applied more thickly, either unthinned with any medium or mixed with a variety of mediums. The thicker the paint, the more opaque it is and the less the colors of the underlying layers show through, although they may show a bit with semi-opaque paint. Instead of layers of color, it is the combined, harmonized color of the opaque painting surface that creates the final visual impact.

Opaque oil painting was first introduced in Lesson 2, where I mixed the more transparent hue of raw umber with varying amounts of opaque titanium white to bring out the structure and contrasting lights in *The Green Doors*. In *The Marketplace* (Lesson 4), I also used an opaque technique, this time with a limited palette, to effectively represent the textural and light and shadow contrasts of the baskets, fruits, and vegetables. In this demonstration, *Sally's Red Barn*, I will use the same technique but with a full palette of colors.

General Procedure

I begin the painting with a light pencil drawing on the surface of the panel. There are no details in the drawing, it is just for placement and composition. I then reestablish the drawing by going over it with a wash of raw umber mixed with turpentine in preparation for painting with color. In this early stage of the painting, I work with an underpainting of transparent color as the base, concentrating on the placement, the patterns of light and shade, and the subject's predominating colors first. When this stage is completed, I begin working with the colors opaquely, combining the color mixtures on the palette with a medium such as Maroger or a combination of one part each damar varnish, linseed oil, and turpentine. I then develop the painting with semi-opaque applications of paint and finish it with further applications of opaque oil paint.

I work lightly, especially in the beginning, as I put down my initial thoughts and feelings. I feel that applying opaque paint too heavily and too soon in the beginning of a painting decreases the sensitivity of your first impression and burdens you with a mountain of paint that can become difficult to manipulate and exhausting to control.

The Lesson

In the present demonstration, *Sally's Red Barn*, you will learn the further use and techniques of opaque oil painting. I will also show you how to develop and finish an oil painting with this technique,

demonstrating methods of color mixture, color application, and various effects that can be achieved with opaque paint.

Using a Full-Color Palette

You will also continue to learn the use of a full palette of colors. Whereas in the preceding project, *Woods Interior*, I concentrated on variations of green, in this project I will demonstrate how to paint effectively a subject composed of rich, complementary colors (in this case, the red barn and the green foreground). These colors will be established initially and then harmonized.

Using Opaque Color

The practice of opaque oil painting is widespread, for there are few if any drawbacks. Any kind of subject may be painted opaquely, and you can work in any size, especially on large canvases. Since opaque paint is thicker than transparent paint it needs more time to dry, but it can be reworked again and again, while wet or dry; and while some areas are drying, others can be worked on. Thus the technique is well suited to a lengthy project and to achieving planned effects.

Further Applications of the Technique

Because opaque colors can be mixed on your palette in advance, they can be accurately controlled, and a wide range of color gradations can be achieved. You can also fuse and blend these mixtures easily, and, since it can completely conceal the underlying layer, it can cover over unsuccessful work. Also, great textural effects are possible, ranging from relatively thin, semi-opaque layers to impasto effects. Methods of application can also vary. The texture of brushstrokes applied with a brush can stand out; applying paint with a palette knife achieves beautiful buttery effects. Also, because you can rework opaque paintings for long periods of time, you can develop and build up selected areas or details of interest.

Materials Required

For *Sally's Red Barn*, the painting demonstrated in this lesson, I selected the following materials:

Support

Again, my support was a homemade gessoed panel, 30" x 36" (75 x 90 cm), toned a light gray. I

chose this relatively large size to capture the old barn's sense of weight.

Brushes

I selected the following brushes: round bristles, nos. 3, 5, 7, and 9; flat bristles, nos. 3, 5, 7, and 9; and red sables, nos. 3 and 5, for details and blending. I had to keep several brushes of each size on hand for this painting because I was working with a full palette of colors and I wanted to keep my brushes clean. Therefore, as the painting developed and more colors were added, I used a different brush for each color.

Mediums

Since many mediums can be used with opaque paint, your selection of a medium should depend on the consistency and feel of the paint you like to work with. I prefer the Maroger medium, or a mixture of one part each damar varnish, linseed oil, and turpentine. Opaque paint can also be used straight from the tube with no medium at all or mixed with just a touch of turpentine. Here you should experiment and use whatever feels best to you.

Colors

I used a full palette of colors to paint *Sally's Red Barn*:

Titanium white	Raw umber
Naples yellow	Cadmium green light
Cadmium yellow light	Permanent green
Yellow ochre	Sap green
Raw sienna	Ultramarine red
Burnt sienna	Cerulean blue
Cadmium orange	Cobalt blue
Cadmium red light	Ultramarine blue
Alizarin crimson	Ivory black

I find this palette to be truly well balanced, and I can confidently paint practically any subject with it. As a matter of fact, I also use this palette for painting portraits. The colors here harmonize well, and I rarely find that I need additional colors to complete a painting.

Selecting a Subject

Old, weather-beaten architectural structures that have stood up against the elements for generations acquire a personality and character all their

own. The effects of wear and tear on them result in rugged textures and a particular beauty that is easily captured with the opaque oil-painting technique. When seen in sunlight, exciting and interesting shapes and patterns are created by the contrast of light and shade. I find that a combination of these weather-beaten elements makes a subject challenging, especially for the opaque oil-painting technique.

The effect of the elements also affords an opportunity for interesting color harmonies, allowing you to make *extensive* use of a full-color palette.

Sally's red barn was recently converted into a livable home. Before that it was a wonderful weather-beaten structure with layers of peeling paint, doors hanging from the hinges, and a sagging, leaky roof. Years of exposure to the elements had made it look as though it had bowed and shifted under its own weight.

I was attracted by its large size, its weather-beaten ruggedness, its textures and angles, the play of sunlight and shadows on it, and the contrast between the colors of the barn and the greens of the foreground. In short, the entire scene was a thrilling play of contrasts, invigorating and exciting to look at and a challenge to paint.

Planning the Composition

There were many ways I could have painted *Sally's Red Barn* in terms of composition and light effects. Before I made a decision, I examined a number of possibilities: I could do a closeup and focus on the open door or gaping windows; I could keep the eye level relatively low to emphasize the size of the barn; I could step back and take in more of the barn and possibly the surrounding environment; or I could raise the height of the vegetation to capitalize on the run-down feeling. With all these possible approaches, it was hard for me to grasp it pictorially at first. So in order to relax and understand my subject matter, I did many drawings, two of which are reproduced here. In chess there is a saying, ''When in doubt, push pawn.'' For me in painting, the saying could go, ''When in doubt, *draw*!''

Once I decided specifically what I wanted to paint, I went through an intense period of mentally determining the placement of the elements on the canvas. Here I decided to capture the largeness of the barn by creating the sensation of walking up to a wall.

I next needed to decide at what point to freeze the light to bring out the effect I wanted and also to determine the shapes of the composition created by the light and shadow patterns. (The preliminary studies suggested later in this chapter give advice on handling this important aspect of outdoor painting.)

The light and shadow patterns I decided to use created a composition of exciting shapes and angles that consisted of the slanted, sloping angles of the barn itself and those angles created by the pattern of light and shadow that fell across it. I decided to eliminate details at this point and concentrate on the shapes and patterns of the composition. Later I would decide which areas were important enough to get more details and which would remain as simple masses and shapes. I call this process *selective finishing*. (See Studios Notes for further information.)

Arranging the Values

In painting outdoor subjects like *Sally's Red Barn*, the constantly changing light is a problem because it causes continued changes in the light and shadow patterns. It is thus imperative to decide on the placement and shapes of the light and shadow areas before you begin to paint and stand by that decision.

I always stress the importance of keeping the values in a painting simple because too many values can break up the harmony of a painting. In *Sally's Red Barn*, I reduced the many values I saw there to only three. On a value scale of 1 (white) to 10 (black), I decided to keep the shadow areas only one value, number 8, and reduce the values in the light to two. For the lighter of the two areas in the light, I massed together several different colors of the same or similar values into a number 2 value: the green grass, the gray door, and the roof. But the intense, rich red of the barn required a second darker value in the light area, a number 3 value. This slightly lower value allowed the color of the barn in sunlight to be a rich red.

I was thus able to control the values by grouping and harmonizing the different colors of the various value areas. The dark, deep holes made by the doors and windows were added for contrast and accent, using a much darker color value composed of alizarin crimson and ultramarine blue. The final effect of the value structure of *Sally's Red*

Barn had a certain simplicity, yet created a lovely interest in its interplay of values and colors, and shapes and angles.

Deciding the Colors

In planning the colors, I considered the values of the subject and squinted to see the masses better. I then played down anything that broke up this simplicity, especially within the shadow mass. Although the values of the painting were kept simple, I realized that the colors within these values would create variety in the picture.

It was a sunny day with a very blue sky, and I observed the effects of this sky in working out the colors in the shadow areas. Because the sky was reflected in the cast shadows, they were thus bluer than the colors of the upright planes that were in shadow. I also knew that I would use my cool blues for the roof and foreground shadows which were also affected by the sky color. On the other hand, the upright planes of the barn in shadow and the sky were facing neither me nor the sky. Consequently there would be less blue and more of the rich local (red) color of the barn there.

In the sunlight areas, there would be more color variations within the light values. For the vegetation, I used cadmium green light. For the patches of earth that show through, a mixture of raw sienna and Naples yellow creates the light, muted tones I want. Getting the color of the barn in sunlight was challenging. I used mixtures of cadmium red light, alizarin crimson, and a touch of cadmium orange to get the correct color. I wanted the lower part of the roof to come forward; to achieve this, I added a bit of warm color to it.

The edges between the light and shadow areas were left sharp, but the edges within the shadow area itself were made soft. In these dark areas, the colors harmonize and blend so that they subtly flow in and out of each other. The result is that the greatest contrast is in the areas in the light, where I wanted the viewer to look.

Suggested Preliminary Studies

I believe that the best preliminary study for this subject matter is drawing. I myself did many drawings for this painting, studying the subject from many different points of view. Any drawing material you are comfortable with is suitable. I used an IBM electronic scorer pencil no. 350, a soft lead pencil, and two-ply vellum bristol board.

There are so many ways to compose a subject like this old barn that it is important to complete many simple, uncomplicated drawings to analyze it (see drawings on page 30 and 89). I first studied the light and shadow patterns before deciding how I wanted to paint it, then I decided what colors I wanted to use. To study the colors, I recommend small studies in oil, spending no more than 20 or 30 minutes on each. You'll be surprised at what you can accomplish in half an hour. Ordinary canvas board in small sizes, 9″ x 11″, 8″ x 12″, or 10″ x 14″ (23 x 28 cm, 20 x 30 cm, 25 x 36 cm), is excellent for these oil studies. Use any brushes and paint medium you are comfortable with. The object here is to capture the colors, shapes, patterns, and effects of the changing light. It's a good idea to time yourself, for carrying the color studies too far—to finished paintings—could be self-defeating and counterproductive. The studies afford a good opportunity to perceive and comprehend the various elements of a complete painting, while gaining invaluable insight into changing light effects and the nature of color.

Problems and How to Solve Them

If you find you are not entirely happy with the way your painting is developing, you may be running into a problem with color or value.

If the problem is with value, you may have too many different values in your painting, particularly in the shadowed areas. It is always best to simplify them; too many arbitrary values cause the painting to look weak. To simplify your values, squint and try to group the colors into one value for the shadows and one or two values for the light areas.

At the same time you're correcting the values in your painting, check the local colors and see if they're correct in your work. There's an old artist's saying: "You can get the correct value and the color can be incorrect, but if you get the correct color, you automatically get the correct value." The final, harmonic color effects are what you want; the concern for values is only to help you learn to see color. This is why you should also study color and value separately—to better understand their close interrelationship.

If you discover that you have the correct value but the color is wrong, just remix it on your palette and reapply it. Keep repeating this process until you get the correct color.

Here is a detail of Sally's red barn. There was so much to observe about this subject that I did several drawings before I started the painting.

There were so many open doors, half-open doors, and windows in Sally's red barn (see demonstration at the end of Lesson 6), that I decided in this sketch to study only the proportion of the barn and the light-and-shadow patterns. I knew that the colors of the painting would be so rich that they would dominate the work and that the details of the barn would have to be played down, but I still had to become familiar with these details so I would be able to get them accurate, even as I underplayed them. Here, I concentrated on a detail of the barn from an angle different from that of the final painting, using an electronic scorer pencil on two-ply kid-finish bristol board.

Step 1. I begin *Sally's Red Barn* with a loosely sketched-in pencil drawing, one of the advantages of working on a hard surface. I then work over this drawing lightly with turpentine—with no color. This seals in the drawing and also blends it a bit. But if I want, I could redraw and reestablish the masses of light and shade on top of this and thus lay out the composition of the painting. I mix cadmium red light into raw umber for the initial establishment of the rich, dark reddish shadows of the barn. I then mix cerulean blue into raw umber and white and apply it in a thin turpentine wash to establish shadows cast by the roof. The shapes and masses of these shadow areas create a sensation of sunlight immediately.

Step 2. This red is the richest, darkest, and most intense color in the sunlit area. However, I feel it needs to be played down a bit by adding more raw sienna to it so it can be unified later with the other colors that will be put in. Therefore, using Maroger as my medium, I establish the reds of the barn with cadmium red light mixed with a touch of raw sienna to decrease its intensity. At this point I am scrubbing in the colors transparently and semi-opaquely, covering all areas with a slow, controlled buildup of paint. I paint in the lower levels of the barn and the dormer opaquely and also darken the bluish cast shadow on the roof with cobalt blue.

Study the Dutch door to the right. The top half is painted opaquely while the bottom half is transparent. I have done this to leave options open in this early stage as I feel my way around the picture. Also, notice how different the same color appears when applied transparently and opaquely.

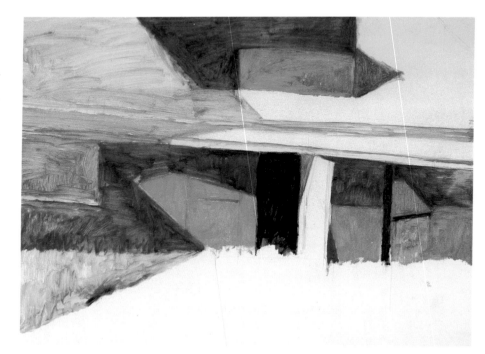

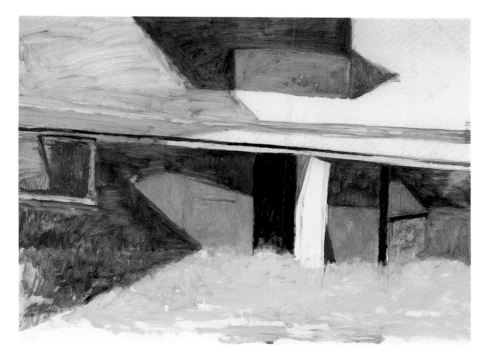

Step 3. There is a scrubbed-in feeling of transparency at this point, and the painting remains in the wash-in stage. I am still planning and building it slowly, feeling my way around as I cover all areas of the canvas. I wash in the sunlit area of the foreground with a mixture of yellow ochre and raw umber diluted with turpentine as a base for the brilliant greens. For the shadow cast on the ground, I use a mixture of raw umber and some purple-gray tones of ultramarine red and alizarin crimson. I then darken the windows on the left and reinforce the line of the roof with a mixture of ultramarine blue and alizarin crimson.

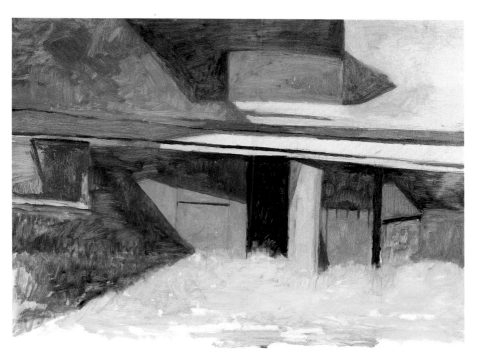

Step 4. I now start to unify and harmonize the contrasting complementary colors, the reds of the barn and the greens of the foreground. I put yellow ochre in the reds and in the tans of the foreground to tone them down a bit. The ochre color also serves to harmonize the two areas. The edges between them are played down, and they start to flow together, in and out of each other. I also begin massing in the shadows of the roof using a combination of warm and cool grays of the same value, mixed from black and white with Naples yellow or cobalt blue. I mass in the light area of the roof with a thin gray turpentine wash of Naples yellow, black, and white. To show you the slow buildup, I have left the lower roof unpainted. At this point, I also start to indicate details, for example, the proportions of the planks in the door.

Step 5. I now establish the lower roof and its upper ledge, piling on opaque paint to emphasize the sunlight. The pink in the mixture (cadmium red light with a touch of raw sienna and titanium white) harmonizes the area with the surrounding reds. I mix some permanent green with raw sienna and use the mixture to play down and integrate the siennas in the painting. I put a smudge of this color on the upper right-hand part of the picture to show where the roof ends and to give a sense of depth. As I paint in the ledge of the lower roof, I intensify the gray cast shadow on the door to tie up the textures of these shadow areas.

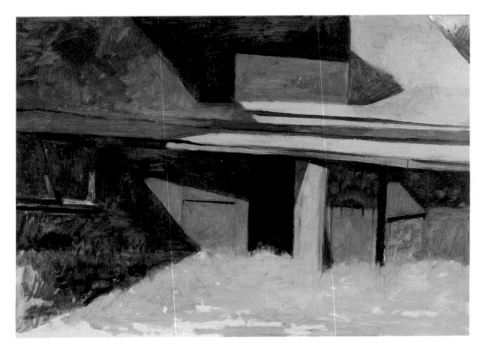

Step 6. I am at a turning point: the picture has been laid out and now texture is of utmost importance. I work over the entire picture, establishing areas opaquely with an eye to harmonizing the painting as a whole. I paint the vegetation in front of the barn with a mixture of cadmium green light and yellow ochre with white. The yellow ochre in the red of the barn also works to harmonize these complementary colors. I start establishing the detail of the barn paneling and work more darks into the windows. I also reestablish the shadow areas more opaquely throughout, clean all the color mixtures on my palette and brushes, lay out fresh paint, and stand back to contemplate where I will be going when I pick up my brushes again.

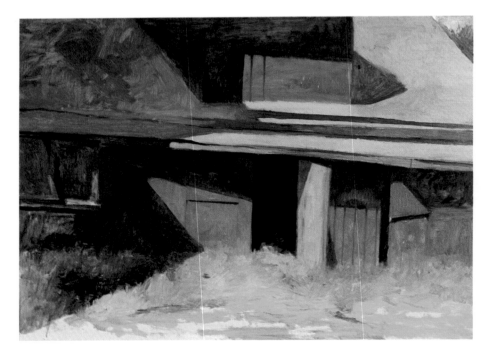

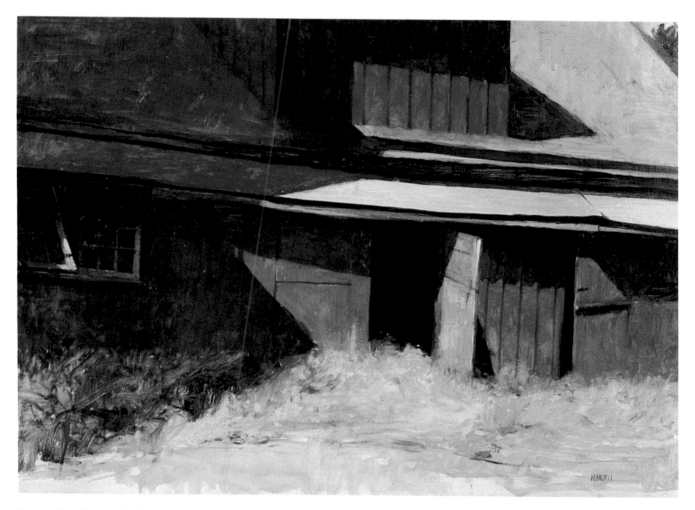

SALLY'S RED BARN, *oil, 30'' x 36'' (76 x 91 cm), private collection.* In this final stage, I work on every area of the painting and select specific details to define. I take a bit of the green of the grass and mix it into the red barn—and conversely I brush some of the barn color into the green grass—to fuse and unite these two areas of complementary colors. I subtly redefine the cast shadows, develop more variety in the greens, and incorporate subtle textures into both the light and shadow areas of the barn.

COAL CHUTE AT CANARSIE (BROOKLYN), *1958, oil, 16'' x 20'' (41 x 51 cm), collection the artist.* This painting brings back fond memories. I painted it while still a student at the League late one Sunday morning. There was a lot of moisture in the air, and the sky had a hazy quality. The sun was already overhead, giving me dark, interesting patterns against the light sky.

ORANGE STREET (BROOKLYN HEIGHTS), *1958, oil, 22'' x 30'' (56 x 76 cm), private collection. Photo Peter A. Juley & Son.* This is another early painting. It won a prize at the Greenwich Village Outdoor Art Show where, while still a student, I used to exhibit my work. The light is again the overhead sunlight of late morning. I was particularly attracted to this scene because it offered the added drama of a low perspective point.

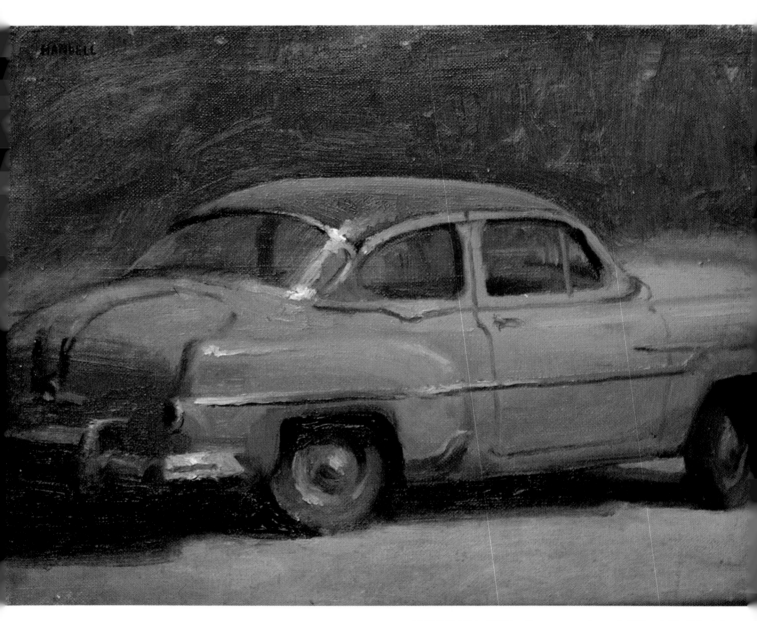

MY FIRST CAR, *1959, oil on canvas board, 10'' x 14'', (25 x 35 cm), collection the artist.* This small painting was done while I was first learning the transparent monochromatic under-painting technique at the Art Students League. In those days, New York City was my subject matter, and I would go out regularly to paint. Prospect Park and Canarsie Bay were my landscape areas; the rest was buildings, storefronts, and street scenes. One afternoon, in Prospect Park, I was not in-spired to paint anything I saw. But I had always wanted to do a portrait of my car and, as I turned to the car to go home, *voilà!* There was my painting! The colors here are muted and har-monized over a raw umber stain using the technique de-scribed in this chapter.

Learning About Shadows

Transparent Monochromatic Underpainting
Semi-Opaque Overpainting, Full-Color Palette

As your painting skills develop, you will discover how mastery of these basic techniques will help you express your visions pictorially on canvas. At this point you should be beginning to realize this.

In Lesson 1 you were introduced to the transparent monochromatic underpainting, a tonal approach to starting a painting. Because the underpainting was in only one color, it eliminated the problems of color at the very beginning. Instead, it forced you to concentrate only on drawing, composition, light and shadow, and values in this early stage of your painting.

The first stage of this lesson is also a transparent monochromatic underpainting, and in this sense is a review of Lesson 1. But this time the underpainting is no longer an end in itself; it is a skeleton or structure upon which to build a painting. Because you have solved most of your problems in the underpainting, all you have left is the color and harmony of the painting, and you can now devote your full attention to their solution.

The intermediate and final stages of the painting will be painted semi-opaquely and opaquely, and you will learn how to use a full-color palette to develop, finish, and embellish the painting.

The Lesson
The value of a transparent monochromatic underpainting—the simplicity and solidity it adds to a finished painting and the sureness it gives in carrying a picture to completion—will all become clear and fully appreciated with this method.

Painting Shadows
An important problem in successful outdoor painting, learning how to deal with shadows, will be discussed and demonstrated here. In *Soho* I will show how I paint shadows in an outdoor architectural subject: how I view, simplify, and relate them to the other elements in the scene. The realization that the shadows make shapes distinct from those in the light areas is essential to capturing the power and beauty of strong sunlight in a painting.

Using the Transparent Monochromatic Underpainting
In *Soho* the patterns of light and shade are very strong. Separating and establishing the correct values for each local color that passes from light to shadow can be a difficult task. The transparent monochromatic underpainting is excellent for es-

tablishing the initial impact of light and shadow in a painting, since its emphasis on values and value contrasts makes it good for suggesting any subject in strong light. In *Soho*, it thus enabled me to create an immediate massing of simple values (see Step 1 of the demonstration), instantly achieving a division into light and dark areas.

The Semi-Opaque Overpainting

With the composition and other basic elements secure, it is relatively easier to translate the monochromatic values into the correct colors. The semi-opaque paints permit greater control and accuracy of color mixing and greater harmony. You can also make a statement subtly, without having to move through thick layers of paint. The color works for you, and the underlying harmony created by the monochromatic underpainting allows you to slip from one color into another easily while keeping the painting harmonious and unified at all times.

Materials Required

I used the following materials for *Soho*:

Support

The surface is an absorbent gesso panel 16″ x 16″ (41x41 cm), toned a light gray. I tend to choose a square panel when painting interesting boxlike architectural structures.

Brushes

I selected two to three of each of the following: round bristles, nos. 2, 3, and 9; flat bristles, nos. 3 and 10; and round sables, nos. 1 and 5. Small brushes were needed here to get the desired textures and details because the painting was small.

Mediums

Turpentine was needed for the transparent monochromatic underpainting in the beginning, and Maroger medium was used for the semi-opaque development and finish. I prefer to paint with the Maroger medium for the buttery texture it gives to the paint. However, you are free to work with any medium you feel comfortable with that gives you a similar consistency.

Colors

The palette selected was my usual full palette of colors with the addition of the color "flesh." Add-

ing this color as an experiment, I used it as I would at times use Naples yellow, to form opaque, muted grays with a little warmth to them. Grays made only with black and white can become boring after a while.

Selecting a Subject

Any subject that is in strong light, creating dramatic light-and-shadow patterns, is good material for this method. Strong light creates shadows that can be grasped and established emphatically in the initial laying-out stages of the painting. The light-and-shadow areas are looked at as patterns and help make up the abstract elements of the painting. It is important to separate and establish them clearly.

In my early years as an art student, I lived in Soho (the name refers to an area in New York City "south of Houston Street") and knew and loved the buildings there. For years I enjoyed the beauty of the area, with its endless streets of imposing old loft buildings. As I passed them on my strolls and observed them at various times of day, I often saw them as still lifes with a great sense of weight, substantial proportions, and much character. Despite the use and run-down condition they were often found in, they still possessed a certain elegance of workmanship. When the buildings were struck by the strong light of a sunny day, the shadows created would sometimes cover large areas, allowing me ample opportunity to see into the shadow area. For me, the shadows are especially exciting and challenging to paint. I enjoy simplifying the large, visually interesting shadow area yet capturing the details there without breaking up the harmony of the shadow mass.

Planning the Composition

Determining the main emphasis of the painting and translating it into a picture is the basis of making a composition. In *Soho*, I was confronted with a composition consisting of the shapes of the building itself, plus those shapes made by the division between light and shadow. I closely examined the building itself: its squareness, sense of weight, shapes and forms, the vertical, rectangular proportions of the doors, the squareness of the windows, the variety of the ledges, and the values and colors in the sidewalk. Although these elements could stand on their own to create an exciting composi-

tion, I decided to play down the architectural structure and instead emphasize the strong light-and-shadow patterns. That meant I had to establish the angle of the sunlight, lay it in, and then build the rest of the picture around it. Once the light and shadow were established, the remaining elements of the composition would fall into place.

Arranging the Values

When doing a painting such as *Soho*, which centers around the division of such strong light and dark areas, it is essential to pay close attention to values. The darks must be made dark enough and kept simple in order to establish the solidity of the light and shadow and to create the contrast necessary to hold the whole picture together. The shadow masses must avoid appearing merely a weak statement of shadow falling across an object; they must have strong angle and direction, and interesting shapes.

I must stress once more the importance of freezing the patterns of light and shade at a specific point. Again, to eliminate details and better grasp a sense of the shapes of the shadow areas, squint. Always try to keep the shadow area simple, going after the shapes and the values. In *Soho*, I kept all the shadow areas one value in the beginning, a middle value of raw umber (see Step 1). That way I could establish an average value for my shadow area immediately, one neither too dark nor too light. In this planning stage I let the gray tone of the panel serve as the light area. I then concentrated on developing the shadow area by going *darker* in value when possible first (see Steps 2 and 3) to insure solidity and density of the shadow area—it would have to hold the picture together. Only after I had acquired the desired strength and simplicity in the masses of the shadow area did I begin establishing the lighter areas and the colors of the painting.

Deciding the Colors

The colors I chose for *Soho* were muted and subtle, to help bring out the accumulated city grime of the subject. Also, I wanted to keep the color harmony subtle. To achieve this effect, I did not turn to color until the shadow areas were well thought out and established. When that was done and I was ready to tackle the color, I started with the most obvious one, in this case the green doors,

and blocked it in. Then I blocked in the second most obvious color, and so on, gradually relating the more subtle colors to those already established ones.

The raw umber underpainting, the tonal base for *Soho*, was an important factor in harmonizing my colors. (This underpainting has the ability to pull in or absorb the colors applied semi-opaquely on top of it, harmonizing them practically automatically.) I used my usual full-color palette here, with the addition of the color "flesh," a color I experimented mixing with my grays, muted reds, and greens. Unlike the brilliant, alive greens of nature, the green of these doors was olive, a man-made color. I was able to mix it with Naples yellow, a touch of flesh, and a bit of cadmium orange added to permanent green. The cool bluish shadow areas in the greens were enhanced with the addition of cerulean and cobalt blues. I also allowed the rich underpainting to show through certain areas. The cadmium red light mixed with Naples yellow and flesh formed beautiful muted reds. The flesh and the Naples yellow were also used in my green mixtures. I was not only able to achieve the muted tones I desired, but I also kept a wonderful, subtle harmony flowing throughout all the colors of the painting.

Suggested Preliminary Studies

Understanding shadows and their behavior is the basis for success in this type of painting. The best way to study shadows is with tonal studies which will capture dramatic lighting effects swiftly and allow you to observe the changing light-and-shadow patterns.

Small charcoal studies on smooth, sanded, buff-colored pastel paper (made by Grumbacher) are a quick way to get rich tones in different gradations. These papers come in 22″ x 28″ (56 x 71 cm) sheets. Cut them in quarters and take several along with you on a clipboard when you go out to sketch. Then limit yourself. Don't spend any more than ten minutes on any one study. Work with your eyes squinted and go for the masses of light and shadow. Leave the buff tone of the paper for the light areas and concentrate on the shadowed areas only, leaving out the details or only putting in a few.

A second good preliminary study is to do small umber stains (transparent monochromatic underpainting) on the spot. Regular canvas board, 11″ x

14″ (28 x 36 cm), will serve the purpose well. Again, capture the shadow areas only. Lay out the shapes of the shadow area first, letting the white of the surface act as the light area. Then dilute the raw umber with turpentine and fill in the average or approximate value of the entire shadow area first, working darker to define shapes and accents. Try to squint often to see the shapes of the shadow masses more clearly.

Limit yourself to no more than 30 minutes to discipline yourself to going after only one element. Also, when possible, take a Polaroid camera along. Repeated photographs of your subject are an invaluable aid to studying passing light-and-shadow effects. The photographs will also help you later in the studio as you finish the painting.

Most important, these studies will continue to develop your awareness and get you in the habit of observing different lighting conditions and their effects on your subject throughout the day, and this constant observation will help you to paint sunlight.

Problems and How to Solve Them

A common problem in not developing a strong light-and-shade pattern is a general weakness of the pattern itself that probably results from an inde-cision as to where to freeze the light. If you keep changing the patterns of the shadows as the light moves across the subject, you will destroy the values and shapes and weaken the composition. If this is happening, stop and reevaluate the shapes in your painting and make a firm decision as to what you want. Then reestablish them—and stick to it!

Another common problem lies in having too many values in the shadow area. This weakens the composition and results in broken values in the shadow area. The cause is an overconcern with details in the shadow area too early in the painting. To remedy it, take a clean, dry bristle brush and gently brush the entire shadow area together, reestablishing a single basic, average value. This process is called ''massing (or remassing) the shadow area.'' By blending the different values together and losing the details, you will unify the values of the area again. Now start again, this time being careful not to lose the initial strength and impact of the shadow pattern that is so essential to the carrying power of your painting. Check the shapes of your shadow area, see if they are as strong (simple) as you can make them, then leave them alone and go on to the next step.

This 8″ x 10″ (20 x 25 cm) drawing was done for the demonstration painting that follows. I knew that my sunlight patterns would change soon, and since I was so excited by the patterns of light and dark I did this quick sketch so I would implant them more clearly on my mind.

Step 1. I lightly sketch in the outline of the composition with pencil. Then, with a mixture of raw umber and turpentine, and using nos. 2 and 3 round bristles, I lightly mass in all the shadows. I immediately separate the light from the shadow, grouping each as a single average value. Since I don't want the paint to run, though I do want it to be transparent, I scrub the mixture onto the panel rather than wash it on.

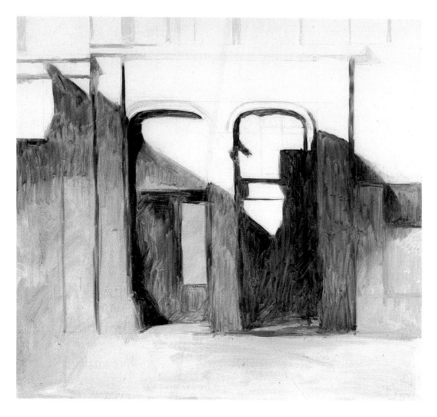

Step 2. Now, using more paint and less turpentine in my umber mixture, and with more brushes of the same size, I accentuate selected shadow areas by darkening them. I brighten the area around the top of the right-hand door with a touch of ultramarine blue.

Step 3. I strengthen and redefine the shadow area within the doorway. As the shapes are strengthened and the shadows emphasized, the effect of sunlight grows. Notice the variation I have achieved within the shadow area by using just raw umber. The sidewalk and window panel on the right-hand door are untouched, but they look lighter simply through contrast, because everything surrounding them has been made darker.

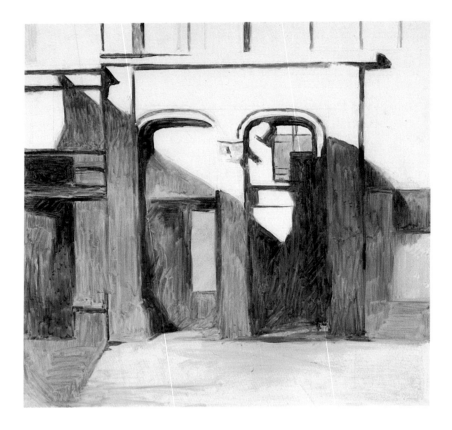

Step 4. Still working with raw umber and turpentine as my medium, I continue building the monochromatic underpainting in preparation for the transition into color, when I will be painting the correct color and value over this umber stain. I reinforce the left-hand door and begin to put notes of green color into the pillars, muting a mixture of permanent green and sap green by scrubbing it thinly over the raw umber stain.

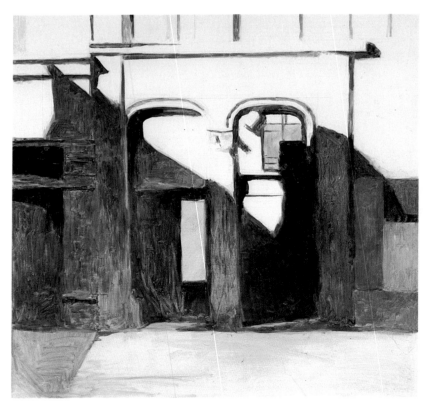

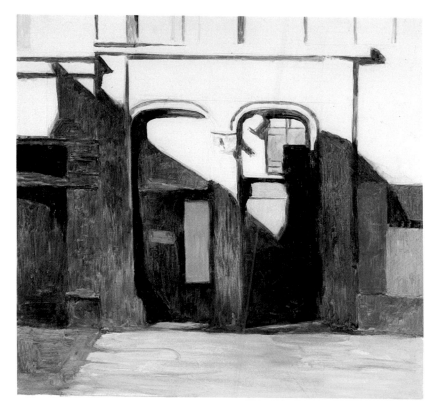

Step 5. The monochromatic underpainting is well developed now, and I complete building the shadow area with color. I mix a little Naples yellow or ultramarine blue into raw umber for the local colors of the doors and shadows, but the tone of the canvas still serves as the sunlit areas. This proves that, from the very beginning, the underlying effects of color can be indicated with little or no color.

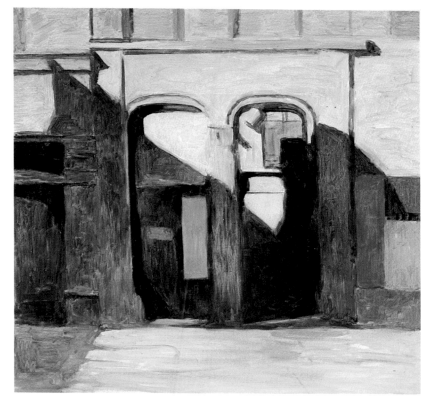

Step 6. I begin to work opaque paint into the sidewalk and sunlit areas where they touch the shadows to create a dynamic effect. I use a mixture of ultramarine blue, Naples yellow, raw umber, and titanium white. The cool blue grays I add to the sidewalk give a luminosity to the shadow area by comparison. The blue-gray is darkened as it merges into the door and the side panel of the door, integrating the two areas and strengthening the overall harmony of the painting. I now feel ready to establish the remaining sunlit areas and carry the painting to completion.

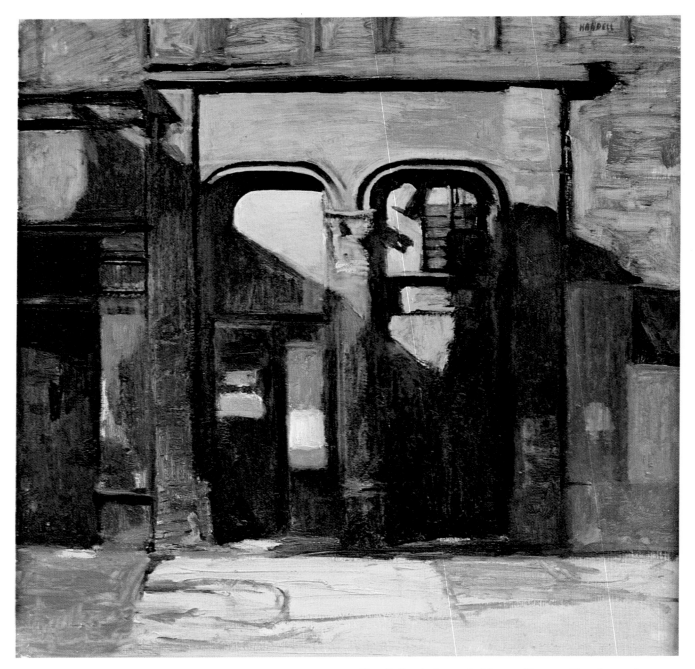

Step 7. I lay in the rest of the sunlit area with yellow ochre, Naples yellow, cadmium green pale, and flesh color (Grumbacher), scrubbing in the colors transparently and in some areas opaquely. I now have a strong foundation for the final picture. Some details are already being lightly noted in the shadow area of the doorways. Above the right-hand doorway, an indication of the railings of the grille is put in thinly so it won't be confused with the shadow area.

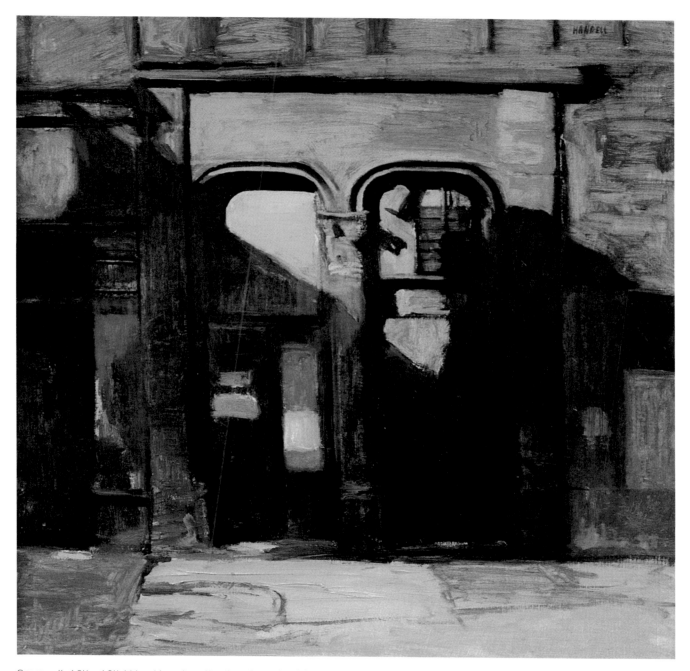

Soho, *oil, 16'' x 16'' (41 x 41 cm), collection the artist.* I decide to leave the sunny areas loosely painted and concentrate on the details within the shadow mass. By keeping the values of these details within close range of the average value there—going only slightly higher or lower to indicate form—I am able to keep the large shadow area well massed yet achieve subtle variety by breaking up this mass with smaller shapes and patterns.

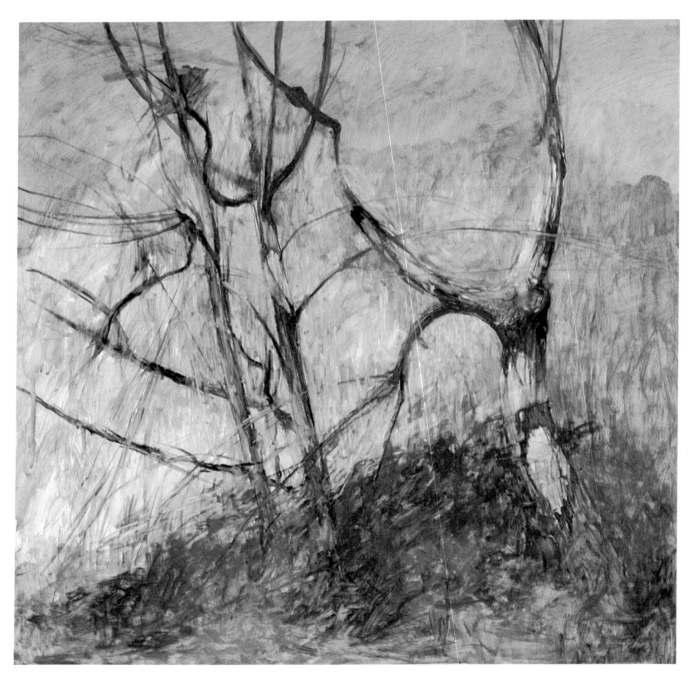

SPRING IN SYOSSET, *oil, 24'' × 24'' (61 × 61 cm), collection the artist.* Here is an excellent example of the turpentine wash technique used to bring a painting to a thrilling, refreshing finish. It was very early spring. There was still a feeling of winter's gray on many of the branches, yet delicately though undeniably the greens of early spring were manifesting themselves. I used turpentine washes for the greens of the entire painting, allowing some of the panel's gray tone to show through. I achieved the sense of rhythm in the greens through my brushstrokes. After the greens were laid in, I painted the trees with washes of browns and blues.

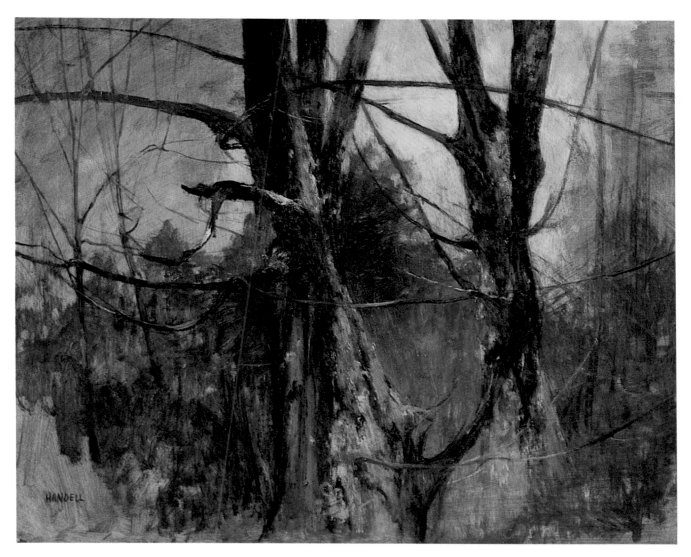

NOVEMBER, *oil, 18″ × 24″ (46 × 61 cm), collection Mr.
Harry Chester and Dr. Suzana Boquet Chester.* The silhouette
of these two trees and the lichen growing on them fascinated
me. The trees have a dark, ominous quality, yet they seem to
be in movement. I worked on a transparent ground stained
with a mixture of raw umber and raw sienna rubbed on over
my normal gray ground. I concentrated on painting the two
trees and their immediate background, harmonizing the
painting at the end with a very delicate scumble of Naples yel-
low mixed with Maroger medium.

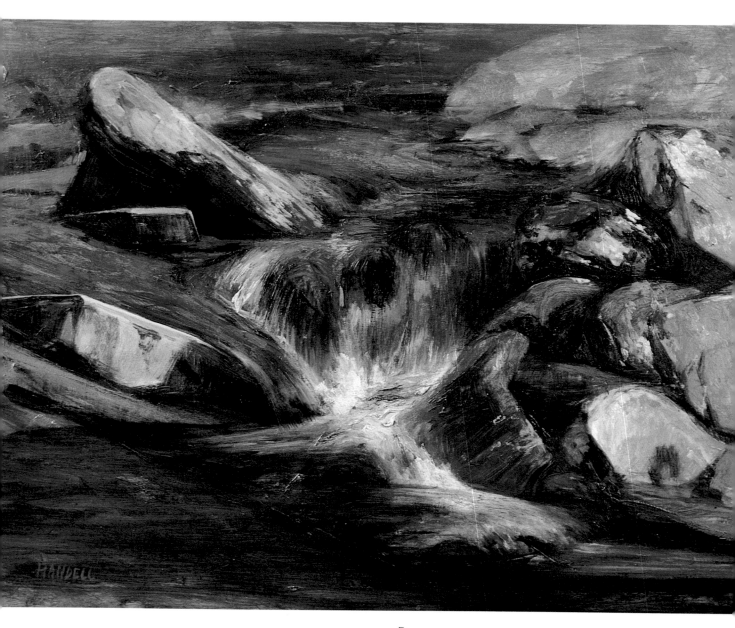

DOWNSTREAM FROM THE KAATERSKILL FALLS, *oil, 29″ × 30″ (74 × 76 cm), collection the artist*. This is another painting done on location in the Kaaterskill Falls area on one of those wonderful painting days when nothing could go wrong. The power of the water is essential to the excitement of the painting. I painted it opaquely, but left several areas transparent for texture and color contrast. A few days later, when the painting was dry, I pulled it together a bit by applying a thin blue glaze over the water and rocks.

Learning About Lights

Opaque Monochromatic Underpainting
Glazed and Scumbled Overpainting

In the previous chapter, in addition to learning a specific technique, we also studied objects lit by strong sunlight; the lesson there was on painting shadow. Now the lesson is on lights, and to see the many beautiful and subtle tones in the light, we need exactly the opposite lighting effect—the soft light of a gray day, a light without strong shadow patterns. Although sunlight produces strong light-and-shadow patterns which create dramatic effects in a painting, it also bleaches out the colors in the light and washes them with its own bright color. On the other hand, a painting done in the steady, low-keyed light of a gray day creates a rich, mellow, romantic mood. It also enables you to see the actual colors of objects at their purest.

I will also be introducing two new painting techniques here: glazing and scumbling. Used knowledgeably and skillfully, these two tools will allow you to control and achieve special color effects in your work. Both are often used subtly in the middle and finishing stages of a painting, adding considerably to the painting's overall color harmony.

Glazes are thinned-out oil colors (I use Maroger as the medium) that are applied to the painting very transparently when the underpainting is *dry*. They tend to make the picture richer without making the values much darker, and they give the effect of looking through colored glass. Glazes are used most often in a painting's final stages.

On the other hand, *scumbles* involve the use of semi-opaque color, which when applied tends to lighten the colors of the painting at the same time that it harmonizes them. The scumbled colors are pre-mixed on the palette with a touch of Maroger medium to create a workable consistency. The paint mixture and the paint medium are mixed together on the palette, then *scrubbed* onto the dry underpainting, allowing the colors underneath to show through. Once a scumble is established, it can be painted into while wet or on top of when dry.

General Procedure

When I use a combination of these techniques, as in the following demonstration, I usually begin with an opaque monochromatic underpainting. I work with raw umber plus titanium white, laying out the entire picture thinly and thickly, depending upon where desired textural contrasts are wanted. The underpainting establishes a tonal skeleton, then color is added, followed by glazing and scumbling. Thus, much painting and embellishing are done on top of what has already been established, allowing you to carry the painting to a finish.

Using the Opaque Monochromatic Underpainting

For a subject such as the tree of this demonstration, the opaque monochromatic underpainting

permits you to get very definite, distinct, and lively paint textures without becoming preoccupied with color. Thus, an enormous amount of texture can be built up through this underpainting, allowing you a great range of expression.

Shapes make patterns and have values. The monochromatic underpainting builds on this concept and maintains a sense of design throughout the entire painting. It also allows you to get involved with the shapes and light and shade on them in a simple, uncomplicated way.

Using Glazes and Scumbles

I always feel that the technique you choose must relate to your objectives. Combining the opaque monochromatic underpainting with glazing and scumbling enables you to paint a variety of challenging textures. You may also work large in this technique without losing any of the inner tonal strengths of your painting.

The greatest advantage of glazing and scumbling is that they allow you to unify the painting as you work and to retouch it later after the painting is dry. You can also work on specific areas without disturbing others.

Painting Gray-Day Light

There are also many advantages to painting in the light of a gray day. First of all, the light is subtle and without strong contrasts so the entire shape and local color of the object are seen clearly. Second, the light is constant so you don't have to rush to record your subject before it shifts but can take the time to study it more carefully. Also, the close values and subtle tones enable you to create a rich, dreamy, romantic mood with a "relaxed" harmony. You can further apply the knowledge and experience you gain in painting in this light to rainy days, snowy days, and fog scenes.

Materials Required

The character of this large old tree is best captured on a large canvas, 36" x 42" (90 x 105 cm). As usual, I use a homemade gessoed panel, toned a light gray.

Brushes

I selected round bristles nos. 2, 4, and 6; and flat bristles nos. 6, 8, and 10. I used larger brushes than I normally prefer in this painting to achieve the desired "meaty textures" of the tree and for the large green masses of the background. Larger brushes were also needed for scumbling and glazing.

Medium

I used the Maroger medium for glazing and scumbling because I prefer the texture and consistency of paint mixed with Maroger. I personally feel it has no equal. The gel quality of the Maroger medium adds a wonderful buttery texture to the paint, which affords great control and eliminates the dangers of dripping when glazing or scumbling.

Palette

I used my usual full palette of colors. Since the subject was painted in the light of a gray day, when colors are seen at their purest, I was able to use a wide range of colors to express the colors I saw in nature.

Selecting a Subject

Study and paint as many subjects as you can under the light of a gray day in order to appreciate the forms and colors you can find in this type of light. One advantage of working outdoors on a gray day without sunshine is that your subject is seen in a steady, even light. It is also a light without sharp contrasts and constantly changing light-and-shadow patterns. Therefore, this light is excellent for slowly studying your subject.

Of course, any subject can be painted with glazing and scumbling techniques, even objects lit by a strong, contrasting light. But for best results with these techniques, I suggest painting subjects lit by the light of a gray day, when beautiful colors and interesting textures are revealed to their fullest.

In painting outdoors, I often focus on one individual tree. Trees have distinct characters and personalities, and painting a lone tree is like doing a portrait. The large old tree of this demonstration is located in Magic Meadow, a well-known site on the top of Meads Mountain in Woodstock. It is an old, gnarled, and weather-beaten tree. Its solid, enormous trunk sits heavy and thick as it rises from the ground, covered with a very rough bark, delicate, intricate designs of lichen, and dark green moss. Its great, sturdy limbs twist and turn as they emerge majestically from the trunk. Its aura of ele-

gance and silent dignity commands respect as it nobly rules the edge of the meadow.

I have visited and painted this tree often and under many varied lighting conditions; here, seen in the light of a gray day. Because of the lighting, the value contrasts are minimized, and I was able to single out and accentuate the tree's aged textures, growths, and rhythms.

Planning the Composition

I spent much time contemplating the tree before deciding to paint only a detail of it. I sensed immediately it would be a large painting and so considering its placement became important. I believe that when planning a composition you should look straight ahead at the subject, and whatever you can see is all you should include. Don't move your head about, looking around and trying to squeeze everything into the picture. Including too much at close range will create a distortion in the perspective and result in bad proportions. As a matter of fact, one reason I decided to paint only a detail of the tree was because I didn't have enough room to stand back far enough to include the entire tree. I also feel that closeups have a special impact.

Once I decided how much to include, I began to study the shapes I was viewing and indicate their relative placement on the canvas. Remember that shapes seen in flat light are subtle and follow the true form of the object more closely than shapes seen in sunlight. A composition in flat gray-day light thus often becomes one of positive and negative shapes. The positive shapes (the tree and oliage) come forward while the negative shapes (the surrounding sky) recede. Then, within the positive shapes, the limbs of the tree come forward, and the green foliage recedes.

The movement and rhythms of growth of the tree also are important elements in the composition. The vertical twist of the trunk hints of a spinal column, the branches are the arms, reaching outward. I placed the tree off-center to achieve an interesting but simple asymmetrical composition. Placed directly in the center, it could have easily become monotonous and boring.

Arranging the Values

The values on a gray day are very simple and close, and every effort should be made to keep them this way. The objects also appear purer in color and closer to each other in value. This is because there are strong contrasts or sharp edges separating the light and dark areas of the objects.

In planning the values for *The Tree* and similar types of composition, an interesting element always exists: the silhouette. This is because on a gray day, the sky is the lightest value in the painting, while the earth planes (such as trees and mountains) are closer in value and *darker* than the sky. These planes viewed against the sky create a silhouette. This effect of dark ground objects against a light sky is only altered when there is a flat reflective surface, such as water or snow on the ground, that *reflects* the light sky which, in turn, breaks up the close, dark values of the earth planes. Otherwise, everything on the ground remains darker than the sky.

I planned the values of *The Tree* around the negative and positive shapes. The only sharp value contrast in the picture is the light sky, which makes everything else a silhouette. (If you squint, this becomes more obvious.) Since there were no reflecting surfaces and no bits of sunlight breaking through this day, it was easy to keep the values simple. Again, using a value scale of 10, the sky, the lightest value in the painting, is a number 2 value. The general values of the delicate green foliage are kept at number 5 to 6.5, and the darks of the tree at number 6.5 to 8. I was careful not to have any sharp divisions of lights and darks in the lower four-fifths of the painting so attention would be concentrated on the forms of the tree. I kept the values close. The colors, quietly slipping in and out of each other, created a very subtle, powerful harmony.

Deciding the Colors

I had my usual full palette of colors on hand to paint *The Tree.* Just as the form and shape of objects are seen most clearly under gray-day lighting, so the colors of the objects are also seen then at their purest. Thus I was able to make extensive use of many of the colors on my palette.

Because of the closeness of the values on a gray day, you must squint and look for the most similar values first, where only the colors are different. Once you have decided on a color area, ask yourself: Are the colors there warm, neutral, or cool? Study these areas, separate them mentally, and match the colors as accurately as possible on your

palette. Mixing the colors first on your palette and establishing them on your painting in this way gives a solid color and value key on which to build the rest of the colors of the painting.

I knew that the major tone of this painting would be cool, since there were absolutely no warm, sunlit colors anywhere. I also knew that the values clearly fell within the range of 5 to 8 on a scale of 10. I looked for the areas of the same value where the colors overlapped and established them first, giving myself a stable focal point to relate my other colors to and going darker or lighter where necessary.

The background greens are a play of neutral and cool greens varied within a value range of 5 to 6.5. I played down the yellow of the greens because of the coolness of the light and worked into the background with combinations of permanent green, sap green, and a touch of cadmium green light. The browns are rich and dark for the most part (within a value range of 6.5 to 8), with lots of grays in them composed of mixtures of ivory black, titanium white, Naples yellow, and raw sienna. These mixtures gave me various warm grays. (Grays made with only black and white are very cool by comparison.) I was able to use many of the other colors to create still more nuances in these mixtures. As I worked I continued to group greens and browns of the same value, allowing them to float in and out of each other by eliminating their outlines as much as I could to allow the eye to flow from one area to the other.

Suggested Preliminary Studies

I always suggest drawing as the best means of getting directly involved with your subject. With trees, it is the best way to get into the rhythms of their growth. I spent many hours enjoying, absorbing, admiring, and drawing this tree. One of the detailed studies I did of it is reproduced here.

To learn how to paint in the steady cool gray light of outdoors, one excellent preliminary study is to sketch the subject in pastel on a middle-tone gray pastel paper. First choose a pastel stick, a neutral light gray (no. 1 or 2 value) to represent the sky. Then limit your selection of colors to the following: four or five dark greens (5th to 7th value on a scale of 10); four or six dark browns (7th to 8th value on a scale of 10); three or four lighter browns (6th

value on a scale of 10).

Though the temptation may be great, don't take any light greens along with you. With only darker greens to work with, you will be forced to work within a narrow range of dark values seen against a light sky, which will make you keep to the silhouette created by this type of light. There will be color mixing involved, but because your values are limited you will be obliged to observe carefully and make do with what you have. This will also give you good practice in simplifying the colors seen in this type of light. You will also see how the silhouette quality can be achieved immediately with dynamic effects.

Another study I suggest to help you capture the sense of a silhouette and the volume of objects seen in this type of light involves working with inks in a special way. Take a full bottle of sepia (warm) and a full bottle of a cool green. Pour half of each ink into separate empty bottles, then fill to the top with water. You should have two half-bottles of undiluted color and two full bottles of diluted color. Take all four bottles of ink plus pencil (try my preferred electronic scorer pencil—it's very special) and paper (two-ply bristol board with either a kid or plate finish) along with you when you go outdoors to study your subject. Limiting your materials teaches you to simplify the subject and helps keep your concentration directed to the task at hand, especially in preliminary studies, which are aimed at mastering one concept at a time.

After selecting your subject, draw it in with pencil. When you are ready to start massing the colors and values, switch to ink. Cover the whole foliage area and the tree with a wash of diluted green; then, wash in the trunk and branches with diluted brown. Both of these areas will be massed simply and, of course, will be darker because that is the very nature of a wash on top of a wash. Let the white of the paper represent the sky. Work darker in areas of the trunk and branches with the *undiluted* brown to build up the study of the tree. Use the undiluted green sparingly to add variety to your background foliage. When dry, you can still rework the ink study with pencil if you like, to bring out selected details. The finished study should be low in key, close in value, harmonious, with selected suggestions of detail and, of course, the silhouette effect of the tree against the sky.

Problems and How to Solve Them

With glazing and scumbling, most problems can be avoided if a few important points are kept in mind. First, remember that the painting *must be dry* before a glaze or scumble is applied. If the paint is still wet, the glaze or scumble will smear what is already on the canvas, destroying the shapes, colors, and value harmonies. There would be no way to correct this, and you would have to start over.

A less serious problem occurs if you apply the glaze or scumble too wet and it runs or drips down the picture. As long as the painting was dry before you applied it, it can be removed. Just take a dry rag and wipe the surface down well. Then remix your color with less medium this time and reapply.

With regard to the silhouette effect in the painting, remember to keep the values *simple* and in a middle-value range. If there are too many contrasts, it will break up the harmony, and give the effect of sunlight. If the painting is too dark, it will have a muddy, obscure quality.

If you have the problem of too many contrasting values, you must reevaluate the values and decide how to simplify them. Then paint over the areas to be corrected, and remass them into one or two middle values. To correct areas that are too dark, instead of repainting them, you can scumble a light color over them, which will also add some special color effects. For example, you can use a weak, grayish yellow like Naples yellow. When scumbled on thinly with Maroger medium, Naples yellow lightens dark areas beautifully, giving the underlying colors an unusual pearly gray tinge that cannot be obtained in any other way.

A final problem that may be encountered in painting under the light of a gray day is that the colors of the objects in your painting may not be harmonious. If you paint them with many different, unrelated colors, they will stand apart from each other, disrupting the unity of the painting. To remedy this, paint the entire painting with a thin glaze of a single color. This will tie all the objects and colors of your painting together and bring your painting close to a finish, which is one of the amazing qualities of a final glaze or scumble.

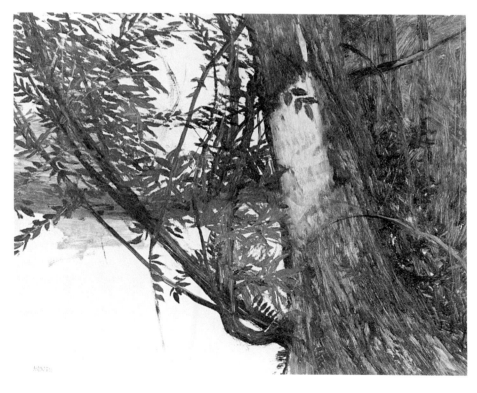

TREE STUDY, *oil, 14" × 17½" (36 × 45 cm), private collection.* This study was done on a painting trip in Florida; I loved the jungle-like verdant green of the trees there. Notice the upward surge of the brushstrokes on the trunk. I left the leaves as shapes that make a design of their own, as a group. I also left the background unpainted to bring out this design quality in a fresh way.

I recommend making many studies of trees twisting and growing out of the ground in
various ways. Simple drawings such as these will help familiarize you with your subject
matter.

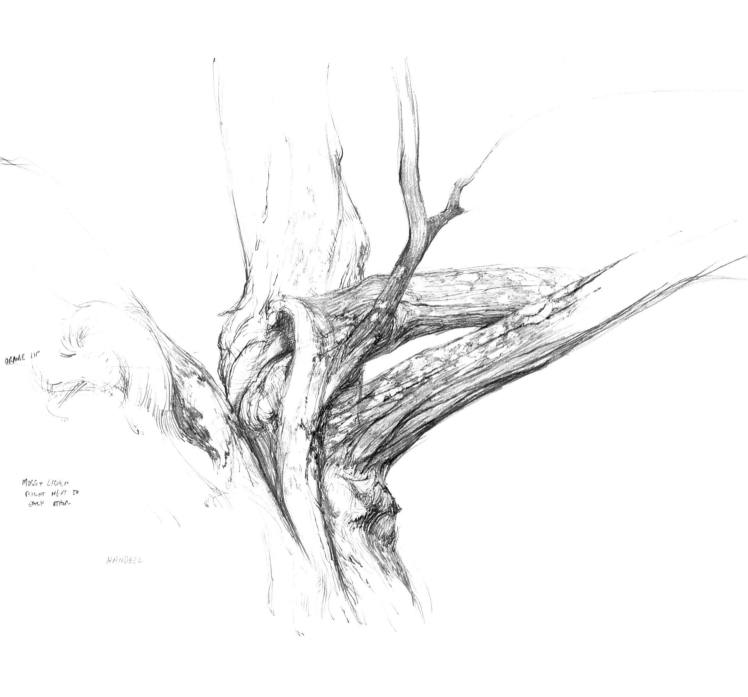

ORANGE LIP

MOSS + LICHEN
RIGHT NEXT TO
EACH OTHER-

HANDELL

THE TREE IN MAGIC MEADOW, *pencil, 11″ × 14″ (26 × 36 cm), collection Ileane Cuollo.* This drawing was done the day before I began the painting (*The Tree*) demonstrated at the end of this chapter. I was able to study the details of the tree in this small drawing, leaving the larger painting to solve other problems, such as color and design. Here the main rhythms and thrusts of the tree are established with line. There is also a sense of the rugged quality of the bark and a delicate suggestion of the lichen that was growing on the tree. The entire drawing is dominated by the tree's strong, vital energy.

Step 1. Starting with a warm mixture of raw umber and Naples yellow, I lightly scrub in the trunk of the tree with a no. 6 round bristle brush. I work thinly, using a combination of one part each damar varnish, linseed oil, and turpentine as my medium. Painting in the trunk gives me an immediate sense of the design of the painting, especially the arrangement of negative and positive spaces.

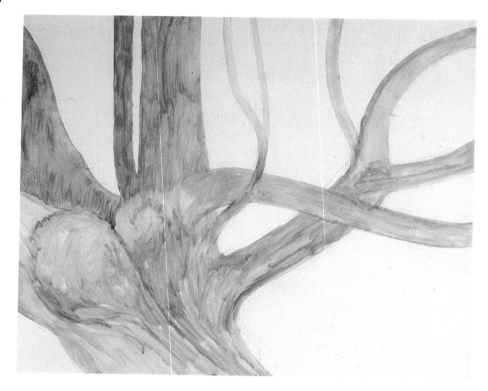

Step 2. To capture the rough texture of the trunk, I rework the area. The opaque monochromatic under-painting is done with an assortment of nos. 6 and 8 flat and a no. 4 round bristle brushes, and using an opaque gray of raw umber and Naples yellow.

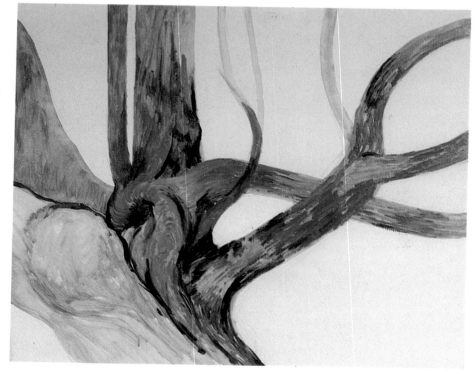

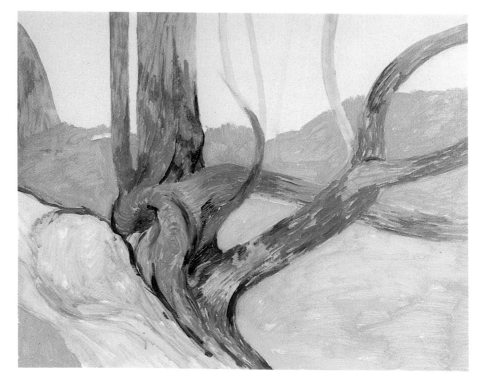

Step 3. I brush in the green background transparently for the most part with a no. 6 flat bristle brush and the medium I used in Step 1. The yellow olive green, which is the overall tone of the foliage, is made up of cadmium green light with touches of sap green and yellow ochre. Using more color and less medium, I add more opaque touches here and there for variety, as in lower left.

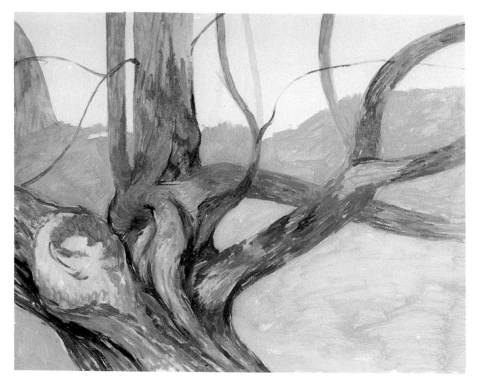

Step 4. Mixing a touch of Maroger medium into my colors now, I work up a buttery texture and begin to establish the variety of colors I see in the tree trunk. I mix grays of black and white or by combining the three primaries, varying them with touches of ultramarine red, ultramarine blue, and Naples yellow. I work with smaller brushes, nos. 2 and 4 round bristles, to better express the rhythms. The tree and the foliage are not unified yet, and the lighter opaque tree stands apart from the darker transparent background. However, I expect to float on a subtle green glaze later to bring the trunk and leaves together.

Step 5. Using only Maroger as the medium now, so that I am working with rich buttery textures, I rework the green foliage, developing it to the same level as the tree trunk. Starting in the middle of the painting where the green foliage is framed by the limbs and branches of the tree, I work thinly with semi-opaque color. As I develop the foliage subtly, I scumble some of this green into the tree trunk so the two areas become a bit more united. I can leave the sky unpainted because the tone of the panel is the same value as the sky. The entire underpainting is now developed to a point where it is ready for subtle unifying glazes.

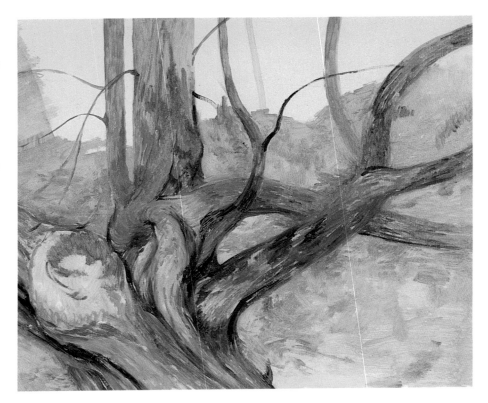

Step 6. Since glazing must be done on a completely dry painting, I allow it to dry for a few days. I then glaze the entire tree trunk and foliage with permanent green, a cool light green. I mix the paint with Maroger medium, which is excellent for glazing, and scrub it on. In places I paint directly into the wet glaze to suggest leaves in the background. I also start to establish the rhythms of foliage seen against the sky. I establish some of the darker greens in the dense foliage under the extended limb and then work into the trunk and branches to reestablish some of the darks and other colors there. The other changes here are subtle, but the glaze which has successfully pulled the various elements of the painting together, is apparent.

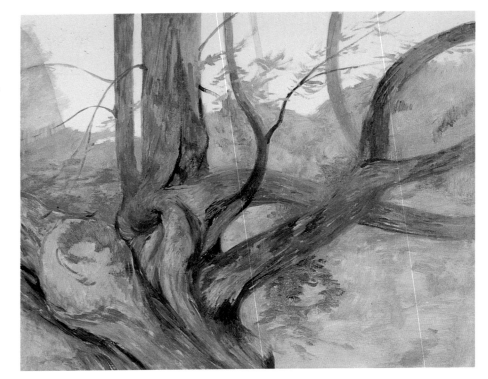

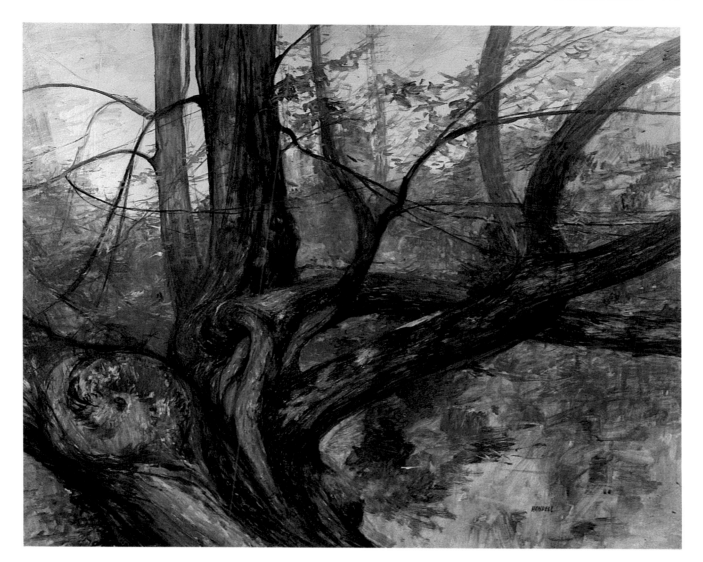

THE TREE, *oil, 36" × 42" (91 × 107 cm), collection the artist.*
Finishing the painting is now only a matter of adding select
details and textures. I work into what is already established,
reinforcing it and adding the smaller branches. I add whatever
brushstrokes I find necessary to capture the sense of rhythm
and movement of the green foliage, using small brushes for
the details, especially for the shapes and movement of the
leaves. I paint the sky with a light gray tone, the same value as
the original color ground of the panel, and gingerly paint in
the leaves that dance in front of the sky. The final details and
color variations of the bark are also added with small brushes,
which better capture their textures and rhythms.

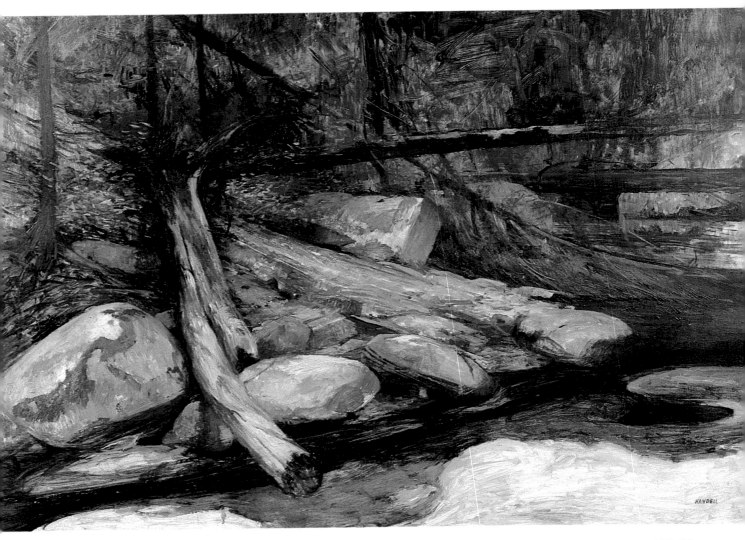

WOODS INTERIOR, AT THE PLATTECOVE, *oil, 23'' × 36'' (58 × 91 cm), private collection.* This is another woods-interior painting. Because of the woods, the distance in the painting is held down to a minimum. I like this type of subject, although it's complicated to paint because things get tight, crisscross, and overlap in a woods interior. The background is composed of different colors that together make up a very rich middle-tone value. On top of this patchwork of background colors are lighter green colors, representing the green foliage as it "floats" on top of the background, adding its own rhythms to the painting. The foreground light gray rocks are painted the same way as the foreground rocks of *Monhegan Island* (demonstrated at the end of this chapter)—using glazes and scumbles at the end to get beautiful, cool color nuances. The background is kept simple and is basically a color lay-in with some modification.

Learning About Optical Color Mixtures

Harmonizing Transparent Underpainting, Full-Color Palette
Semi-Opaque and Opaque Overpainting

We will now learn how to combine several techniques learned earlier to obtain beautiful optical effects with color. To fully comprehend the almost limitless possibilities for color variation that optical color mixing affords, you will require at least a minimal knowledge of color theory. (See Bibliography for a list of suggested books on the subject.) Simply stated, optical color mixtures are harmonious layers of color placed one on top of the other, allowing lower layers to show through in order to achieve a color impact. The final effect is achieved carefully, with delicate glazes, scumbles, and selective overprinting.

At this stage, the painting techniques are advanced and require a sound knowledge of values and color and their interrelationship. Therefore, experience with painting techniques introduced earlier is advisable. The techniques involved in this chapter are transparent color washes, semi-opaque and opaque applications of oil paint, and glazing and scumbling, each layer harmonizing with what is already on the canvas.

General Procedure

To begin the transparent full-color underpainting, I dilute the paint with turpentine and lay in the colors of the painting in free-flowing washes, much as I did in *Woods Interior* (Lesson 5). The turpentine wash technique I used there was very uninhibited and flowing, but should you desire a more controlled effect you can scrub the colors on with less turpentine. If you wish additional body and even more control, you can mix a bit of Maroger or other gel medium into your paint. However, be sure to scrub the colors on thinly to maintain the transparency. Although you should try to get as close as possible to the colors of the objects on this initial lay-in, at this point the colors don't have to be exact; an approximation is sufficient. But the underpainting should establish the entire tonal (value) and color range for the painting before the overpainting is begun.

When this is done, the painting is ready to be developed with semi-opaque and opaque colors applied over the transparent color wash, this time aiming for more accurate color mixtures. As the painting is carried toward completion, some of the transparent layers of color from the underpainting are allowed to show through. Finally, when the painting is dry, delicate glazes and semi-opaque scumbles are used to bring everything together harmoniously and finish the painting.

The Lesson

By working with a transparent full-color underpainting with opaque and semi-opaque overpainting plus glazes and scumbles, you are involved with color from the very beginning. You then proceed to build up the painting by strongly emphasizing the colors, and, after glazing and scumbling on top of it all, the result is rich optical color effects.

Using a Transparent Full-Color Underpainting

With the full-color underpainting, you always have a sense of the final colors from the very beginning. It also allows you to build up to the final color effects slowly, as you feel your way around.

Using Semi-Opaque and Opaque Overpainting

You can learn a great deal about economy of color by combining both transparent and opaque techniques, for there is considerable difference in the look of transparent or glazed color compared to the same color applied opaquely or scumbled. You can easily see this for yourself if you place a thinned-out wash of, say, ultramarine blue next to a patch of this same blue taken to the same value, but with white added. As you become familiar with the look of various colors and color mixtures and become aware of the range of effects possible simply through different methods of application, you will be able to use color wisely and economically.

Creating Textures

In addition to the variety of color possible, this series of techniques offers you the opportunity to create rich textural effects within the color masses. The thicker opaque colors sit on top of relatively thin transparent colors, allowing you to play with the textures as you wish.

Materials Required

I used the following materials for *Monhegan Island:*

Support

Again, I used a homemade gessoed panel, 18" x 24" (46 x 61 cm), toned a light gray.

Brushes

I used nos. 2, 4, and 6 round bristles and a no. 5 flat bristle. Since details were essentially eliminated from this painting, I didn't need any small sables.

Mediums

I used pure gum spirits of turpentine and Maroger medium. However, any medium with enough body can be substituted for the Maroger. A word of caution: if you do use the Maroger medium, do so sparingly. A little goes a long way.

Colors

I used my normal working landscape palette (see Lesson 5). A full-color palette was required, though, because in the opaque applications of paint I had to mix a number of tertiary colors in order to subdue and harmonize the intense, vital colors of the transparent underpainting. (This is usually the case with colors painted transparently with oils; they have to be harmonized.)

Selecting a Subject

Eventually when you reach a certain point in your painting experience you won't need to ask yourself what technique to use for a particular subject; you'll know instinctively which one to select. But, until then, I suggest you try to decide what originally attracted you to the subject—for example, color, value contrasts, shapes, patterns, or whatever—and decide what it is about the subject you want to bring out. Then select the technique that will do this best.

My choice of subject is naturally based on my own personal preferences, but, for the combination of techniques discussed in this lesson, any subject matter you choose will be fine. However, the techniques are particularly applicable to subjects with beautiful colors and textures. For that reason, I strongly recommend that you work in the light of a gray day when, as you may recall from Lesson 8, objects and their color nuances are seen in their purest and most complete state.

Monhegan Island, the subject of this painting, is a magical place for me, as I am sure it is for everyone who has visited it. Known to artists and landscape painters for many generations, Monhegan is a small island located eleven miles out to sea, off the rocky northern coast of Maine. The heights are numerous and the sights breathtaking as you meander up and down the dirt trails that crisscross the island. At all times you are surrounded by the

most beautiful, varied coastline found anywhere.

At low tide early one morning, I was overcome by a moment of peacefulness of the sea. There, rocks covered with seaweed and mosses were lying exposed, revealing a brilliance of color often hidden by the rolling sea. A fog was lifting, but the sun had not yet made its way through the clouds. The moisture-laden air gave a soft beauty to the atmosphere and a sense of distance to the rocks and sea. The colors and shapes created a delicate, flowing design, simple yet tremendously powerful, as the fog gradually and silently lifted.

My shoreline painting of Monhegan combined abstract shapes and patterns with a delicate but muted harmony of colors. The fog was lifting, and I realized I would have to work quickly to capture this moment before the sun would break through and the scene before me would disappear.

Planning the Composition

I have painted a wide variety of compositions throughout the demonstrations of this book, from the planned symmetrical composition of the outdoor still life (*The Marketplace*), to the elusive, lyrical composition of *Woods Interior*. The center of interest of many of my paintings, which influences the composition, has been varied, too. For example, the center of interest in *Soho* was actually a quality of light and shadow; the building was only a secondary element in the painting. On the other hand, the center of interest in *The White Pine* was obviously the tree.

In *Monhegan Island*, I took yet another approach to the composition. I centered it on the element of design, presenting objects primarily as shapes seen in relation to other shapes, and combined to create a specific pattern. I was drawn to the flowing rhythms made by the rocks and to the shapes they created individually and together. To put it another way, the shapes of the rocks and how they related to each other seen in the light of a lifting fog were my prime concern.

As you can see in the initial layout of the picture (Step 1), the design element in *Monhegan Island* was strong from the beginning. The swirls found in the foreground rocks lead into the dark masses of the middle foreground rocks. The shapes formed by the rocks stand out strongly, with the light value shapes of the water reflecting the sky. The darker masses of the middle background also act as a frame surrounding the light foreground rocks, locking all the shapes of the painting into place.

Arranging the Values

As you no doubt know by now, too many different values can destroy the simplicity and intrinsic strength of a painting. In *Monhegan Island*, where the entire composition is based on the simplicity of shape and design, this is particularly true. Reducing the composition to only a few values is essential to the carrying power of the painting.

To do this, I had to ask myself several questions: Where do I see colors that are the same value? On the value scale, how much darker is the green seaweed than the red of the distant rocks? Can I paint them the same value? How light are the ocean and the foreground areas that reflect the sky? Are they the same value? How much lighter or darker are the foreground rocks? How do these values compare to each other? Upon examining my subject in this way, I am able to reduce most of the values to three: two of them light, and one a contrasting dark. This immediately gives me a strong value structure upon which to build the colors.

As a general rule, I always recommend planning the values in a painting from dark to light, especially in oil painting, where lighter colors sit beautifully on top of darker colors. However, because I was seeking optical colors and flowing patterns that would move into the distance, I started *Monhegan Island* with the lighter values.

The gray rocks of the foreground occupy the lower third of the painting and are a number 4 value on a scale of 10. Since they cover a large area and their forward position is important to the desired effect of distance in the painting, I established this light value area first. I then moved into the dark, contrasting areas of the middle distance, which are a value number 8. These areas recede gently; there are no sharp lines within this darker mass. Instead, variation is achieved through color nuances. Finally the distant ocean and bits of reflected sky are value number 2, with the white of the wave being the lightest area of the painting. This value difference helps to create the distant haze into which the dark shapes recede.

The resulting value harmony of *Monhegan Island* reinforces the element of design upon which the picture is built, achieving much variety within limited values.

Deciding the Colors

As in the case with values, simplicity of color is important in *Monhegan Island*. The painting is composed of many neutral tones and colors, all muted and harmonized within a limited value range. I wanted the final effect to have rich colors showing through the thin gray haze of a lifting fog. I also wanted to keep the light, dreamy mood of the scene. Because of the lifting fog, I realized there would be a lot of gray in the picture. I therefore started to lay out the painting with a warm, light gray made with a mixture of black, white, and yellow ochre.

In the beginning stages, I established many of the colors in the underpainting more intensely than I planned to end up with. This is usually advisable when you are aiming for optical color effects and want the bottom transparent layers of color to show through successive layers of paint. For instance, I initially laid in the blue of the distant ocean brighter and more intensely blue than what I knew I would end up with. I later subdued and harmonized this blue to a light bluish gray by painting mixtures of light gray over it.

The reds and greens of the rocks and seaweed are dark, rich colors of the same value. I harmonize them by varying the proportions of Naples yellow, cadmium red light, and permanent green which they were composed of. To create the optical effect in this portion of the painting, I scumbled on a middle-value gray composed of black and white, with a touch of cobalt blue to keep it slightly cool.

Suggested Preliminary Studies

Paintings like *Monhegan Island* that require strong, simple values, colors, and shapes to carry the design need preliminary studies that train you to see and mass these design elements. For practice in massing values, use an ordinary chiseled-point layout pencil. The values are established easily and quickly with this tool. Use any paper you wish and practice making large masses with its broad, flat point. This type of broad lay-in of values can give you a good immediate idea of the composition and design of the whole picture.

Also, try massing colors and values with watercolor. It is a powerful and effective way to simplify masses and determine their placement relative to each other. To get a feel for the colors, try working with a full palette of colors, but keep the diluted watercolors in separate compartments on your palette so they don't muddy each other. Again, go after colors and shapes only, striving to capture the design element in simple terms.

I like to work on two-ply bristol board (kid or plate finish) when doing preliminary studies with watercolor. Bristol board takes pencil beautifully and takes watercolor without buckling. The color sits on the bristol board, and, when it's dry, I can draw into it with a clean, wet brush to lighten the values. I can also draw (with pencil) on top of the study when dry if I wish to add more details.

Preliminary studies should always be undertaken seriously. Don't discount their usefulness as an aid in planning a finished painting. Done with care, they will be invaluable later in the studio, allowing you to paint directly from them and from memory.

A Polaroid camera can also serve a useful purpose. Repeated photographs taken at different times of the day (especially on sunny days) can record details you might have missed or problems you may have overlooked.

Problems and How to Solve Them

The most common problem in painting optical color effects is caused by loss of simplicity. There is great strength in simplicity, in getting to the essence of your subject and leaving it like that. Always keep in mind that successful painting is based on simplicity.

In a painting like *Monhegan Island*, if you don't keep the values simple, you could end up with incorrect value relationships and thus lose the impact of the design. If that does occur, to correct the problem, you must harmonize the values and colors by working on top of what you have delicately and carefully with opaque and semi-opaque paint, using glazes to lower values and scumbles to lighten them. This will take some practice.

Remember that the object of this lesson is to create optical color mixtures. Too much opaque overpainting could block out the underpainting, leaving no recourse but to begin again. But should this occur, don't be discouraged; repainting is excellent practice toward mastering this technique and is therefore time well spent; the quality of color that can be achieved makes the effort worthwhile.

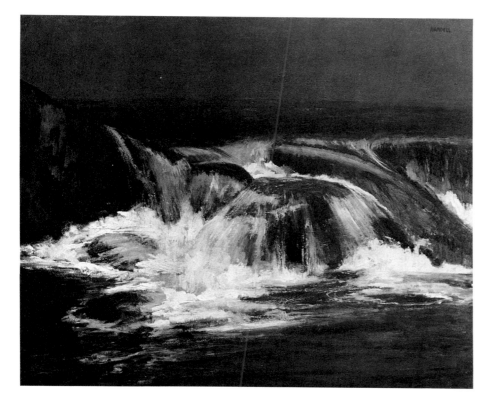

BREAKING WATERS, *oil, 24″ × 30″ (61 × 76 cm), collection Mr. and Mrs. Ken Ousterhout. Photo The Tom Reynolds Studio.* I couldn't resist painting the tumultuous movement and strength of the crashing sea breaking over the rocks. Unlike the rock paintings, where the subject is stationary, the movement of the waves calls for some memory painting. Though painted on location, I look on it as a painting composed of rhythms, colors, and their placement on the canvas. This subject is wonderful to attempt but requires a lot of practice.

CHRISTMAS COVE, *oil, 30″ × 30″ (76 × 76 cm), collection the artist. Photo The Tom Reynolds Studio.* Here is another moment on Monhegan Island. The foreground rocks and boulders are light tan in color and are tilted at a precipitous angle that gives the entire painting movement and excitement. The background rocks are dark and moss-laden; the sea is quite gentle by comparison. Much work was done on the foreground rocks with a palette knife to bring out their rugged texture.

Step 1. With a mixture of ivory black, titanium white, and a touch of yellow ochre to warm up the gray, I lightly sketch in the design of the painting. I use a no. 2 round bristle brush and turpentine as the medium. Notice the arc of the foreground rocks that frame the middle foreground, setting it back a bit. I then begin the transparent color wash-in, which will be the base for my optical color mixtures. With a no. 4 round bristle and turpentine as the medium, I thinly scrub on the tannish-gray tone of the rocks with my initial gray. I allow the brush to follow the sweep of the rocks.

Step 2. Picking up a smaller brush for more rhythmical strokes—a no. 2 round bristle—I lay in the color wash of the seaweed-covered middleground rocks. This is done with a mixture of permanent green mixed into a middle-value gray composed of black and white. It is low tide, and as I paint the green seaweed I take careful note and delight in the rhythms and patterns the seaweed is left in as the water recedes. As the green of the middleground is put in, the foreground greens are reinforced and strengthened.

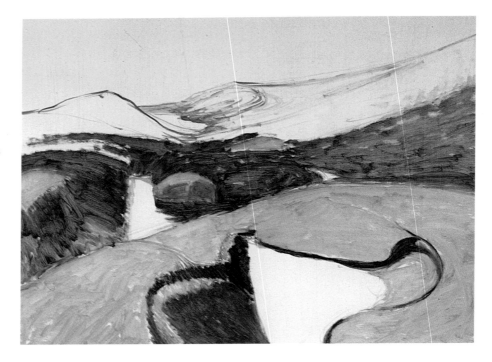

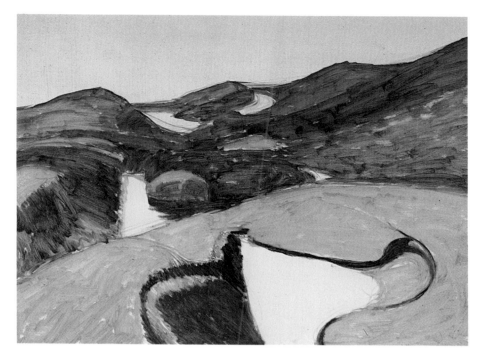

Step 3. By now all of the shapes have been established with color as I lay in the distant red rocks with a no. 5 flat bristle brush and a mixture of cadmium red light and gray (black and white). I again take careful note of the patterns and shapes. The positive shapes are all laid in with color; the negative shapes are unpainted. The design of the picture is now set.

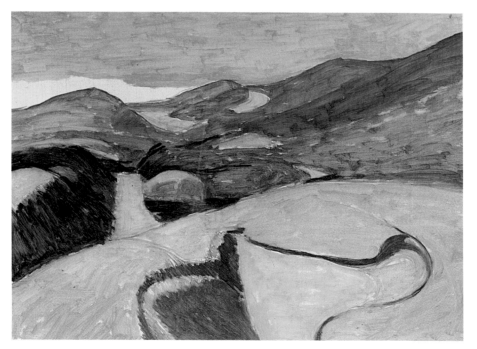

Step 4. This is the last phase of the transparent color lay-in, which forms the basis for the finished optical color mixtures. Still using turpentine as the medium and a no. 4 round bristle brush, I lay in the sea with a mixture of ultramarine blue toned down with a very light gray so it will stay in the background. I also reestablish and strengthen the seaweed area of the lower left with a combination of the permanent green and middle-tone gray mixture, but a touch thicker now and more opaque.

Step 5. With the transparent under-painting finished and relatively dry—I used turpentine as my medium and worked on an absorbent ground—I'm ready to begin the overpainting. I clean off my palette and set out fresh paints. Taking a few no. 4 round bristles to keep the colors clean and separate, I begin working up the greens and reds in the middle fore-ground. I switch to the Maroger me-dium and, using it sparingly, I estab-lish richer colors, using more pigment, to make a good, solid base for the optical color mixtures that will come later.

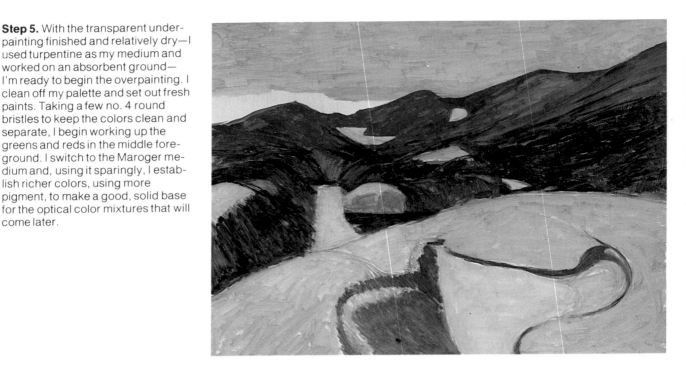

Step 6. I concentrate on massing the green, seaweed-covered rocks and the distant red rocks together so that they flow into each other. Continuing to mass and unify the areas, I put touches of blue in the foreground and middleground rocks, so as not to lose sight of the light source, al-though it is foggy and overcast. This also keeps a hint of "bluishness" in the painting due to the cool light. With a gray of black and white, I paint the puddle next to the rocks and add some of the textural details to the foreground rocks.

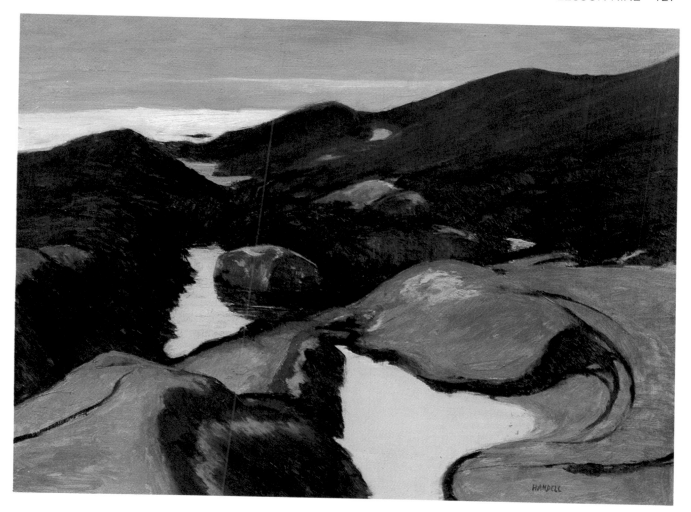

MONHEGAN ISLAND, *oil, 18'' × 24'' (46 × 61 cm), collection the artist.* I now glaze and scumble on a light blue-gray mixture of ultramarine blue, a touch of white, and Maroger medium. I float it over the picture, unifying it through this bluish haze, letting the various underlying colors come through. By scumbling the bluish gray over the red rocks I push them back a bit and soften and harmonize these well-defined shapes against the background sea. I scumble a warm gray tone of the same value over the sea, pushing it back still further and creating an optical color sensation. The foreground rocks get richer and warmer as I add more Naples yellow and yellow ochre to my colors and work more detail into the foreground rocks. Working a bit more opaquely with a little Maroger medium mixed into the paint mixtures, I continue to gently pull the entire painting together. The optical colors give a simple painting like this a luminous colorplay, yet the painting retains a subtle and harmonious unity.

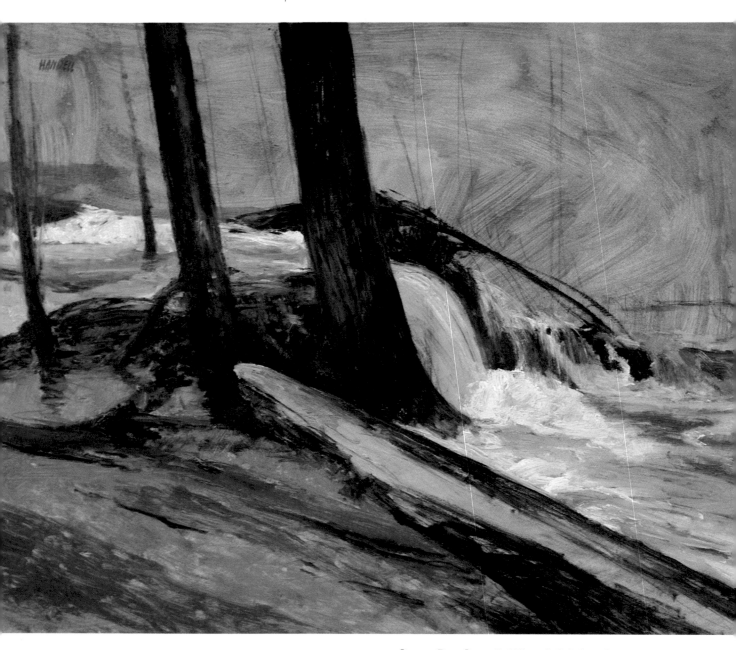

SPRING RUN-OFF, *oil, 18'' × 24'' (46 × 61 cm), private collection.* It is early spring and the power of the run-off of terrific amounts of water can be seen everywhere. The winter snows high in the mountains are melting. Now the dried-up streambeds sleeping under the winter snow and ice suddenly wake up, rushing and overflowing with power and energy. I kept the painting very simple. At first I eliminated the water to establish the earth, rocks, and trees. I painted the background with a transparent wash of raw sienna over my normal light gray tone. I then painted in the water opaquely. After this was completed, I used a scumble to flow the water over some of the debris in its path (middle area on the right-hand side of the painting). This gave me immediate optical grays—grays I would not be able to obtain by mixing on the palette.

More About Optical Color Mixtures

Contrasting Transparent Underpainting, Limited Palette
Semi-Opaque and Opaque Overpainting, Limited Palette

In the previous lesson I demonstrated how a transparent, full-color underpainting followed by a harmonizing semi-opaque and opaque overpainting plus glazes and scumbles could create beautiful, harmonious, optical colors. In the present chapter I use essentially the same method, but with a slight variation. I will employ a contrasting underpainting of complementary colors for yet another optical color effect, one more subdued than the other yet still quite lively and vibrant.

With a contrasting underpainting you can immediately establish and separate the objects of the painting into distinct positive and negative areas. Also, with this type of underpainting you don't see the final color harmonies at the beginning, but the color design of the underpainting gives an underlying color sensation to the whole picture. The object of the overpainting is to develop the underpainting to completion, while permitting its underlying, contrasting colors to show through. The local colors of objects are overpainted semi-opaquely, and create a harmony by incorporating the vibrant colors underneath.

General Procedure

As in the preceding demonstrations, I apply the transparent colors of the underpainting with turpentine, quite loosely at first, to feel my way around as I draw in and lay out the painting, moving with the rhythms and angles of the composition. Once I decide on the placement, I continue to scrub on the colors of the underpainting transparently, with Maroger as the medium. Building up the underpainting by scrubbing on the colors makes them richer and darker. When they're completely established, I develop the picture with semi-opaque paint, allowing as much of the underpainting to show through as possible. The result of this procedure is unusual color effects, especially if only a few colors are used in the underpainting.

The Lesson

This combination of techniques offers an opportunity for lustrous optical color effects, with or without the additions of glazes and scumbles, which are optional here.

Using a Contrasting, Limited-Palette Underpainting

This type of underpainting offers a rapid way of obtaining optical color effects. It is laid in simply, using contrasting complementary colors to separate the negative and positive shapes of the picture. You can then get into the overpainting immediately, keeping the painting as loose or detailed as you wish. Not only are the color effects achieved quickly—other techniques often involve tedious planning and several applications or layers of paint—but there is an innate harmony because the strong underpainting unifies the many color areas of the painting.

Finally, using contrasting colors at the very beginning is a real plus because it lessens the need to center on value contrasts and lets the play of color take precedence. By being bold and free with the design of the painting—through color—you will be rewarded by a strong painting and beautiful optical color you could not get any other way.

Materials Required

For the demonstration of the advanced techniques in the painting *Kaaterskill Stream*, I used the following materials:

Support

I used a homemade gesso pressed-wood panel, 24'' x 28'' (61 x 71 cm), toned a light gray.

Brushes

I used round bristle brushes, nos. 1, 2, 3, and 5; flat bristles, nos. 5 and 7; a no. 4 stiff, short-hair, bristle brush; and a 2'' trowel-shaped palette knife.

Mediums

I used pure gum spirits of turpentine for the transparent underpainting and Maroger medium for the build-up and completion of the painting.

Colors

I used a limited palette of ultramarine red and yellow ochre for the contrasting underpainting and a limited palette for the entire overpainting too, which was done with only seven colors:

Ultramarine red	Ultramarine blue
Yellow ochre	Ivory black
Raw sienna	Titanium white
Permanent green	

I was able to use a limited palette in the overpainting because of the initial impact of the complementary colors of the underpainting. As the first three steps of the demonstration will show, the contrasting underpainting was essential to the underlying design of the entire painting. Less work was required in the overpainting because so much variety and harmony came from underneath and showed through at the finish.

Selecting a Subject

A complicated subject where many objects need to be stated and harmonized is an ideal choice for this technique. *Kaaterskill Stream*, for example, is composed of rocks, earth, and water. Each element is separate yet intricately interwoven with the other. The rocks are part of the earth, and the water flows over and through the earth, breaking it down and moving it along as silt and revealing the rocks. There is also great variety within each element: the many shapes of the rocks; the growths of light-colored lichen and dark green mosses that cling to the exposed rocks; and the movements, directions, and rhythms of the embankment. Through the procedure, the overlapping and convergence of these separate elements is established in the underpainting, and their essential unity is obtained in the overpainting.

Another consideration when selecting a subject for this combination of techniques is the lighting conditions. Again, the light of a gray day is best because here, too, the color effect is of prime interest, and the subtle, soothing light of a gray day, where nothing jars or jumps, can best bring this color out. Sunlight, with the dark shadow and cast shadows and strong value and shape patterns it creates, cuts across everything like a moving scar.

The area surrounding the Kaaterskill Stream is rugged, with many steep, rocky inclines and numerous waterfalls. Sunlight trickles into the woods and creates a rhythmical dance of light, color, texture, and shapes. The water flows down the mountainside continuously, swirling about the rocks and creating pools. I often wonder where this continual flow of water, with its perpetual rhythm of movement, its power, colors, and force, comes from; but it is there. Such scenes remind me of the power of nature, and I wished to capture this sensation in my painting.

Planning the Composition

There was a bit of sunlight trickling through the woods, and the changing light and moving water caused many different shapes and patterns. I decided to eliminate any direct sunlight so I could better observe my subject: the colors, the tilt of the rocks, the flow and energy of the water, and the tumbling land. I decided to build the composition around a detail of the stream and the earth and rock formations and above it, to capture the sense of weight and strength they possessed.

In planning the composition for a complicated subject like *Kaaterskill Stream*, you must know right away where you want the center of interest to be. There are so many alternatives that, unless you determine this in the beginning, you will get lost in a confusion of objects that all demand attention.

To emphasize the weight of the rocks and embankment, I decided to place the waterline relatively low on my canvas. The line of the top of the pool was also placed low to further enforce its weight and importance. I then concentrated on the sharp descending angle of the rocks, which allowed for a diversity of shapes, patterns, and colors characterizing a downward movement. The water, which tumbled down the rocks and boulders into the pool below, contrasting with the angles and shapes of the rocks with its direct, downward flow, was the center of interest.

Arranging the Values

Kaaterskill Stream provides a good example of the strength that can be obtained through simplicity of values. The values here are close, the only sharp contrast being the white of the falling water, a relatively small area compared to the rest of the painting. I kept the values simple so they wouldn't distract from the optical color sensations.

The values of the rocks, pool of water, and upper foliage—which constituted the major portion of the painting—were all related. The flowing tie-up of these areas was only broken in places by the darks within the rocks and by a few lighter colors here and there representing growths of lichen on the rocks.

Deciding the Colors

It was late spring, and the greens of the foliage were turning from the yellowish greens of early spring to the verdant greens of summer. The earth had a lot of yellow ochre, raw umber, and umberish-gray colors in it, and the rocks were composed of purple, gray, and other tertiary colors.

I selected a delicate, yet specific color scheme that enabled me to lay in my underpainting with a limited palette. I kept the underpainting to two colors: a weak purple (ultramarine red) for the rocks, and yellow ochre for the earth and water. I could sense these colors as I looked at the subject and felt that, if I could get their vibrancy to come through the final combinations of color I planned to use, it would add to the finished painting. Ultramarine red, which is purplish, and yellow ochre are somewhat complementary in color. I used them to establish the negative and positive areas of the painting. They would also help bring out the optical colors in the later stages of overpainting.

Although I added more colors to my palette for the overpainting, I didn't need the full landscape palette because of the extensive underlying harmony of the contrasting complementary underpainting, which gave me a head start. I tried to unify the colors of the overpainting without losing the contrast and separation of the underlying colors. As you can see in the finished painting, the tan of the rocks in the overpainting has some yellow ochre in it, and there is also green in the rocks. At the same time, the purple underpainting comes through and links these areas, harmonizing them. The elusive effects of optical color are evident here.

Suggested Preliminary Studies

Painting is not merely the act of putting down on canvas the lines and colors you see; it goes beyond mere mechanics. It is a way of life, a way of seeing. So, in a sense, taking the time to become directly involved with what you see is a preliminary study that will become an approach to life. Try to become intimately acquainted with your subject matter. Experience it and feel a part of it, yet be aware that it has a life apart from yours, too.

For instance, go into the woods, sit by a stream, and simply observe. Look, relax, breathe deeply, and try to become part of the scene. Take no drawing materials with you at first; rather just try to free yourself from the pressures of work. For many of us who feel we have to be producing something or

other all the time this may not be easy, but try just to sit, relax, and reflect. This is a sort of meditation.

After a while, pretend you have your drawing materials with you and start to draw the scene mentally. Notice how much fun this is; you are now earnestly at work. You will be amazed at how free you are with your subject matter and observations and how easily you can concentrate. This is a superb mental exercise I recommend that everyone try. It's fun and uninhibiting and will help develop your memory painting quite well.

After you have practiced this exercise several times and feel relaxed with it, take your drawing materials along. Again, sit and reflect. Then turn your back to your subject and draw it from memory. You will not do the same type of drawing you would while looking at the subject, recording and taking notes quickly as you go along. Instead, you'll find yourself putting down only the essentials, responding more to your feelings and to the subject's underlying rhythms. You won't be preoccupied with the details of the subject that you normally would with the subject in front of you. Instead, all the unessential details will disappear as you become one with your subject. As you get closer and closer to the underlying essentials of your subject, the painting techniques you should use will gradually come to you. So relax and go with your feelings. A great awareness and depth will come into your work with this approach. Oriental Zen oil painters and watercolorists who have left the world beautiful landscapes to experience supposedly went out into the woods, sat by a waterfall all day long, and just looked. They then went home and either that day or the following day painted the subject matter from memory. In the West, I feel we don't do this quite enough. Most often we go out on location and slam, bang, allakazam, we're working! I think painting should be a quieter activity, a far more reflective one. I especially recommend this type of preliminary study for the experienced painter. Reflecting and meditating on your subject will be a tremendous asset to your future paintings and to your realizations about painting and yourself in general.

Problems and How to Solve Them

The major complication and basically the only serious problem here is making the overpainting too heavy-handed and opaque, which would cause you to lose the opportunity for optical color effects. Try to work the overpainting mostly semi-opaquely, keeping the opaque paint to a minimum. Actually, as a general rule, you should always work lightly and semi-opaquely and avoid becoming too opaque too soon so you don't lose the contrasts from the underpainting.

However, once you have lost the underpainting, with this technique you cannot regain it. So you have two alternatives. You can accept this fact and change the technique to one more opaque and continue to develop the picture. (Do not consider it a failure: it is perfectly valid to change the technique in "midstream" if it is absolutely necessary to do so.) Or, if you're determined to go after the same objectives using the same painting technique, you can begin a new painting, keeping in mind where you went wrong and being careful not to let the same mistake occur.

Optical color mixtures may be tricky to achieve, but once you have developed a taste for them, they are so special, so elusive, and so beautiful that I'm sure you'll want to add this method to your repertoire of painting techniques, as I have.

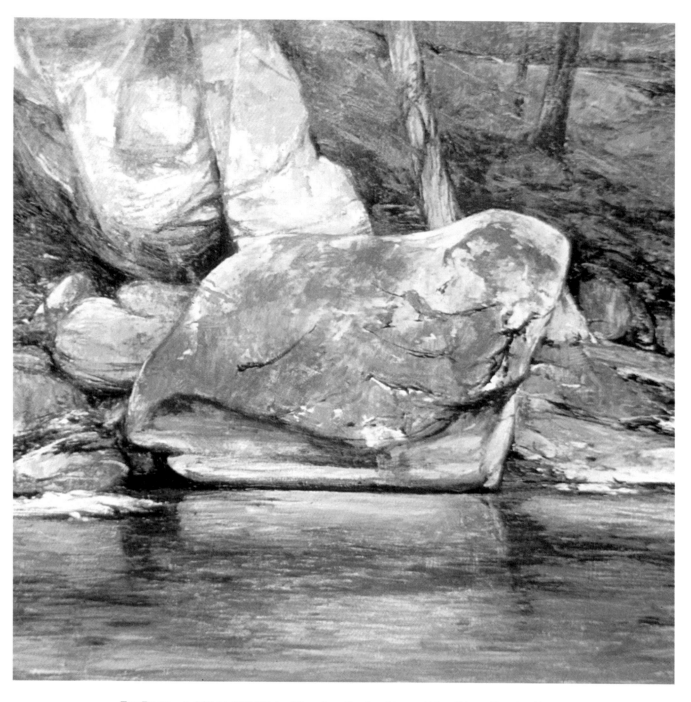

THE ROCK, *oil, 36'' × 36'' (91 × 91 cm), collection Mr. and Mrs. Edward Legier.* Here is a simple, yet beautiful, subject I stumbled upon while walking along a streambed in Pennsylvania. The shapes, colors, and textures here excited me. There was a strange reddish-purple tinge in this and the surrounding rocks. The lighter tones were lichen; I kept them a light gray-green for color contrast, and eliminated all details.

This drawing was done one afternoon at the Kaaterskill Stream. It took all afternoon and when I had finished, I turned to my right a bit and saw another group of rocks. Struck by what I saw, I decided to return the next day. I went home and thumbtacked my drawing to my studio wall. The next day I returned to the area with my sketchpad and drew the tumbling rocks (opposite page). Again the sketch took all afternoon. When I returned home, I thumbtacked the drawing next to the previous day's work. Much to my delight, the proportions of both drawings related to each other exactly!

SMALL WATERFALL ALONG THE KAATERSKILL STREAM, *pastel, 24″ × 28″ (61 × 71 cm), collection the artist.* To know your subject well, it is wise to study it at different times of the day, in different seasons, and with different painting materials. Here I chose pastel to capture a fleeting moment of water falling in the light of a late summer afternoon.

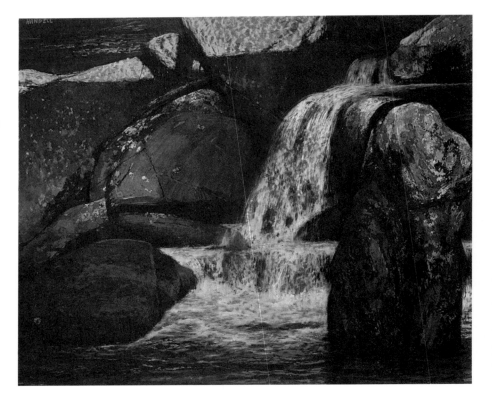

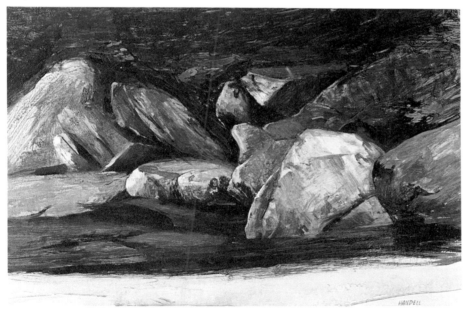

THE ROCKS AT PLATTECOVE, *oil, 14''
× 20'' (36 × 51 cm), collection the
artist.* There are many streams
where I live; all are quite different
and all quite beautiful. This group of
rocks was found at the Plattecove
Stream. I liked their sense of weight,
their haphazard leaning quality, and
their rhythms. This is a small paint-
ing. I worked on the spot with both
thick and thin paint mixtures. Two
weeks later, when the painting was
thoroughly dry, I applied delicate
glazes over some of the rocks.

Step 1. Mixing ultramarine red with titanium white and a little turpentine, I take a no. 5 flat bristle brush and begin to sketch in the tumbling rocks. From the start, my brushstrokes follow the direction of the rocks. The ledges are tilted and emerge from the water at a severe angle, giving a sense of weight and force immediately. I establish the waterline low, adding to the sense of pending weight above.

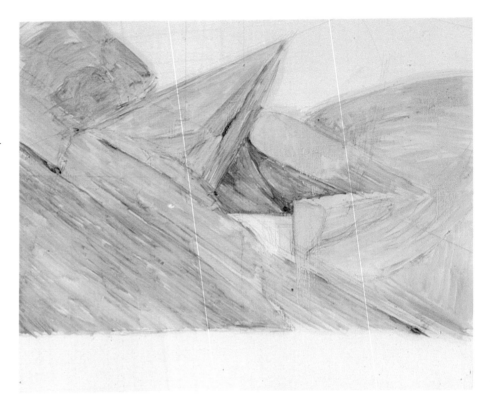

Step 2. Still using turpentine as the medium and picking up a no. 7 flat bristle brush, I lightly lay in the earth and water with yellow ochre. Here I also allow the brushstrokes to follow the direction of its movement and rhythm. For example, I use horizontal strokes for the water and curved strokes for the textured earth. Notice how the shapes of the purple rocks and the shapes in yellow ochre contrast and complement each other.

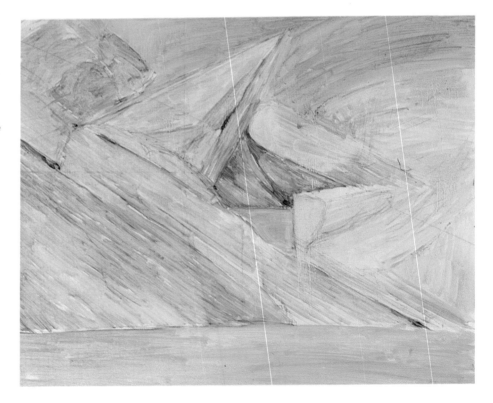

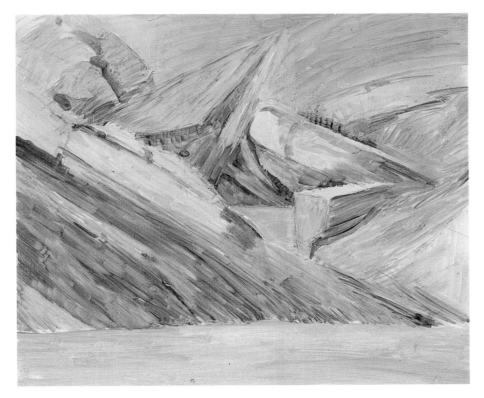

Step 3. Still working on the transparent lay-in with turpentine as my medium, I build up the rock formations with ultramarine red. The general values and colors of the painting are now getting deeper and richer. My brushstrokes are still following the direction of the rocks.

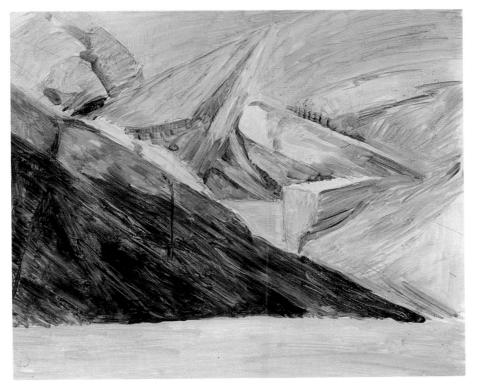

Step 4. I have carried the picture to this point with only two colors, ultramarine red and yellow ochre plus turpentine. The painting is dry by now and I begin the overpainting. Laying out fresh color on my palette, I first glaze the lower rocks with permanent green. Then, with a mixture of gray and ultramarine red, I paint into the wet areas semi-opaquely. I will intensify these rocks still more later, but at present they form a basic tone for the painting to which I will relate future tones and colors.

Step 5. With a mixture of ultramarine blue and permanent green mixed into gray, I continue the same procedure of painting in the rocks, going thicker in paint quality for texture and darker in value. The rhythms, textures, movement, and colors are very alive now. The reds of the rocks in the underpainting vibrate through to create optical color effects and harmonize all the rocks.

Step 6. I now paint the green of the water with a mixture of permanent green, yellow ochre, and a touch of titanium white. This color is the same value as the rocks on the right of the painting. The green foliage (the same mixture as the water) is brushed on in a rhythm that suggests its growth. The yellow ochre of the underpainting shows through, warming up the green optically. I blend some of the foliage green into the rocks, which relates and harmonizes the two areas.

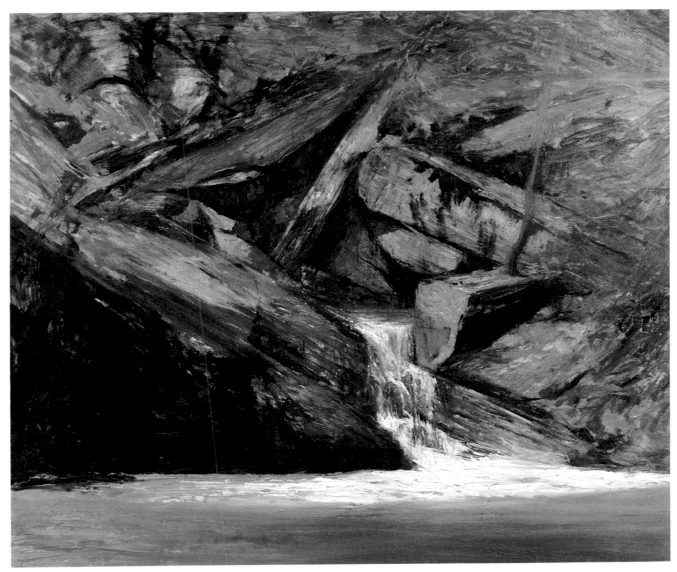

KAATERSKILL STREAM, *oil, 24″ × 28″ (61 × 71 cm), collection the artist.* I continue to pull the painting together and harmonize the established colors, putting in details as I work with a no. 3 round bristle brush. (I use several brushes of the same size to keep the colors separate.) In this final stage, I continue working with variations of the color mixtures used in the buildup in order to maintain the tonal harmony. The white tumbling water is painted in speedily and thickly with a palette knife, creating an exciting, sharp contrast to the softer brushstrokes in the rest of the painting. I add subtle nuances of color in the rocks. The initial angle of the rocks and its result-

ant sensation of tumbling and weight is maintained in the finished work. The purple underpainting of the rocks vibrates through, giving an underlying color harmony to the entire painting. The rocks are painted opaquely yet thinly in places. The water is painted opaquely except at the lower left, where the yellow ochre underpainting comes through. The white of the water is the most opaque area of the painting and does not allow for optical color mixtures. But I do mix in a little purple to keep it in harmony with the rest of the painting. When the white of the water is dry, I give it a final glaze with a bit of the foliage green.

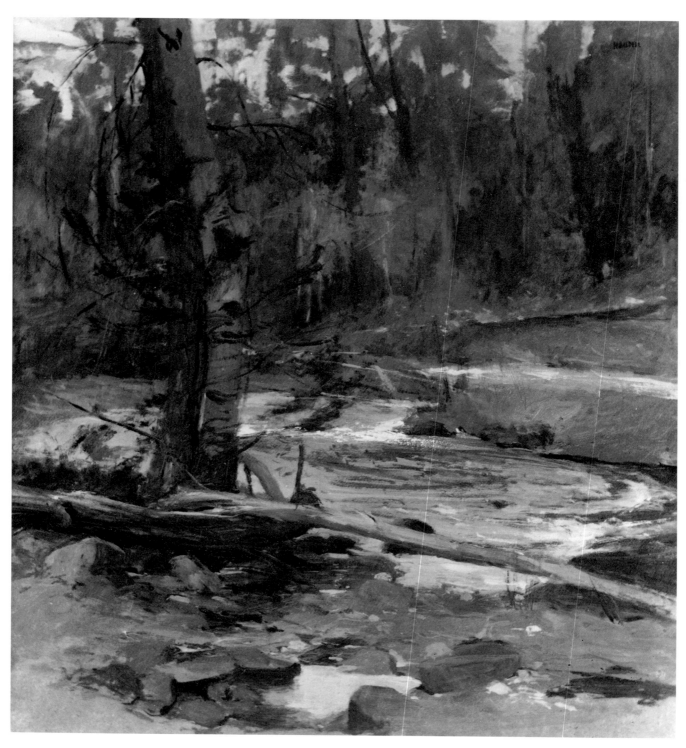

THE CREEK, *oil, 24″ × 30″ (61 × 75 cm), collection Dr. and Mrs. Bruce Sorrin.* I did this painting while on a camping trip in the Wasagh Mountains in Utah. There is a feeling of being deep in the woods, near a fine fishing pool in one of the many streams and creeks found there. Because it was an overcast day, with no changing patterns of light and shadow, I was able to spend the better part of a day on this painting, finishing it on location.

Bibliography

Carlson, John F. *Carlson's Guide to Landscape Painting.* New York: Dover, 1973.

Cennini, Cennino. *The Craftman's Handbook; "Il Libro dell 'Arte."* Translated by Daniel V. Thompson, Jr. 1933. Reprint. New York: Dover, n.d.

Cole, Rex Vicat. *The Artistic Anatomy of Trees.* 2nd ed. New York: Dover, 1951.

——*Perspective.* London: Seeley, Service, New Art Library, n.d.

De Lisser, R. Lionel. *Picturesque Catskills, Greene County.* 1894. Reprint. Cornwallville, N.Y.: Hope Farm, 1967.

Doerner, Max. *The Materials of the Artist: and Their Use in Painting.* New York: Harcourt Brace Jovanovich, 1949.

Franck, Frederick. *The Zen of Seeing, Seeing/Drawing as Meditation.* New York: Vintage, 1973.

Hoopes, Donelson F. *Eakins Watercolors.* New York: Watson-Guptill, 1971.

Kay, Reed. *The Painter's Companion.* Cambridge, Mass.: Webb Books, 1961.

Lucie-Smith, Edward. *Fantin-Latour.* New York: Rizzoli International, 1977.

Mayer, Ralph. *The Artist's Handbook of Materials and Techniques.* 3rd ed. New York: Viking Press, 1970.

Pike, John. *John Pike Paints Watercolors.* New York: Watson-Guptill, 1978.

Savage, Ernest. *Painting Landscapes in Pastel.* New York: Watson-Guptill, 1970.

Schmid, Richard. *Richard Schmid Paints Landscapes: Creative Techniques in Oil.* New York: Watson-Guptill, 1975.

Taubes, Frederic. *The Technique of Oil Painting.* New York: Dodd, Mead, 1942.

Wilkinson, Gerald. *Turner Sketches, 1802–20.* New York: Watson-Guptill, 1974.

Wyeth, Betsy James. Wyeth at Kuerners. New York: Houghton Mifflin, 1976.

Index

Edited by Bonnie Silverstein
Designed by Jay Anning
Graphic production by Hector Campbell
Set in 11-point Helvetica light